ARIZONA

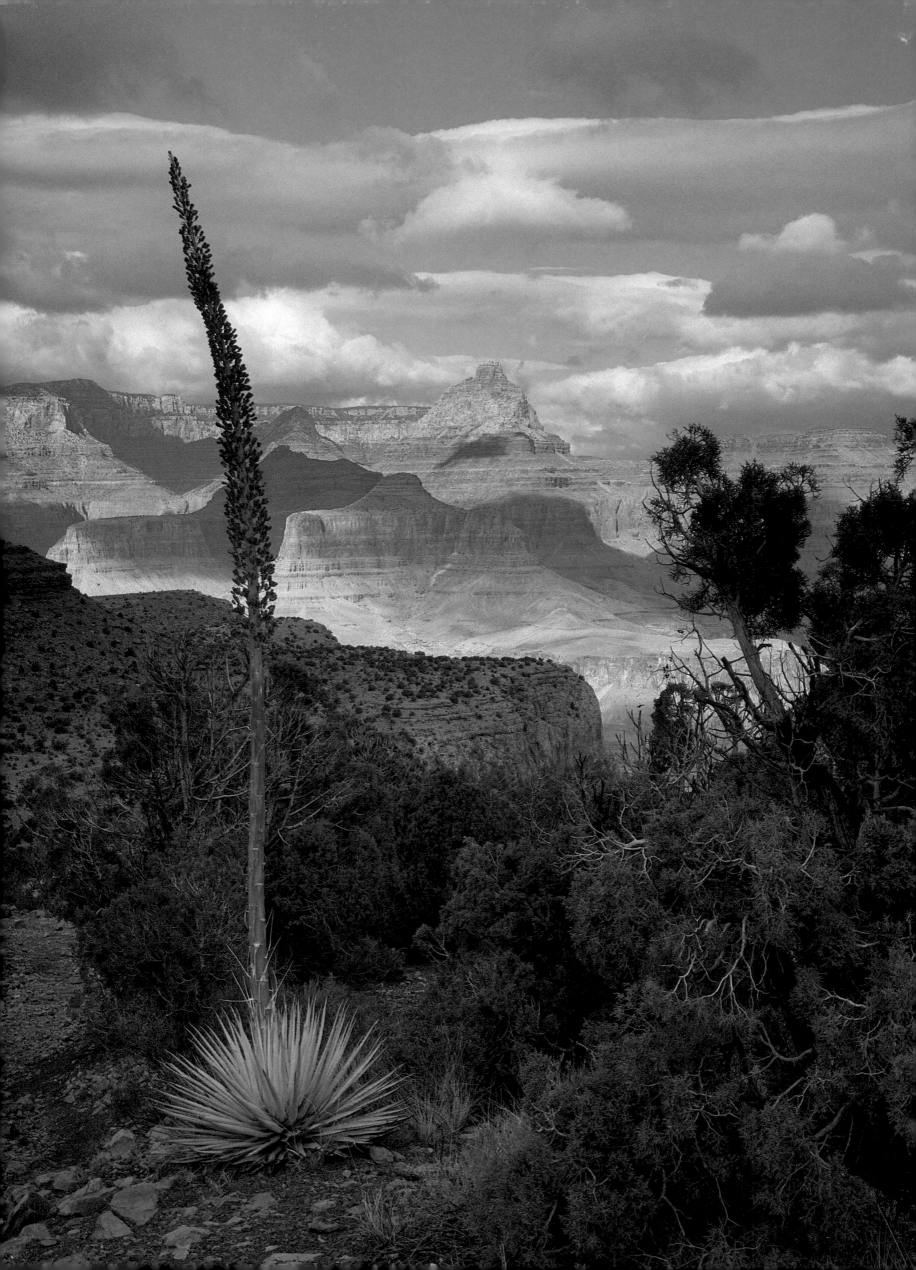

ARIZONA

PHOTOGRAPHY BY FRED HIRSCHMANN
TEXT BY SCOTT THYBONY

GRAPHIC ARTS CENTER PUBLISHING COMPANY, PORTLAND, OREGON

ARIZONA

▶ *Autumn comes to a dark narrows of Wet Beaver Creek in the Wet Beaver Creek Wilderness of the Coconino National Forest.*

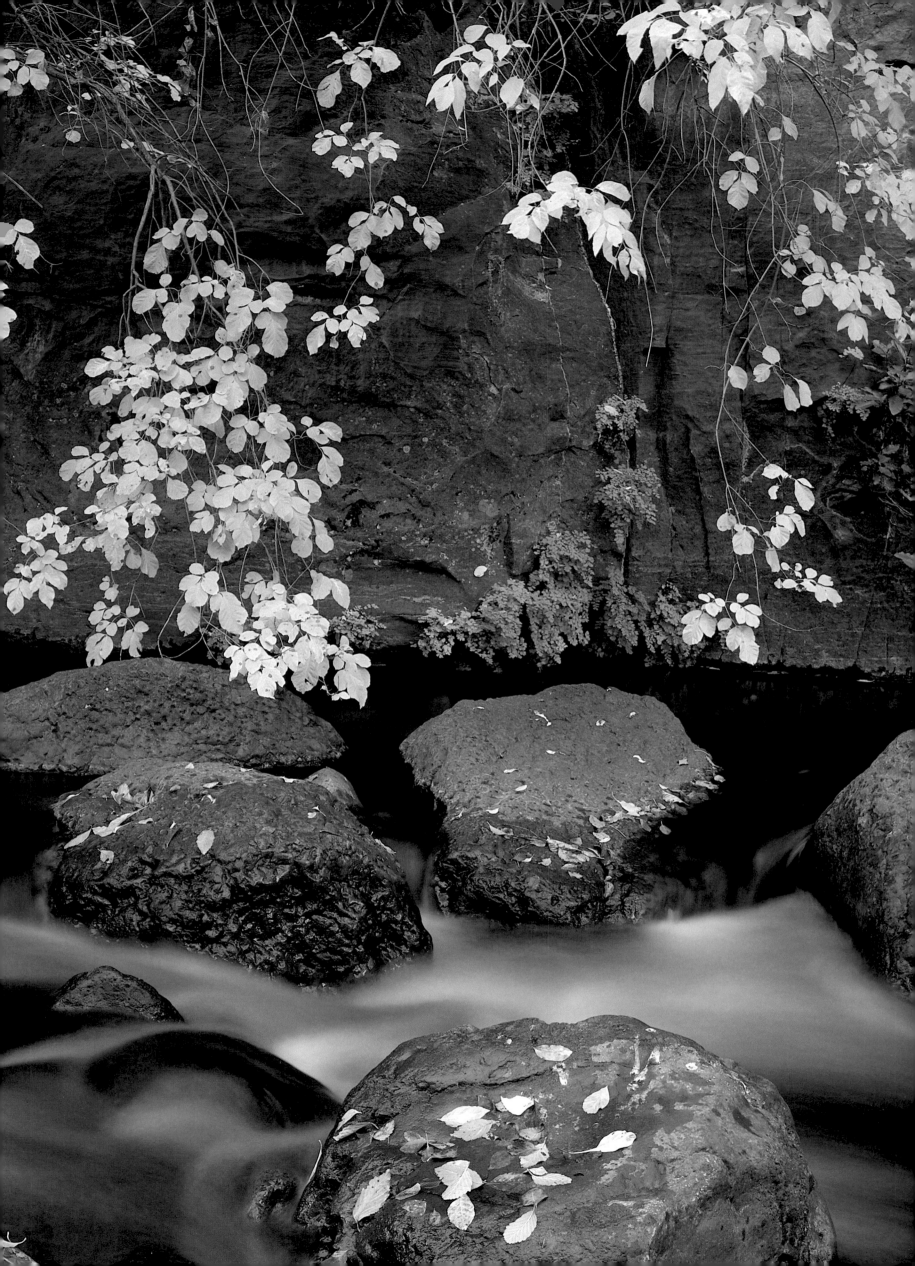

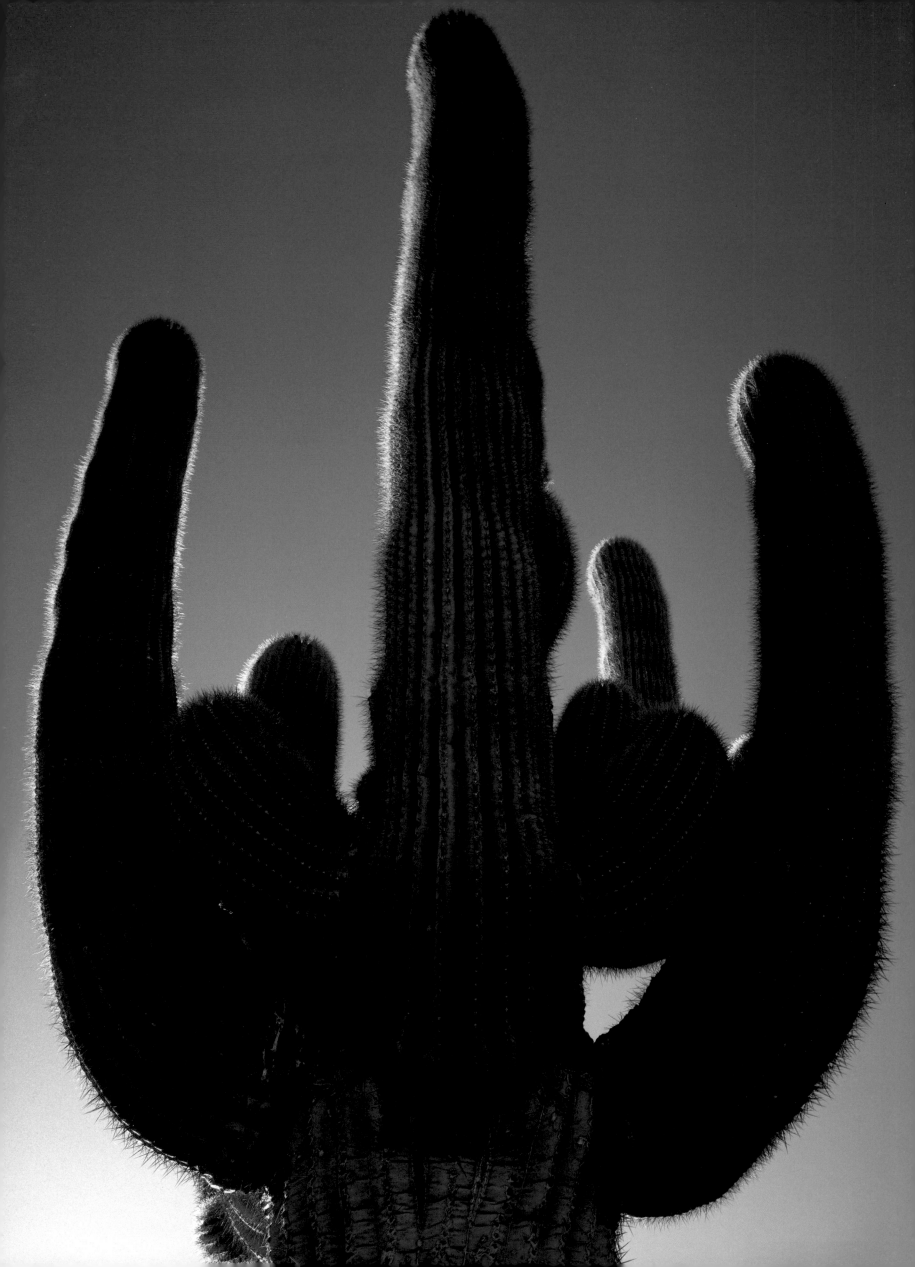

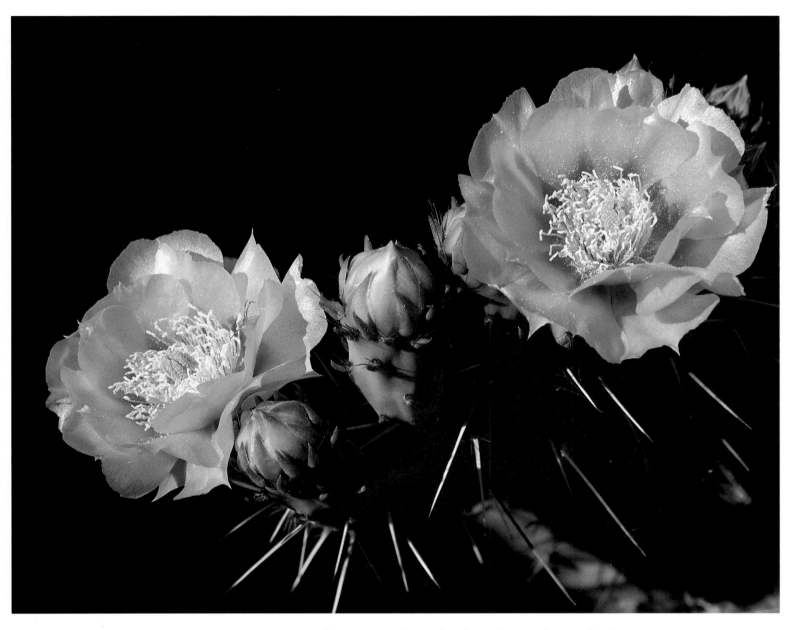

◄ A mature saguaro spreads its arms to desert sky above the Antelope Hills of the Cabeza Prieta National Wildlife Refuge. In addition to protecting stately saguaros, Cabeza Prieta provides a critical habitat for desert bighorn sheep and endangered Sonoran pronghorn antelope. ▲ Yellow blossoms of spring grace a prickly pear in the Tucson Mountain Unit of Saguaro National Park.

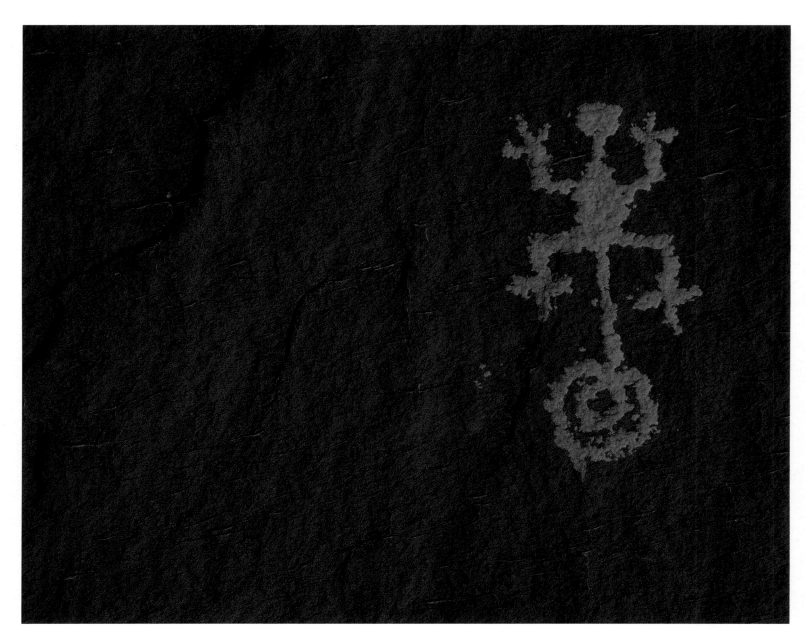

▲ Desert varnish is a dark coating of iron oxide and manganese oxide affixed to sandstone by bacteria. A durable medium over the centuries, this dark veneer was used by ancient Anasazi artisans to incise their drawings in stone. Thousands of petroglyphs are scattered across the wild places of Arizona. ▶ Indian paintbrush decorates the weathered roots of a fallen juniper in Navajo Canyon.

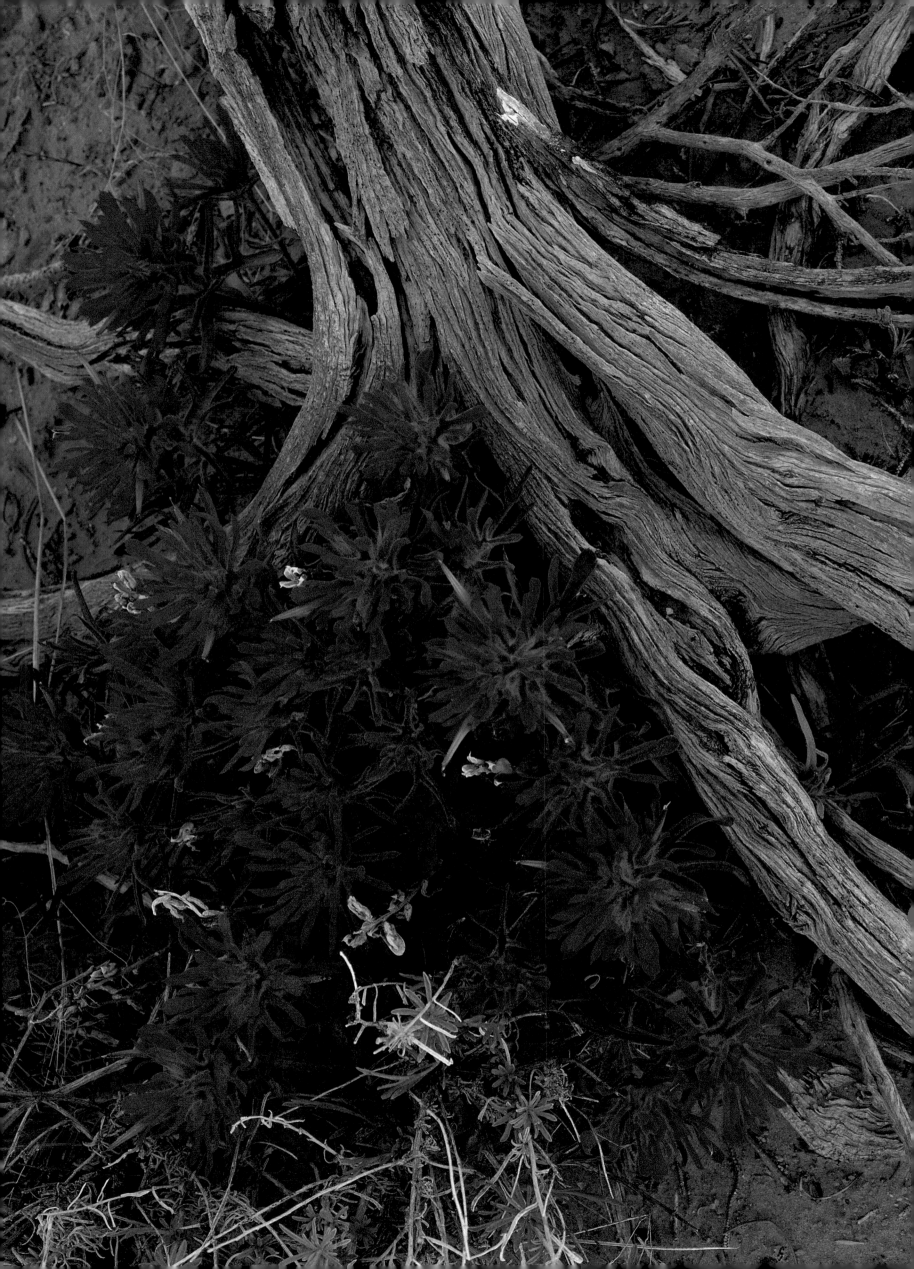

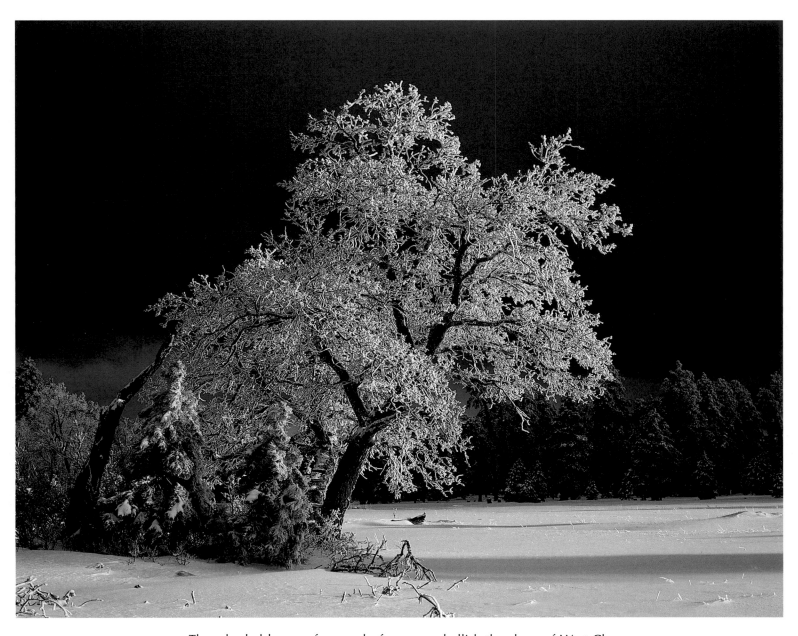

◄ The whorled leaves of narrowleaf yucca embellish the slope of West Clear Creek in Coconino National Forest. ▲ Rime and fresh snow cling to oak branches as a storm breaks over the Mogollon Rim. At an elevation of nearly eight thousand feet, during winter the rim is occasionally enveloped by ice fog.

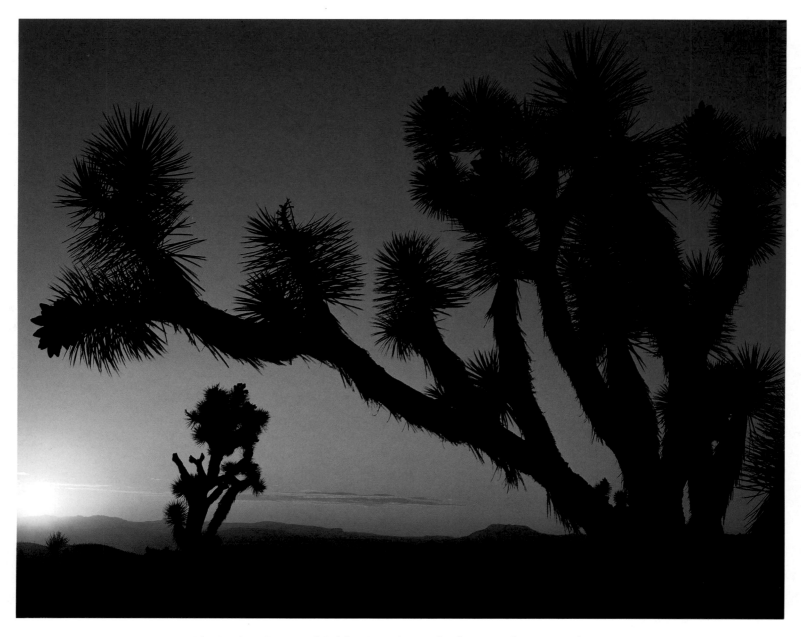

▲ The Mojave Desert of California and Nevada also spreads over northwestern Arizona. Stately Joshua trees create an enchanting forest in the White Hills. ▶ At the dawn of the age of dinosaurs, tremendous volcanic ash deposits accumulated across much of northeastern Arizona. Today, the Chinle Formation has eroded into fanciful badlands at Blue Mesa in Petrified Forest National Park.

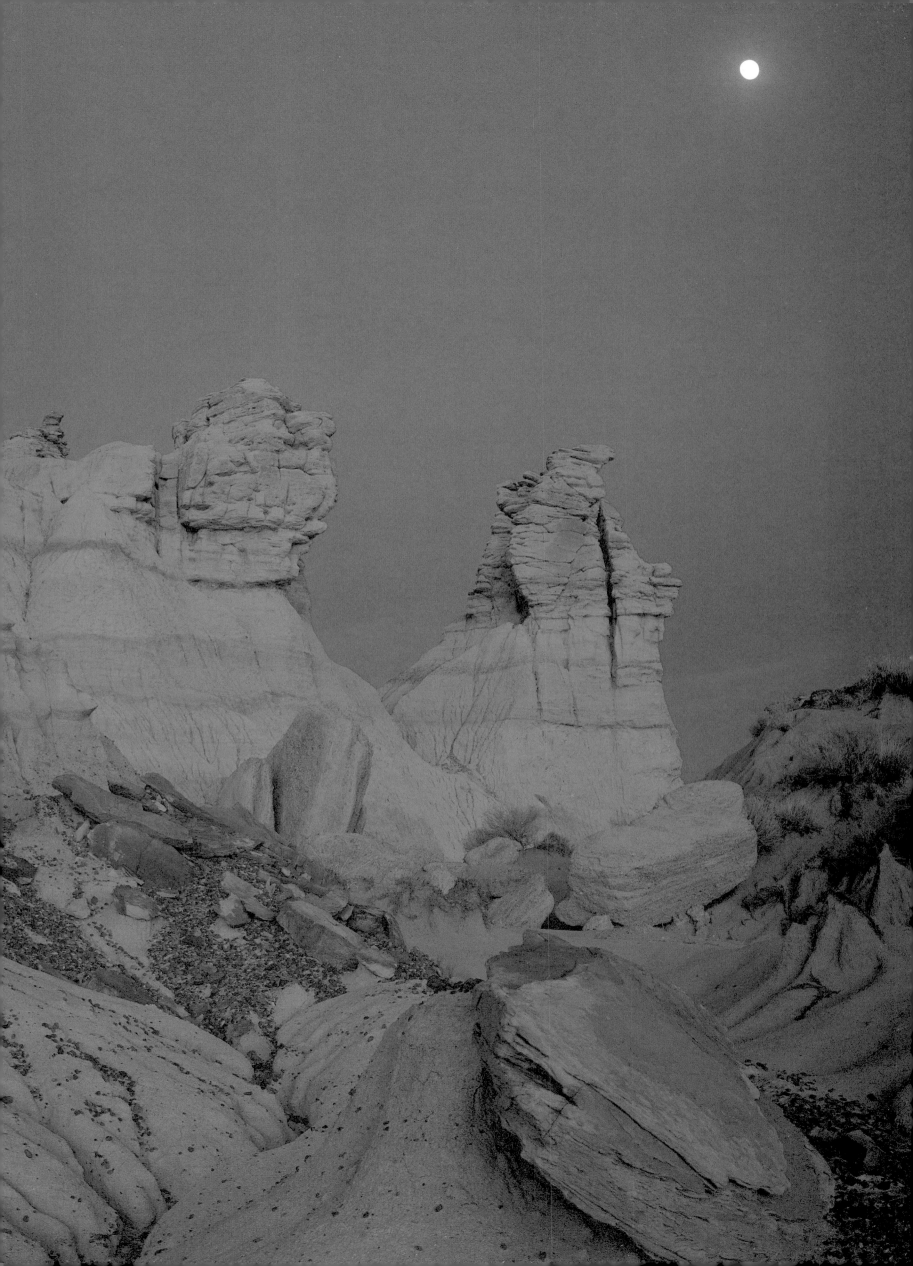

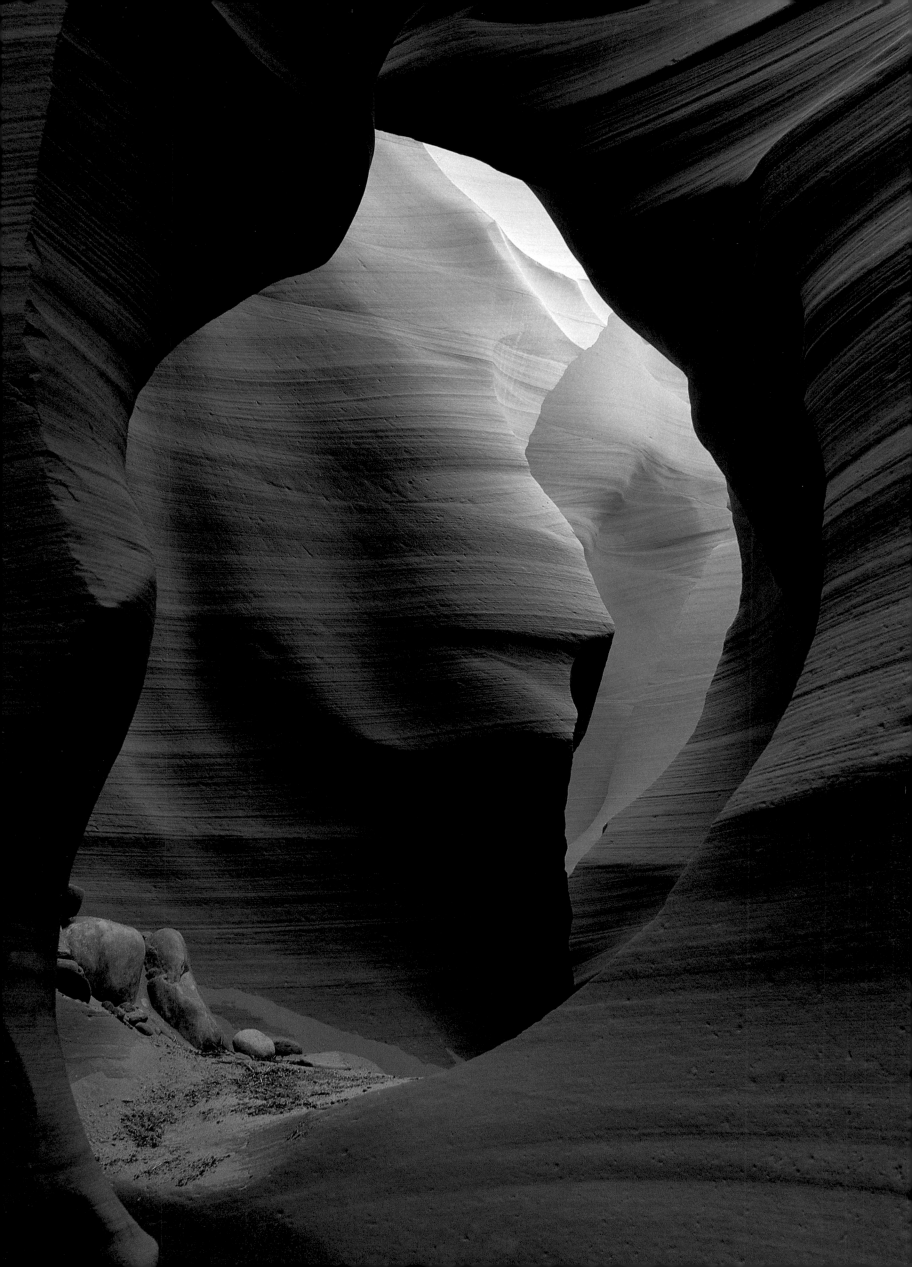

praying for rain

"We need water," Kent Tso told a dozen Navajo farmers crowded together in the front room of John Yazzie's house. Many sat with their elbows on their knees, staring at the floor, listening. It was summer at Sand Springs, a remote corner of the Painted Desert on the western edge of the Navajo Indian Reservation. The rains were late; the Little Colorado River was bone dry. "We need water," the seventy-six-year-old Indian said again. He farmed near Grand Falls without the aid of a well, relying instead on an intermittent spring and an unpredictable river. Both were dry. He told the others that unless the rains came in a couple of days his crops would die.

Each farmer took his turn speaking; each told of problems—a broken pump, no help from the sons—but the talk always returned to water. In the room hung an old print of an alpine lake surrounded by snowy peaks and tall trees. Outside, sand blew across the hard-packed ground where a hen scratched away the hours.

On an earlier trip to Sand Springs, I had followed Benson Nez, the Navajo ranger responsible for patrolling a large part of the western side of the reservation. Navajo Indian rangers are different from the rangers found at national parks. They not only manage the tribal parks, they also inspect livestock; catch poachers; track down pothunters, who loot prehistoric sites; and keep the lid on at the tribal fair.

Nez had agreed to show me one of his favorite places in the desert. We headed north, skirting the face of a mesa where great dunes climbed sheer cliffs of red sandstone. This marked the beginning of a line of weathered cliffs that stretched eighty miles to the Colorado River. From here north, the palette of desert colors grew richer and more varied; the rock, more sculptured. This was the threshold of the northern desert—a region of sand dunes, rock spires, and painted cliffs.

We stopped at a fork in the road near Sand Springs. "I like them best after a light snow," Nez said, looking at the colorful exposures of rock. "The white really brings out the reds."

Although I hadn't seen a hogan, the traditional Navajo home, since we left the paved road, the ranger said that people do live here, but seldom year-round. I asked him if they were bothered by outsiders. "Oh, sometimes one of them might complain about strangers," he said. "They've lived here so long, they feel real protective of the land." Nez had to return, so I thanked him and headed west toward the Little Colorado River. For most of the year, the river is just a trickle, but flood season transforms it into a foaming, muddy torrent.

When I stopped to stretch my legs, a curious raven landed on a nearby rock. Turning its head at a right angle to its body, one eye looked straight at me; the other scanned the empty horizon. In such wide-open country, the raven took whatever company it could find.

After driving miles, I had seen only a couple of deserted hogans. It is a land of sand and rock that absorbs those who come to here to live. The winds alone seem to thrive here. In calm weather, they take the form of a dust devil, whirling across the flats. In stormy weather, they drive horizontally across miles of open space, then suddenly explode into clouds of sand towering above the highest cliffs.

Before reaching the river, I glimpsed to the north an intriguing country that was bordered by rock towers and fluted cliffs. To reach it before sunset, I had to hurry, because no roads head directly that way.

Seeing a faint track that led toward the higher terrace, I began to follow it. Over the next rise, a beat-up old pickup inched along, herding a few scraggly goats before it. An ancient grandmother with a bulbous nose and a hardened scowl on her face was at the wheel. A man in his thirties, probably her son, walked next to the truck, keeping the goats together. "What's a white man doing out here?" he asked, genuinely puzzled. "Looking at the red rocks," I told him. "Yes," he said in Navajo and walked away, still confused.

◄ *Incised in the slickrock desert of northern Arizona, a slot canyon radiates orange light. Flash floods sculpt these beautiful chambers.*

borderlands

I took the turnoff to the old mining town of Arivaca and the historic Cruce Ranch, once home to a herd of more than seventy-five Spanish mustangs. They descended from horses brought in the late 1800s from the Delores mission in Sonora, once the headquarters of Father Kino. Their color patterns bore a strong resemblance to the horses depicted in fifteenth-century Spanish paintings. But managers of a national wildlife refuge felt the herd did not belong and ordered its removal.

At Arivaca, I followed a dirt road that led toward the border and the Pajarita Wilderness. It hugged the dips and twists of the topography of the foothills, steadily climbing into the heart of the mountains. Emory oaks dotted the lower hills, mixing with manzanita and juniper in the higher country.

Ruins of an old adobe house marked the head of Sycamore Canyon. I parked and started down the trail at a quick pace to reach the border and get back by dark—about twelve miles. Rough cliffs and eroded rhyolite pillars formed the rim. Water flowed along the canyon bed, sometimes sinking beneath the gravel, sometimes pooling in bedrock pockets, but always giving life—sycamore trees, live oak, and juniper.

To bypass several deep pools, a little climbing was required, and one pour-off formed a barrier to cows drifting up canyon. Beyond it, I passed cattle trails that pushed through the brush in directions I did not want to go. It was quite reassuring to find that we had different interests.

Although it was the heat of day, shaded turns of the canyon came alive with birds. A particularly graceful one with a long, copper tail sat on a limb watching my approach. It was a trogon, a Central American species rarely seen in Arizona.

A few more bends of the canyon brought me to the Mexican border. Saguaro, ocotillo, and creosote covered the foothills. A very faint trail climbed a ridge overlooking the international boundary—a good lookout. I wondered about smugglers, but I had heard they rarely use Sycamore Canyon because it's too rugged. Many backpack across by easier routes, and some use pack horses. Tired of repairing fences cut by smugglers, ranchers along the border have put in gates.

A four-wire fence marked the border—no signs, no flags. I climbed over it and stood in Mexico, an illegal alien for a few moments. On a map, each country has its own color and a thick boundary line. Here, it was different.

The border passed through the middle of a giant sycamore tree. Half the trunk was rooted in Mexico, half in the United States. The wash on one side of the fence was as dry as the other. I wanted to see what had caused this region to be divided into separate destinies, but, standing at the borderline, all I saw was a boundary as thin as barbed wire.

The next morning, I parked on a back street in the El Presidio Historic District of Tucson and began to walk. No matter how many times I return to downtown Tucson, I always feel slightly disoriented. It is hard to redraw a mental map. I first walked here before the massive urban renewal of the 1970s. Things have changed. A stranger has an advantage, taking the city as it is given. I walk through neighborhoods long buried, down streets that no longer exist.

In a city of seven hundred thousand, only 15 percent of the population is Hispanic. For many residents, the Hispanic heritage of the region only goes as far as the dinner plate—enchiladas and tacos and burritos and tostadas with a mariachi band to set the mood. But for half its history, Tucson was a Spanish and Mexican frontier post. The Spanish legacy continues to lie close to the soul of the city.

Before the Anglo-Americans entered the region in large numbers during the mid-1800s, the Hispanic population never numbered more than one thousand people. Most lived at Tucson or in the presidio of Tubac, since outlying ranches and mines had been overrun by the raiding Apaches. Tucson itself fought off nine major Indian attacks.

borderlands

"It was a desperate struggle for survival," said James Officer, an authority on the Hispanic Southwest. "What's amazing is that they did survive." Foundations of the original presidio wall lie buried beneath the modern streets. A sign at the intersection of Washington and Church, written in both Spanish and English, marks the northeast corner of the presidio. When the archeologists excavated this street corner in the 1950s, they discovered remnants of the presidio's old adobe wall. It once stood twelve feet high and ran for seven hundred feet on each side, enclosing the plazas, chapel, cemetery, stables, and the living quarters for soldiers and settlers. The foundations of the city literally rest on a Spanish past.

But Arnold Smith, whose ancestor commanded the presidio in the 1830s, told me that the Hispanic heritage of the city is dying. The old cemeteries have been desecrated; the old neighborhoods, leveled. It was time, he stated, to take their history into their own hands.

Urban renewal had replaced the worn-out barrios with government buildings that now tower above the restaurants and bars where lawyers do business. Galleries, shops, and homes in a mix of architectural styles line the back streets. Some old adobes were remodeled long ago with ornate Victorian gables and porches, while typical American-style houses add a few Spanish touches. I had trouble telling where one influence ended and another began, and from the look of things, so did the people who lived here.

From the very beginning, the city has been a place where different ways of life have blended. At first, I was surprised to learn that Tucson residents turn out in force on Saint Patrick's Day to celebrate the city's founding as a Spanish fort.

But spend a little time here, and it will begin to make sense. In 1775, Lieutenant Colonel Hugo O'Conor, a failed Irish rebel turned mercenary commander in the Spanish army, marked out the site for a royal fort that has grown into the modern city of today. A knot of cultures lies at Tucson's heart. That's where it draws its strength.

Continuing south across the old Plaza de Armas, I passed homeless men lounging under shade trees where Spanish soldiers once drilled. I kept walking south across parking lots that covered streets I used to avoid at night. We bulldoze the rough-edged past, keeping an old house or two as a memento to draw the tourists, and then recreate it in our own image.

West of Tucson lies the famous living museum of desert plants and animals, the Arizona-Sonora Desert Museum. Nearby is a movie studio called Old Tucson. Tourists crowd into streets lined with false-front buildings to see staged gunfights and to watch the dance-hall girls. For most, Old Tucson has become the city's real history, not the run-down neighborhoods once inhabited by Mexicans, Chinese, and maybe an Irishman or two.

Leaving the renewed city behind, I entered the Barrio Historico District. Rows of adobe houses here have a strong Sonoran flavor: flat roofs, deep-set doorways and windows, thick walls. Some were remodeled into offices and restaurants; others served as homes.

As I walked around the block, I noticed a shrine set back from the street. A niche in an adobe wall held votive candles; more stood in wrought-iron candle racks. This was the wishing shrine of El Tiradito.

Many legends have grown about the shrine over the years. Most tell of a young man murdered in a tragic love affair. Being a sinner, he was buried where he fell. He is said to intercede for those who stand vigil through the night or leave a burning candle in their place. Some pray and leave offerings. And one must have walked home barefoot. An empty pair of boots sat on a shelf above the niche.

Wind had blown out all but one candle. A flame flickered in the bottom of a glass. The adobe wall behind it was smoke darkened; the ground in front, saturated with generations of melted wax. Despite all the changes since Father Kino first rode north, someone had not given up hope. One candle still burned in the heart of the old city.

cliff dwelling

The guide ordered us to dismount and lead our horses down a rough trail that dropped out of sight below. We had reached the rim of Canyon del Muerto, the canyon of the dead. The other horses were starting the descent, but mine wasn't budging. She knew what was in store for us. I looked that horse straight in the eye to let her know who was boss, but the bluff didn't work. Until then, I had never realized how big and inhuman a horse's eye could be. Not knowing what else to do, I gave a solid yank on the reins, and the horse finally started to walk. Hiding my surprise, I followed the others, trying to look like I knew what I was doing.

The party wound its way down into the northernmost of the three branching gorges that form the Canyon de Chelly National Monument. Ron Izzo, head of the Navajo tribal rangers, had the lead. Although not an Indian, he had grown up here and married into a Navajo family. Leroy Yazzie brought up the rear, leading the pack horse. In between walked a group of friends, each coaxing a reluctant horse.

As we descended Twin Trail, red sandstone extended in dramatic cliffs to the canyon floor below. Each fold in the wall held a small ruin that was in the process of slowly being absorbed by the passing centuries.

The trail dropped steadily for the first mile before leveling off where it skirted Navajo fields on the canyon floor. We stopped to regroup in a fringe of Fremont cottonwoods bordering Tsaile Creek. It was easy to see why people had chosen to live here, generation after generation. Water, trees, grass, fields—all contrasted with the harsh plateau country we had left behind.

After a short rest, we began the long ride up canyon. My horse kept looking back until the trail leading home was out of sight. It had been years since I had been on a horse, but Izzo had insisted it was the only way to really see the canyon. Not totally convinced, I was willing to put up with the horses only as a means to reach the more remote country.

We followed the clear waters of the creek that in a few weeks would sink beneath the wash as the heat of summer grew. The string of horses trailed between cross-bedded cliffs rising a thousand feet on each side. Dark stains of desert varnish spilled down the smooth walls. The pure, uniform sandstone had formed from dunes blown by winds from the north two hundred million years ago. Each twist of the canyon disclosed more ruins perched in the hollows of the rock high above the floodplain. Some had been lived in, but most had been used as granaries to store crops. The prehistoric Anasazi Indians had farmed the canyon bottoms, growing cotton, beans, squash, and corn.

They stored whatever they could for the winter months. One excavated storage cist held a cache of seven hundred ears of dried corn that was still brightly colored. But corn was not the only thing the early Anasazi storage bins held. Some contained burials—mummies that had been naturally desiccated by the dry climate of the region.

Passing a tall rock spire known to the Navajo as the Wolf, we reached Big Cave, a rock shelter that sprawled more than a thousand feet along the base of the cliff. We rode close enough to see pictographs painted on the far wall but did not enter the fenced-off ruins.

Archeologist Earl Morris uncovered a mysterious burial here in the 1920s. In one compartment of a storage room that was divided into quadrants, he found a pair of hands and forearms. No other parts of the body ever turned up. Two pairs of sandals, beautifully woven in red and black patterns, had been placed on the upturned hands. On top rested three shell necklaces. The archeologist never came up with a satisfactory explanation for the strange burial.

Two of the other compartments were empty, but the mummy of an old man lay in the fourth. With him had been interred four wooden flutes in perfect condition.

cliff dwelling

Tributary canyons branched to the east as we continued up the main gorge. We moved at a steady pace, falling into the rhythm set by the gait of the horses. Several miles above Big Cave we topped a sandy ridge. Reining in the horses, we caught sight of an ancient stone village on the far side of the canyon. Pressed beneath overhanging rock hundreds of feet thick, the tiered houses appeared to be carved from the cliff face. A three-story tower stood at the center of the site overlooking a warren of seventy rooms. Seen at a distance, it had a floating, miragelike quality. This cliff dwelling awakened a vague longing in me. Of what, I wasn't sure. Perhaps it was only a longing for a life closer to bedrock.

His black cowboy hat pulled low, Izzo leaned sideways in the saddle, looking back over his shoulder as he talked. "That's Mummy Cave," he pointed out. "The Navajos call it Tse'yaa Kini, 'House Under Rock.'" Naturally mummified bodies that were discovered here by a Smithsonian expedition in the 1880s gave the canyon its name.

Anasazi lived in Mummy Cave during a thousand-year span of their history. They arrived about A.D. 300, long before they had learned to make pottery and use the bow and arrow. Only after their population peaked in about 1150, did the Indians begin to construct large cliff dwellings. The square tower may have been the last structure that was built in the canyon; its timbers were cut in 1284. By 1300, the cliff dwellers had abandoned the region.

Some archeologists believe that the end came when an over-exploitation of natural resources led to a major environmental crisis. Clear-cutting trees from the surrounding plateau triggered huge, destructive floods. But the old Navajo say it was fire that destroyed the Anasazi as punishment for trying to learn more than the body of knowledge given to them. Like the people today, they add.

We rode closer to the ruin and tied up the horses. The peculiar sway of traveling horseback lasted even after I had dismounted. Stretching my legs, I realized that the cowboys have it wrong. A novice is not a tenderfoot. After a few hours in the saddle, it definitely is not your feet that get tender.

Needing to cover some miles before camp, we pressed on after a short rest. Not far up canyon, Izzo pursed his lips and pointed his chin toward a place on the cliff face high above. "Massacre Cave," was all he said. Little could be seen from below; we easily could have ridden past without suspecting its location.

In 1804, the Spanish soldiers wearing dark winter cloaks rode up canyon with muskets poised, looking for Indians. They might have kept going, but a former Spanish slave was unable to restrain herself. High above the soldiers, she shouted an insult that gave away the hiding place of almost a hundred women, children, and old people.

The main Spanish force blocked their escape while snipers took up positions on the rim. They fired into the cave, ricocheting bullets off the ceiling into the huddled people. Few remained alive when soldiers climbed to the overhang to complete their work.

These canyons remained the last stronghold of the Navajo before the U.S. Army drove them from their refuge. In 1864, the famous scout, Kit Carson, sent cavalry detachments into the deep gorges. The Indians gave only token resistance as the troopers swept through, burning crops and cutting peach trees.

"Every time the soldiers saw a sheep," said Izzo, "they would shoot it; every time they saw a cow, they would shoot it; every time they saw a horse, they would shoot it; every time they saw a field of corn, they would burn it; if they saw a fruit tree, they would chop it down." By spring, the people were starving and began to turn themselves in to the military.

"Word spread that the soldiers had penetrated the canyon," Izzo said, "something the Navajo thought they could never do. People began to surrender by the hundreds and eventually the thousands." Every refuge becomes a trap in the end.

On a long stretch of packed sand, several riders decided to give the horses free rein. In a sudden burst, we galloped up the

trail. Hooves barely touched the ground, carrying us along in a great surge of power. Speed was visceral. It was felt in every cell, as if the riders were doing the running, and not the animals beneath them. A long half-minute later, we settled back to a walk, as if nothing had happened. By now I was feeling stiff, but no matter. I was enjoying the ride too much. The horse has been linked with this landscape for so long it felt right, a part of this way of life. Late in the afternoon we reached an old sheep camp belonging to Izzo's relatives. An abandoned hogan stood among the trees where we unsaddled the horses. There was still time to look around.

Scrambling over boulders, I made my way up a side canyon. About to return to camp, I spotted a ruin perched on a high ledge. There was no obvious way to reach it, but I wanted to try. Traversing along a steep sandstone face, I noticed a line of shallow handholds pecked into the rock leading upward. I began to climb. One or two had weathered away, but the others gave enough friction to get to a higher ledge. I followed this until I came to an old log propped against the next cliff. It held, and I finally reached the broad shelf leading to the ruin.

Roofs had collapsed, but many of the walls still stood. I stooped through a low doorway into a jumble of rooms that seemed too small and too compact—more like the wreck of a ship than the ruins of a village.

Footprints had been pecked into the ledge centuries ago to mark the best route to walk. On the far wall stood a petroglyph of a masked figure holding arrows, and nearby were red handprints that once had been pressed wet against the rock. The rooms were not well preserved, but normally perishable material, like corncobs and yucca cordage, littered the site. An old shovel rested in the corner of one room where someone looking for pots long ago had dug a shallow pit and stopped.

Sitting on the cliff edge and looking down canyon, I knew that the people who once lived here were not total strangers. I could understand something about them simply by the place they had chosen to live in and the homes they had built for themselves—the stark geometries of need translated into stone. The simple desires that moved them still move within us—the warmth of the morning sun, a nice view, a dry place to sleep, human companionship. And something else.

The maze of rooms hidden high on a remote cliff stood empty but not abandoned. Those who once lived between these canyon walls had left centuries before, but their feeling for beauty remained. The Indians who had stacked these rocks into multi-storied houses had lived within the graceful lines of a canyon scaled to a human dimension. The landscape had not overpowered their way of life.

The Anasazi built small communities that harmonized with the natural beauty of cliff and bare stone. Years of weathering had only enhanced this bond, blending house wall with cliff wall. And although the village walls would fall before the canyon walls, the effort had not been futile. There was no sense of loss here, only a sense of completion. One cycle had ended; another, begun.

As I sat listening to a breeze move through the cottonwoods below, a canyon wren called nearby. The clear notes tumbled down a scale older than the Anasazi flutes of Big Cave. During the ride up canyon I had wondered how one of the old instruments might sound. They would have been keyed to the chants used in their ceremonies, the way Pueblo Indian flutes are today. To hear one would be to hear the sound of the human voice from long ago. Archeologist Earl Morris had heard that sound.

After uncovering the flutes that had not been played in a thousand years, he picked one up, put it to his lips, and blew. "Rich quavering tones . . . seemed to electrify the atmosphere," Morris wrote. Navajo crew members stopped their work and listened. A horse raised its head, and two ravens flew from a crack in the cliff above. It was as if the strange notes echoing from the cave had turned back time.

the man who listened to rocks

Shouldering my backpack, I started down the North Bass Trail, wondering about the man who built it. I knew why William Bass had come to the Grand Canyon, but wasn't sure why he stayed. Told he only had a few months to live, Bass quit his job as a railroad dispatcher in New York City and headed west. He reached the Grand Canyon in 1883. Forty years later, he was still here.

The road to the trailhead passed through alpine meadows ringed with quaking aspen and Douglas fir. In contrast, the trail descended into a canyon of bare rock and charred trees. A lightning strike a year before had touched off a forest fire that swept across Muav Saddle, eight hundred feet beneath the North Rim. A black layer of scorched earth intruded between cliffs of white sandstone and slopes of red shale.

At the saddle, I left the main trail to look for a cabin built by trail crews in the 1930s. The chance that it had survived the fire was slim. The path to it cut through a scorched thicket of manzanita and scrub oak. Years before, I had curled next to the cabin's smoky stove on a cold night. Reaching an opening in the trees, I was glad to see the old shelter still standing.

Inside, I found a logbook lying open on a rough table. Pages were loose and out of sequence. Hikers had filled most with short comments, but one page was different.

"Blazing on all sides of cabin," a firefighter had reported. He went on to describe a night spent cutting a fire line and putting out spot fires. Flames had come within twenty feet before the attack crew checked the fire's spread.

Another page contained entries from the year before. A hiker on his way out noted, "Awesome flash floods in White Creek." Flood one year, fire the next. In this country you don't have to go to extremes; they find you.

William Bass must have thrived on diversity. With surprising energy, he staked out mining claims, built trails, guided tourists, and developed a small hotel on the South Rim. Rumors of hidden treasure brought him to the canyon; something else kept him.

Leaving the cabin, I followed Bass's trail as it dropped more than a thousand feet to the bed of White Creek. Rock slides and brush obscured most of the old route. The streambed itself was littered with debris from a powerful flash flood. Rushing water had undercut ancient cottonwoods, toppling them into the creek. Flood-waters had stacked driftwood against the upstream sides of the trees that had withstood the torrent. Bent brush still held the shape of flowing water. Continuing down canyon, I reached the bottom of the Redwall limestone just before dark. Camp was next to the creek in a spot barely large enough to shake out a sleeping bag. As I heated water, a chorus of mating frogs echoed through the narrow gorge. Havasupai Indians refused to kill frogs, fearing it would bring heavy rains. But after listening to an hour of wild croaking, I knew they must have been tempted. One made a flying leap when I stepped over to the pool. Concentric ripples spread to shore and returned, leap-frogging other ripples still heading outward. After a short lull, the tree frogs resumed, even louder than before.

Grabbing my pack the next morning, I headed down canyon. Around the first bend, a shaft of light burned through a break in the cliff a moment before the sun cleared the inner wall. Desert sunlight is so intense it has mass, weight, even opaqueness. Indirect light illuminates, but this direct light absorbed all color and depth.

Where the creekbed plunged into a sandstone narrows, Bass's old horse trail climbed onto the plateau. Wanting to stay close to water and shade, I worked below the drop and continued boulder-hopping down the creek. Before long, early Precambrian schist welled up beneath the sandstone. The air smelled of wet rock as water spilled over the smooth stone, almost two billion years old.

The junction with Shinumo Creek happened unexpectedly. The narrow gorge of White Creek hid the larger canyon from view until I was right on top of it. Down the Shinumo, I waded knee-deep over a number of wet crossings, not bothering to look for a drier route.

the man who listened to rocks

The spring-green of Fremont cottonwoods and tamarisk lined the creek as it dropped in a long stairway of riffles, pour-offs, and plunge pools. Just below a deep pool, I saw an old irrigation ditch. Long sections had washed out, but enough remained to mark its course. Following it, I came to a cleared terrace above the stream.

This was Shinumo Gardens, the hub of Bass's canyon mining and tourist operations. He discovered the site by tracing remains of an earlier ditch built by prehistoric Indians. Where Anasazi had farmed more than seven centuries before, Bass planted his "famous melon patches," where he grew grapes, peaches, and corn.

Motion beneath a mesquite tree caught my eye. It was a lizard carrying something in its mouth. I looked closer and saw a grasshopper with spread wings. The desert spiny must have caught it on the hop. The lizard was the only thing moving in the late morning heat—a reminder for me to shade-up. An overhanging cliff with a patch of shade stood across the creek. I waded across and walked into what must have been the outdoor kitchen for Bass's tent camp.

Pieces of a cast-iron cook stove lay scattered about, and artifacts cluttered the overhang. Among them were a pick, ax, anvil, and a plowshare still bolted to a moldboard—basic tools for homesteading in a land that resisted control. Over the years, Bass learned not to try. "You cannot run the earth," he wrote.

Besides his tools were coffee pots, a bean pot, and a prospecting pan tucked under the cliff. Bass used Shinumo as his base of operations during the winter. He would load his burro with grub and a few books and disappear for weeks. He prospected in the surrounding canyons and wrote poems he later recited around the campfire.

Near the gold pan was a washtub that his wife, Ada, may have used. The Bass family normally lived on the dry South Rim without surface water or a well. Their only water source was the run-off they caught and stored. During droughts when water was too precious for washing, Ada loaded the burro with dirty clothes and headed into the canyon. Three days later, she returned with clean laundry.

Bass may have started out a New Yorker, but somewhere along the way the pattern of his life shifted. A clue to this lay partially buried in the dirt next to a spent shotgun shell. It was the top of an old can marked, "Ortegas Chiles." The day he first spiced his food with chilies, the change became more than geographic. He must have sat here many times having breakfast with Ada at their open-air table days from civilization. I pictured him eating huevos rancheros while his wife, a graduate of the Boston Conservatory of Music, sliced a melon from their garden and wondered about life.

After a short break, I left Shinumo Camp and followed the high route to the river. This section of Bass's trail remained in good shape, climbing at just the right grade toward a dip in the ridge ahead. A well-thought-out trail is a thing of beauty.

The great Colorado River came into view from the top of the ridge. It ran full-green through an inner gorge of black rock. Nothing obscured the elemental beauty of rock and river. Before Glen Canyon Dam was built, the Colorado ran muddy red. Flood waters prevented Bass from crossing by boat during three months of the year, so he strung a cable and hung a tram from it. This gave him a cross-canyon trail to take hunting and sightseeing parties to the North Rim and to work his mines year-round.

But his plans eventually collapsed. His business survived the coming of the railroad that drew most of the tourist trade to the Bright Angel area. But, ironically, it was the need to preserve the canyon that ended his way of life. When the Grand Canyon became a national park, the government granted the primary tourist concession to another company. After living here for almost half a century, Bass was out of business. Little remains to connect him with the canyon but a few names on the map and a couple of washed-out trails.

By the time Bass left, he was not the New York City dispatcher he was once. A tourist noted that Bass had learned to listen to the rocks. "No other heart," he wrote, "so closely beats to theirs."

white mountain place

As we crossed the parade ground of the old cavalry post of Fort Apache, Edgar Perry pointed out Mount Baldy far to the east. At this distance, the mountain appeared to be little more than a shoulder humped above the recumbent backs of the other mountains. But Mount Baldy is more significant than it looks. The Apache tribal rangers had told me that no one, not even an Indian, was allowed to climb to the very top of Mount Baldy except for religious purposes. Curious, I had traveled to the old fort to ask the director of the Apache Cultural Center why the tribe had closed the summit of the highest peak in the White Mountains.

Edgar Perry led me to his office in a log cabin where General George Crook once had his headquarters. He mentioned that his grandfather had served as an Apache scout for the U.S. Army. When I asked about Mount Baldy, he began by telling me that the Apache call it *Dzil Ligai Si'aan*. Writing the name on the back of a business card, he said it meant White Mountain Place. The tribe protects the mountain as a wilderness, he added, so elk will be free to graze without being disturbed by logging, hunting, and camping.

Indians have made pilgrimages to the mountain for a long time. Perry's father often traveled to the summit to leave offerings of food for the dead. On one trip, he crawled into a cave known to the Apache as the home of the winds. To his surprise, he found barefoot tracks of someone he believed had visited the shrine in prehistoric times. "Medicine men still go to the mountain," Perry said. "They go to pray for their people."

Traditional Indians tell about friendly mountain spirits called *gaan* that inhabit Mount Baldy's wooded slopes and caves. Perry said they were sent long ago by Ussen, giver of life, to protect the Apache. They taught the people to plant corn, to hunt, and to live in harmony with nature. Masked *gaan* dancers appear at important ceremonies carrying sticks representing lightning and imitating the eerie voice of the mountain spirits. Perry described it as the sound of wind moving at the front of a flash flood.

Before I left, Perry again emphasized the importance of Mount Baldy to his people. "They always look to the mountain," he said. "It's their sacred mountain." A month later, I was on my way back to the White Mountains. I planned to follow a trail, lying within the national forest, that climbed the eastern flank of Mount Baldy, but I would stay off the summit. A two-lane highway crossed a treeless expanse that had too much grass for desert and too much rock for grasslands. Above arched a blue midsummer sky with a few stray clouds hanging over a ripple of mountains, fifty miles away.

The road gained elevation as the high country took on mass and shape. Turning off at Phelps Cabin, I parked in a stand of Douglas fir on the edge of the Mount Baldy Wilderness. Although it was already midafternoon, I decided to try to reach the 11,590-foot peak before dark.

Grabbing a pack, I headed across a meadow cut by the East Fork of the Little Colorado River. Close to its source, the river is narrow enough to jump across. The puckered scar of an old ax blaze—dot above a dash—marked the route where the trail left the meadow and entered the spruce/fir forest. This area had never been logged.

Ancient alpine fir towered next to basalt cliffs that had eroded into pinnacles more than one hundred feet high. Bright green moss clung to the gray rock of the megalithic spires. Old, rough-top stumps stood among beds of bracken fern. The weathered heart-wood glowed with warm reds and yellows.

The forest opened as the trail reached the ridge above the cliffs. The valley of the East Fork lay directly below, and beyond it, one ridge after another rolled to the south. It was a green world of meadow and aspen grove scattered across the loden green of fir and spruce. The only motions were cloud shadows, darkening the surface of the trees as they skimmed over the ridges.

Watching the play of shadows below, I was surprised by the rumble of thunder. At first, I thought it was rockfall on a distant

Hopi pueblo of Old Oraibi. Both Hopis and Navajos consider it sacred and have fought to prevent its development.

The mountain's west face, overlooking Hart Prairie, forms a ridge high above treeline. Humphreys Peak anchors one end; Agassiz Peak, the other. Ski runs lie between the two, cutting through ponderosa and aspen on the lower slopes, Engelmann spruce and Douglas fir on the upper. A fringe of bristlecone pine and low mats of dwarf juniper form the treeline. Only patches of tundra grow on the bare rock above.

Weather has reworked the mountain's face, obscuring its volcanic origin. Avalanche chutes and rock slides finger down from the summit, covering glacial moraines and lava flows.

Some places I can approach with detachment; others have grown too close. Living for years at the base of the mountain, I no longer see it the way I once did. It has become a composite of geologic epochs, seasons, and events compressed into a single image. A volcano erupts while glaciers grind. Thunderheads boil up from the highest peak as a vortex of snow blows from a cornice. The sound of the wind mixes with the grunt of the black bear at night. The hiker's pace blends with the mountain lion's graceful stalk. Antlered elk graze as a Basque sheepherder watches his herd pour over a ridge. Memories build up, layer upon layer, forming an unmapped landscape.

I continued down the road to an aspen pole corral marking the turn to the Michelbach homestead. Two solar panels stood in front of the main house, sheltered in a stand of aspen and pine. Barn, corrals, and an old log cabin clustered around it.

Women, some who had helped at the roundup, set out pots of beans and other dishes on picnic tables. Men led horses into the corral, handed out beers—no lites—and brought out rifles to shoot at the prairie dogs. A crew dug the meat from a pit where it had been barbecuing all night; others rolled mountain oysters in flour and fried them until crisp. Calf fries someone called them. After washing up and bandaging a deep cut from his knife, Pete sat down to talk with friends. He wore a cowboy shirt tucked into jeans held up by suspenders. Years of wind and sun had weathered his face into steep ridges cut by a dry wash or two.

As a boy, Pete had left school to help his father run the ranch. Over the years, he worked a number of jobs to supplement ranching. He did maintenance at a nearby military installation and served as under-sheriff for a few years, once having to kill a man in the line of duty. But he made sure his children got an education. One became a teacher; one, a pharmacist; and the other, a surgeon. "The one thing I regret," he said, "was never getting an education."

Michelbach spent spring through fall on the mountain, wintering near Sedona. "We came in the cold and left in the cold," he said in a gravelly voice. He remembered one October when an early storm dumped two and a half feet of snow, stranding him with a hundred head of cattle. All he could do was saddle his horse and lead the herd to safety. "There was so much snow they closed the highway," he said. "I broke trail for them all the way there."

When a young relative asked how they used to make hay, Pete began to describe the hard, back-breaking work. "You had to handle it at least six times," he said. They mowed the heavy oat hay, raked it into windrows, let it sit for a day, then raked it into sheaves. Next they pitched it into the wagon and hauled it off to stack. After several weeks, they baled it and loaded it on the wagon to take to the sawmill in town. There, they unloaded it and stacked it again. "You're lucky," he said, "plain lucky you didn't have to do it."

Conversation drifted to the collapse of old values, old ways of living. Michelbach told about his problems with outsiders cutting his fences and wrecking his corrals. A friend suggested going to Montana, but he said, "No, this is my bailiwick. I'm staying here."

Pete is the first generation raised on the mountain and the last of his family still here. The ebb and flow of settlement is an old pattern. Scattered at the foot of the San Francisco Peaks are prehistoric ruins, deserted homesteads, collapsed log cabins. It's a hard land to make a living in. There is always reason to leave. But some never do.

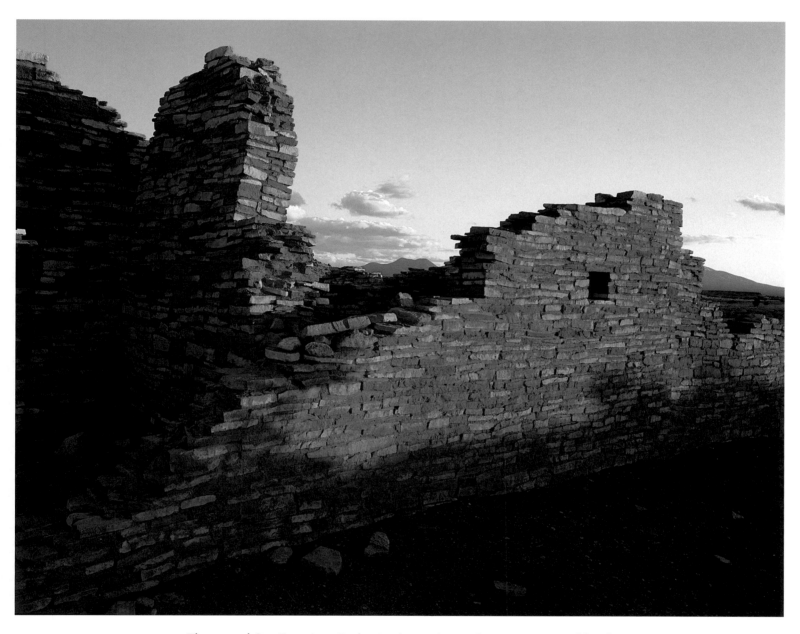

▲ The sacred San Francisco Peaks rise beyond Lomaki Ruin, protected by the Wupatki National Monument. The masonry structure was constructed by the Sinagua in approximately A.D. 1190. Wupatki National Monument contains hundreds of archeological sites scattered in the shadow of a volcanic landscape.

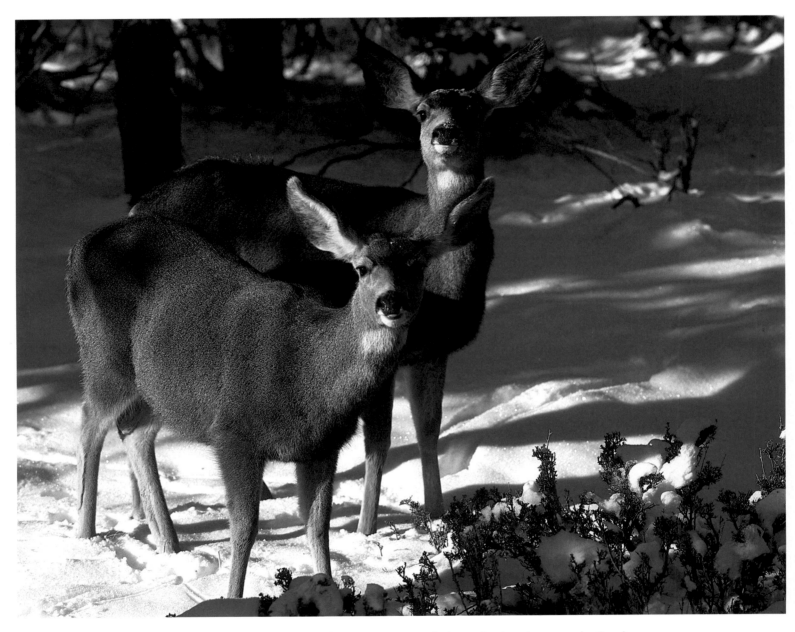

▲ A pair of mule deer stand in a snow-covered pinyon-juniper forest on the South Rim of the Grand Canyon. ▶ False Solomon seal carpets a Kayenta Sandstone cliff deep within Paria Canyon. Perennial springs nurture lush hanging gardens in a desert that receives approximately six inches of precipitation annually.

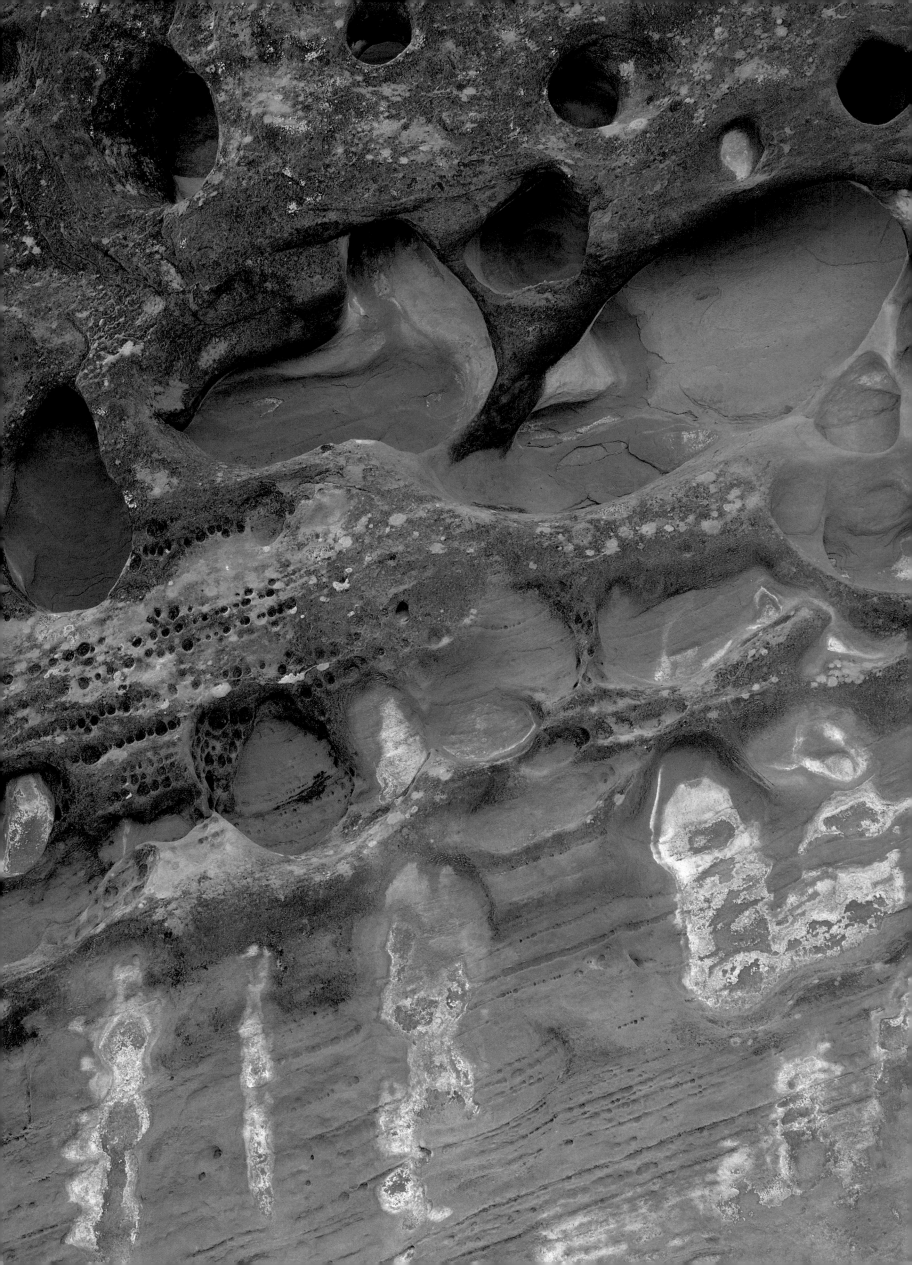

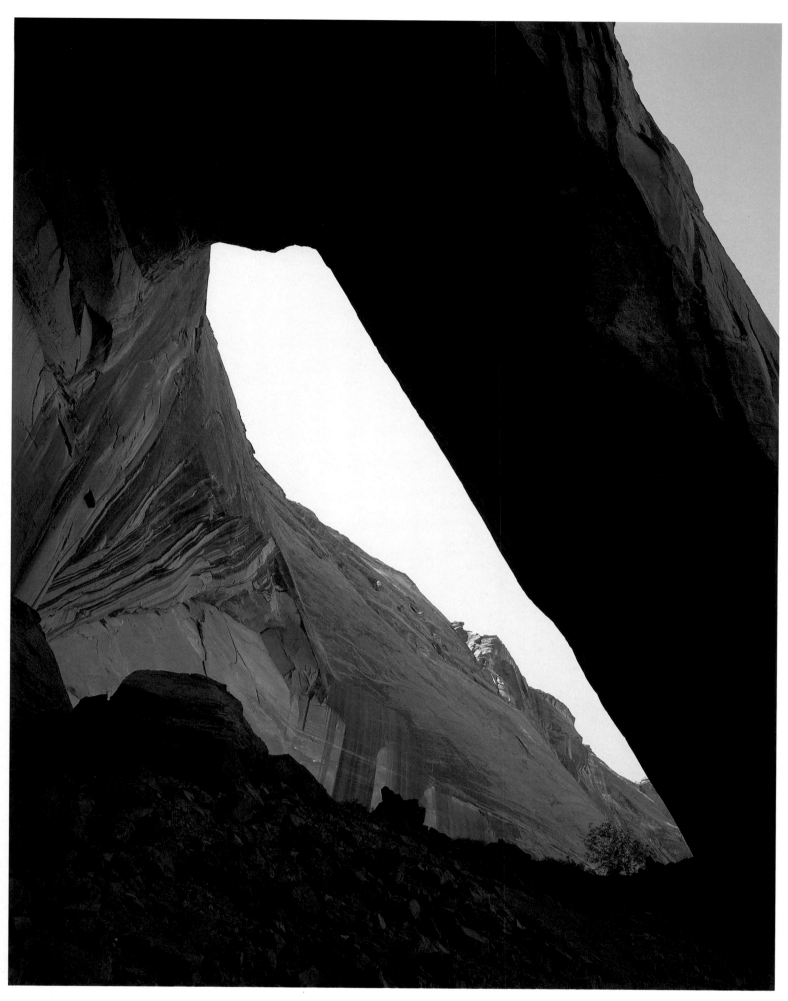

◄ The Paria Canyon-Vermilion Cliffs Wilderness embraces acres of eroded sandstone. From the White House Trailhead to Lees Ferry, hikers follow the Paria River through miles of magnificent canyon scenery. ▲ Near the head of Wrather Canyon, a magnificent arch awaits canyon explorers. Flash floods sometimes roar down the Paria, with the most dangerous period being July through September.

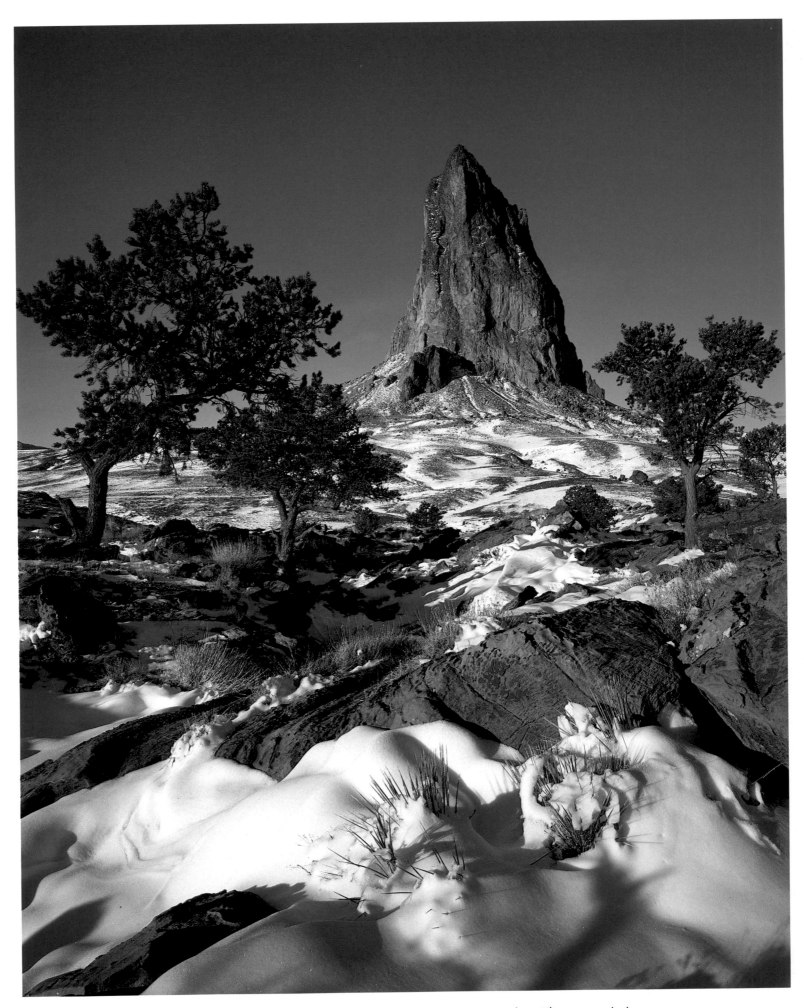

▲ On the Navajo Reservation, Agathla Peak towers 7,100 feet. The mountain is the remnant core or feeder pipe of a larger volcano that was active two to five million years ago. ► Deposits of Navajo Sandstone hundreds of feet thick are solidified remains of huge sand dunes that covered much of northern Arizona 208 to 144 million years ago. Scouring sand carried by wind sculpted this scene.

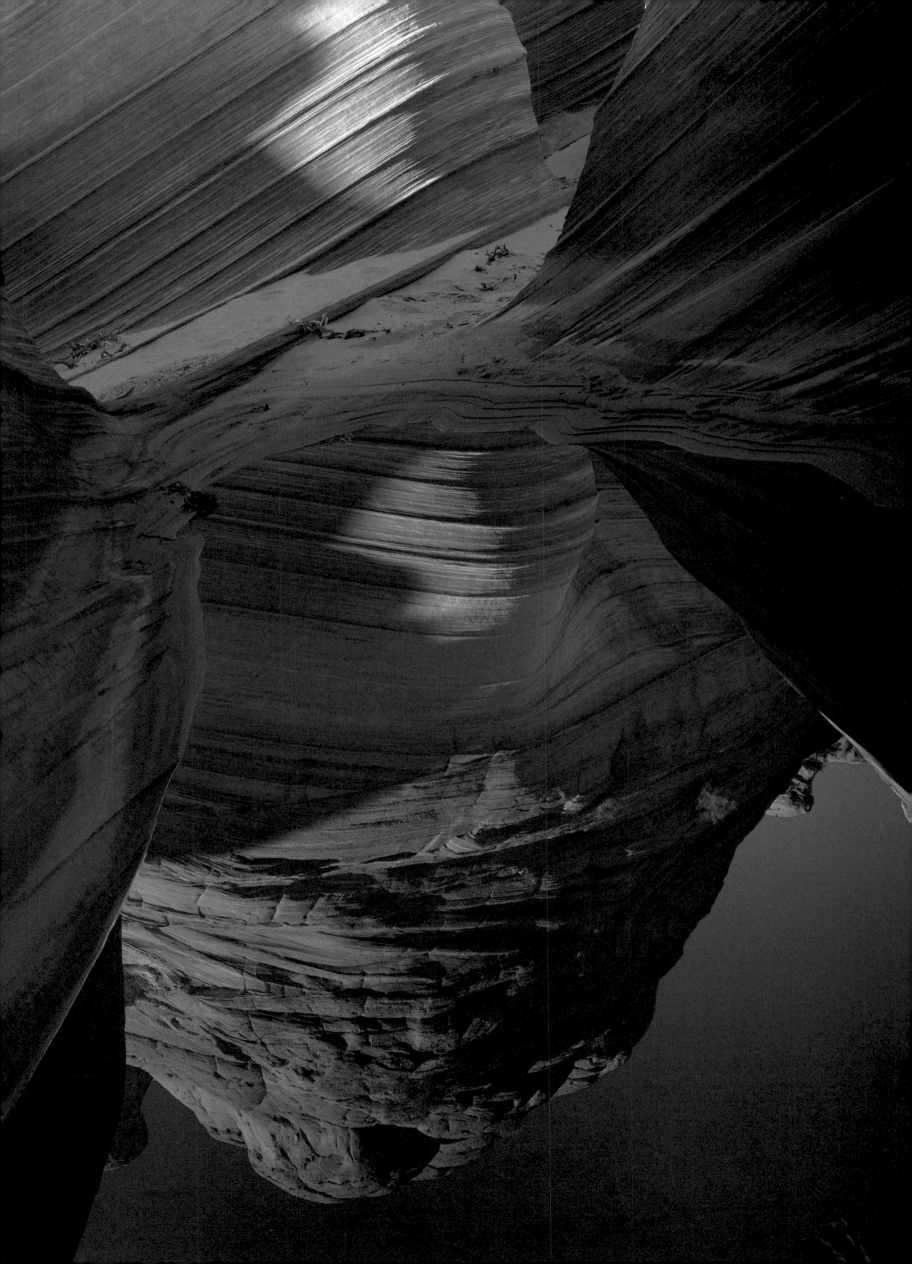

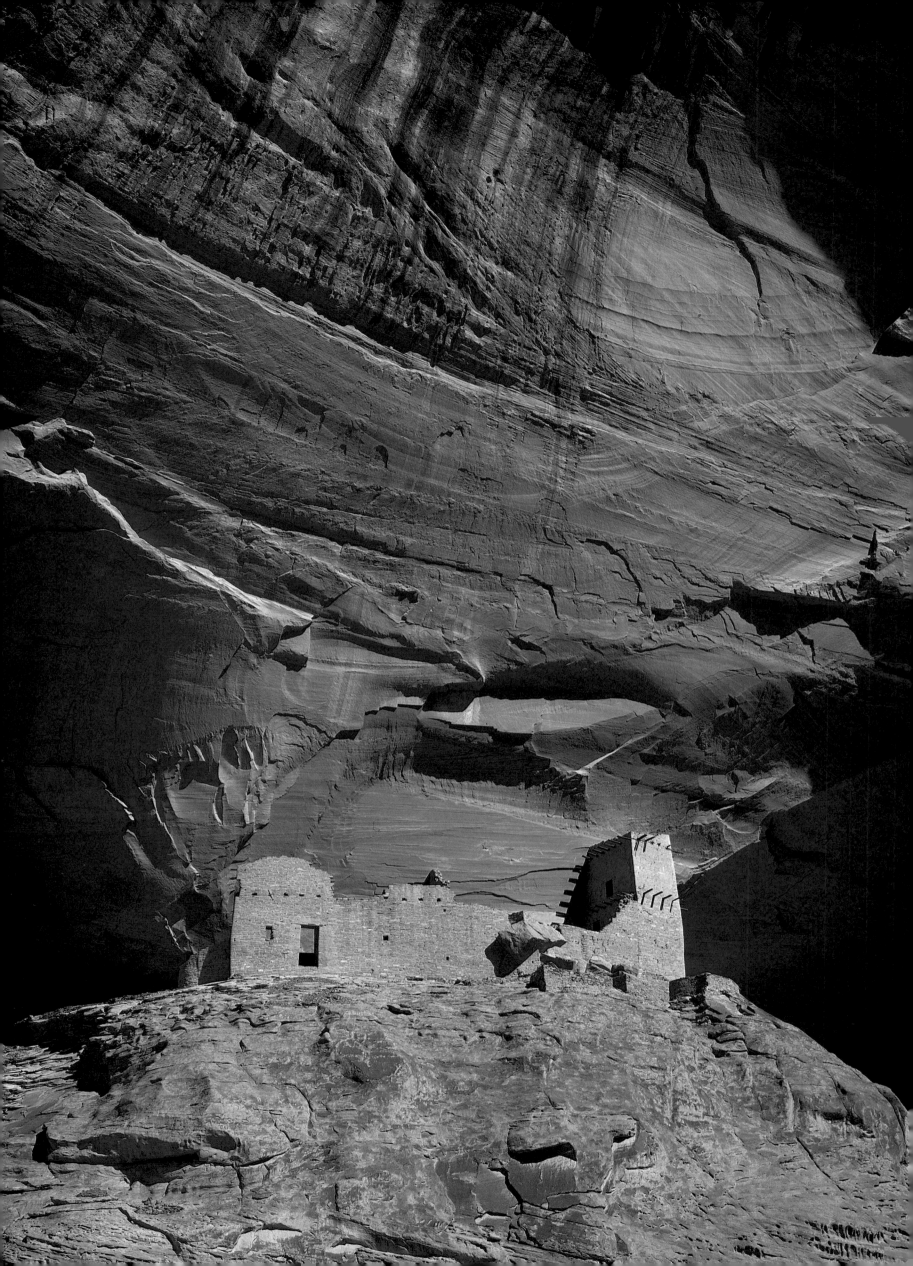

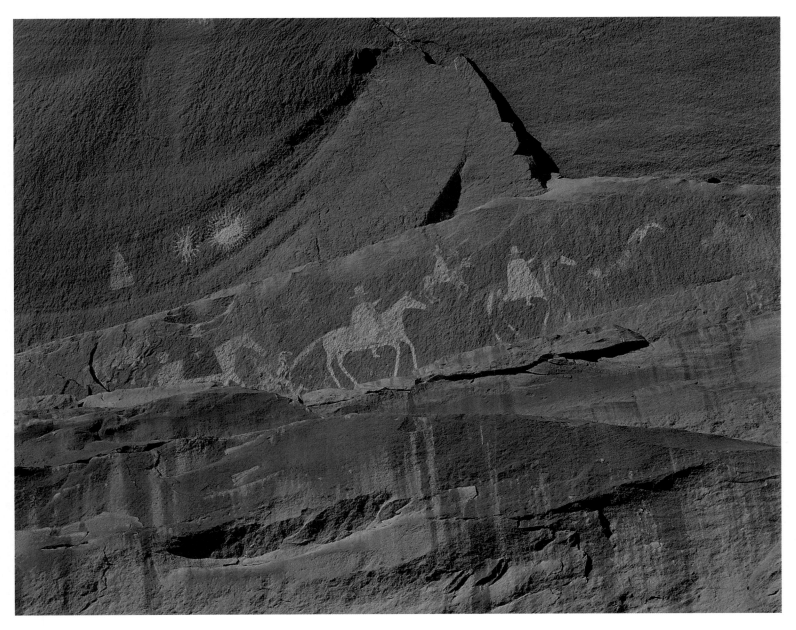

◄ Archeological treasures abound in Canyon de Chelly National Monument. Mummy Cave Ruin is but one of more than seven hundred ancient Anasazi sites that are preserved in the monument. The Anasazis abandoned the canyons near Chinle around A.D. 1300. ▲ Navajo people now reside in Canyon de Chelly. Navajo pictographs from the early 1800s record Narbona's Spanish cavalry unit.

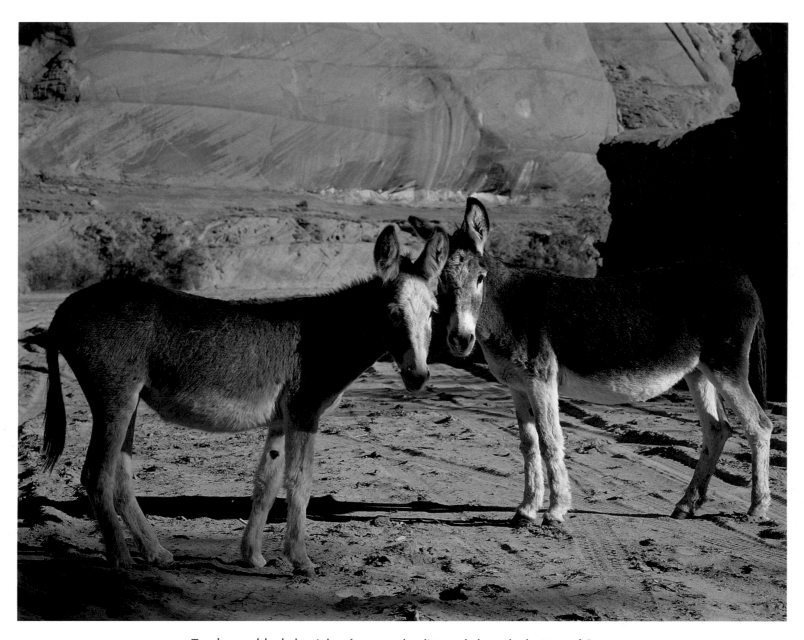

▲ Two burros block the right-of-way on the dirt road along the bottom of Canyon del Muerto. At Canyon de Chelly National Monument, Navajo guides are available to escort visitors through the twisting canyons. ▶ Spider Rock rises eight hundred feet from the junction of Canyon de Chelly and Monument Canyon.

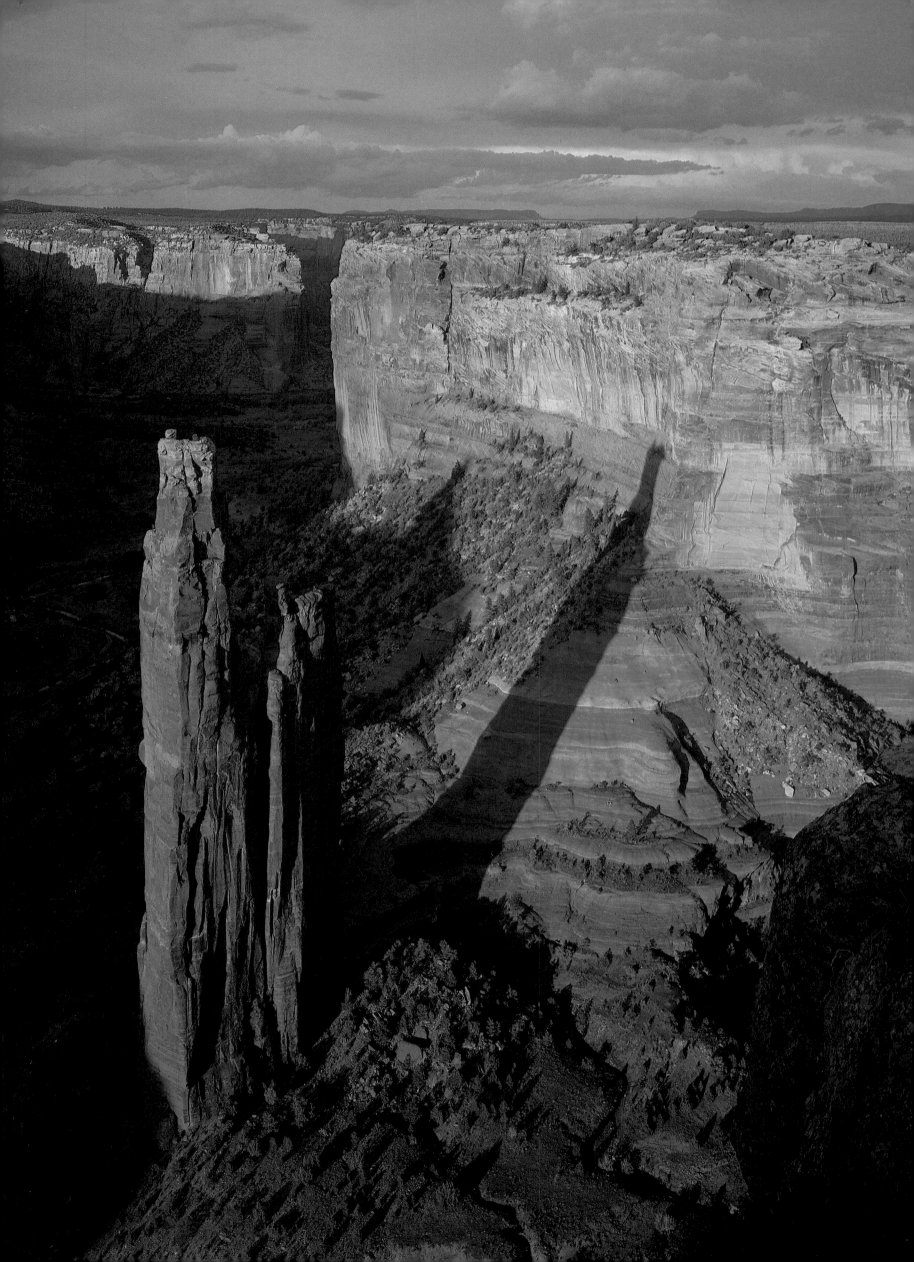

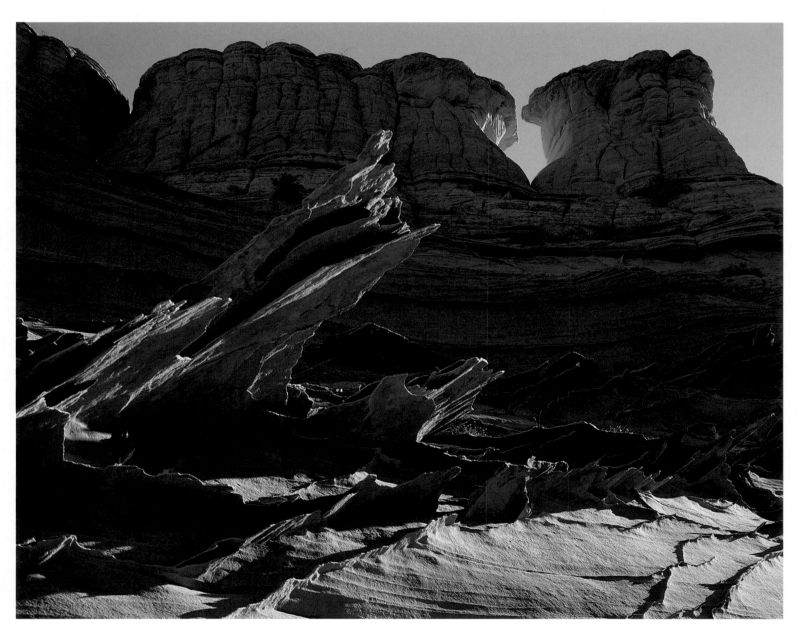

◄ Hard cement filling cracks in Navajo Sandstone has eroded into thin fins. Iron oxides impart colors to the rock. ▲ Wind-sculpted designs carved into Navajo Sandstone seem endless. ► ► The setting sun's last light catches West Mitten Butte and a juniper in Monument Valley Tribal Park on the Navajo Reservation.

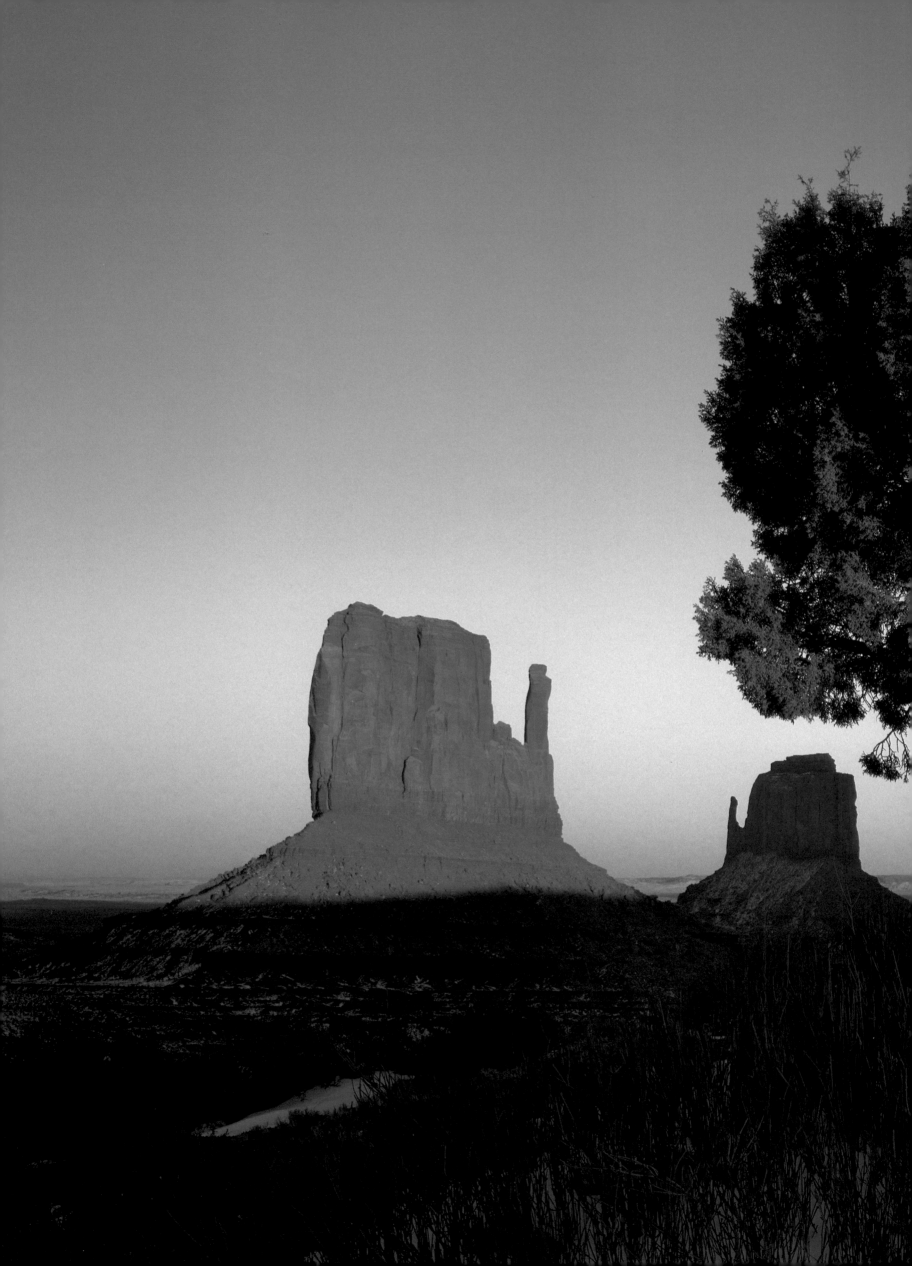

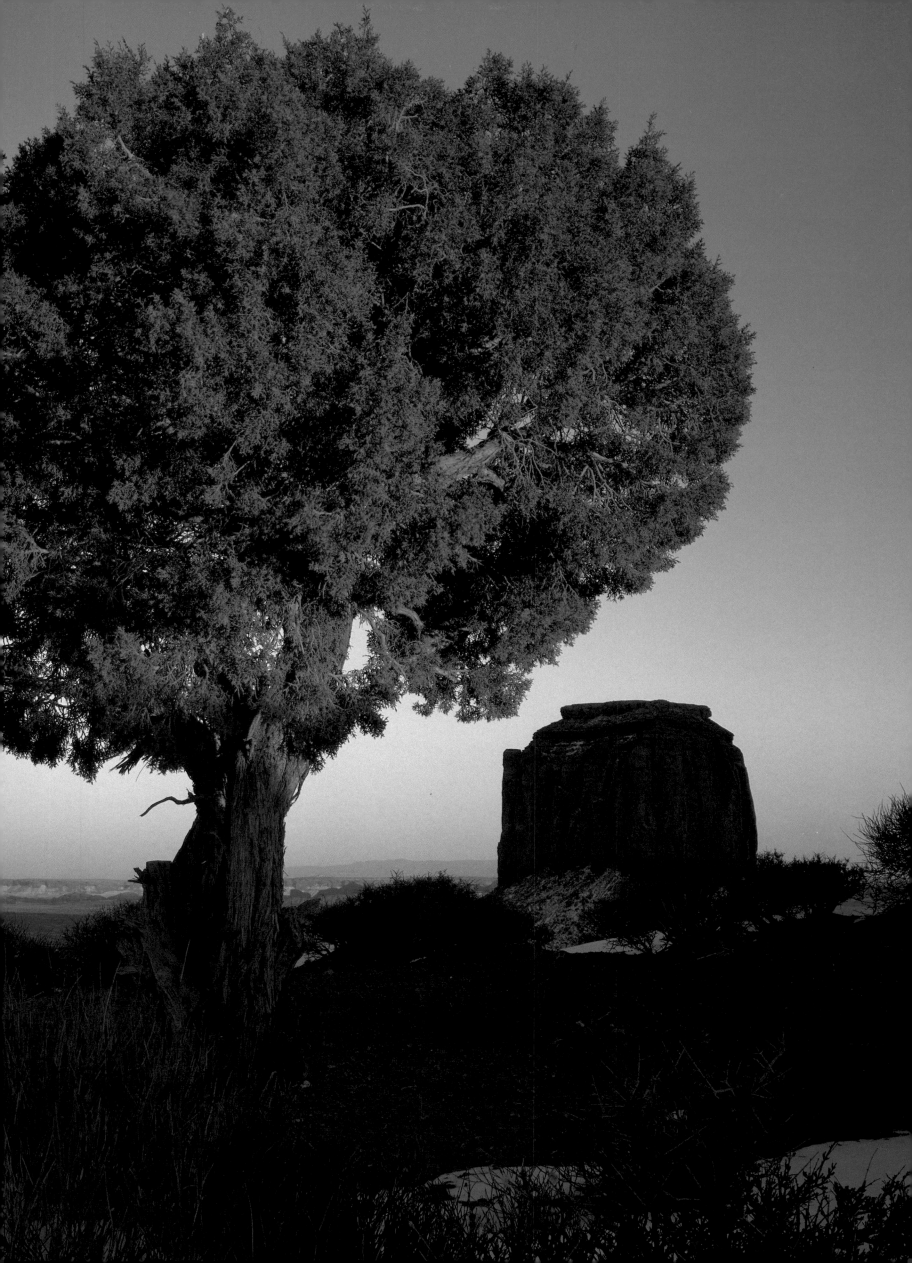

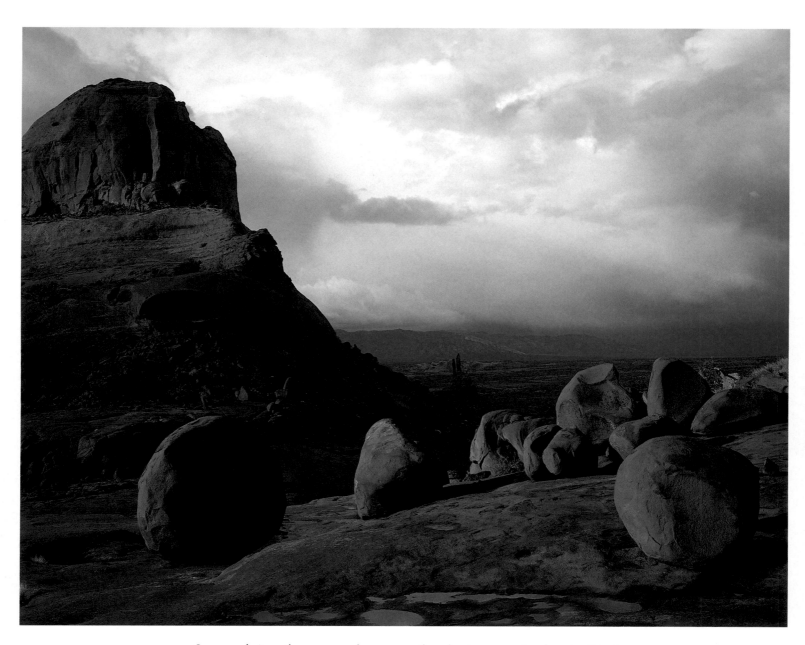

▲ Summer brings the season of monsoon thunderstorms, or "male rains," to the Navajo Reservation. Sandstone boulders stand out before the storm approaching Cove Mesa in the Lukachukai Mountains of northeast Arizona. ▶ Owl Rock seems to peer across a snowy winter landscape of Navajolands north of Kayenta.

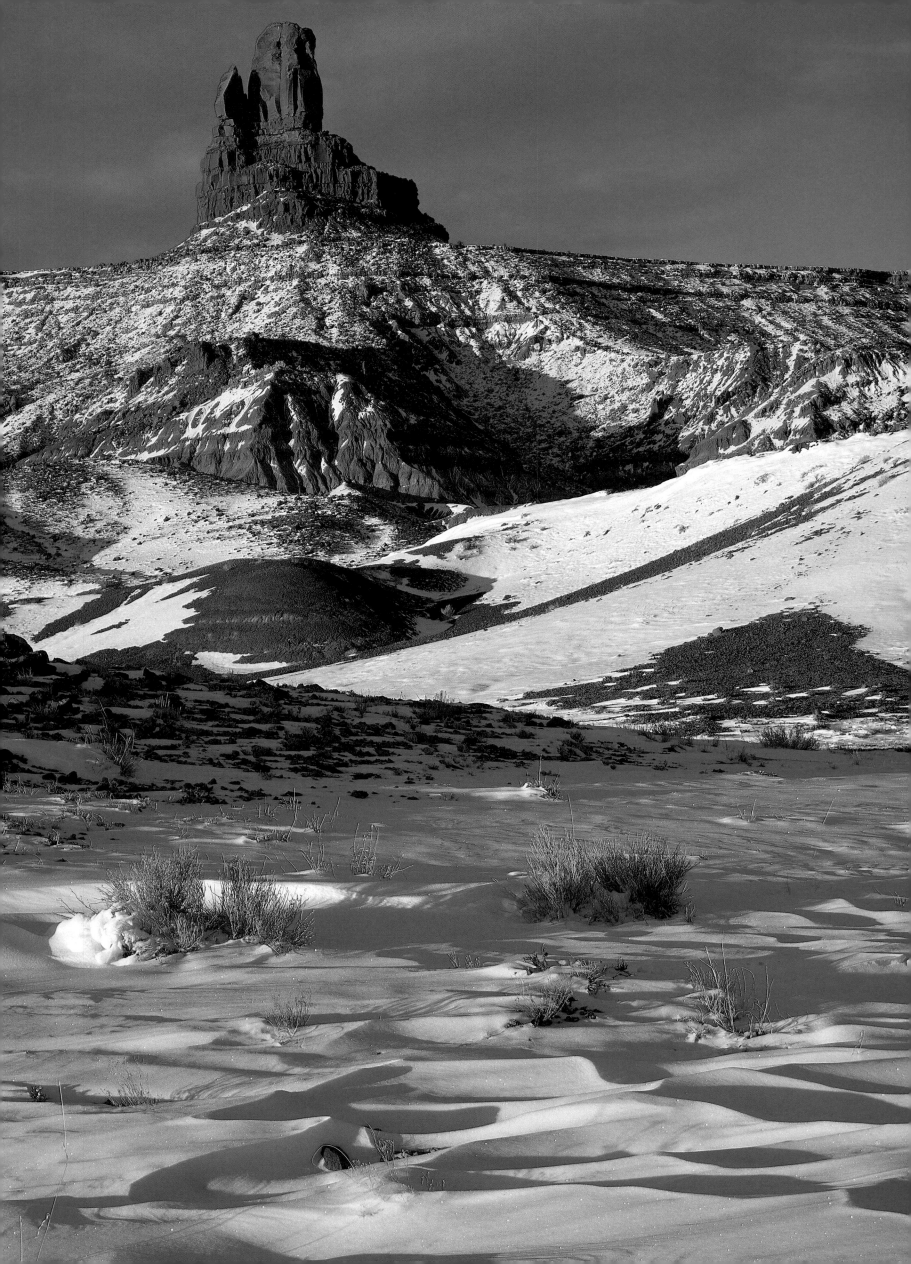

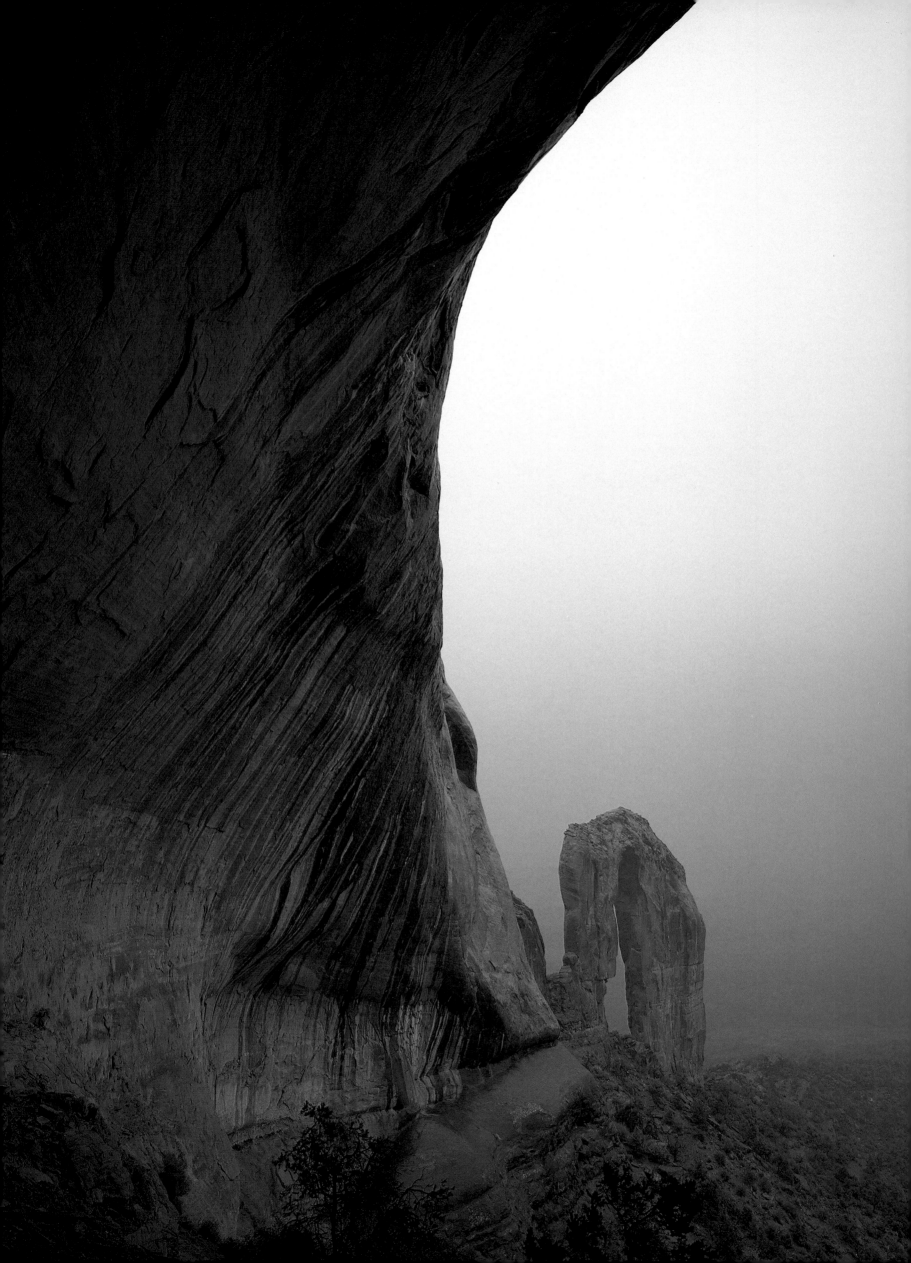

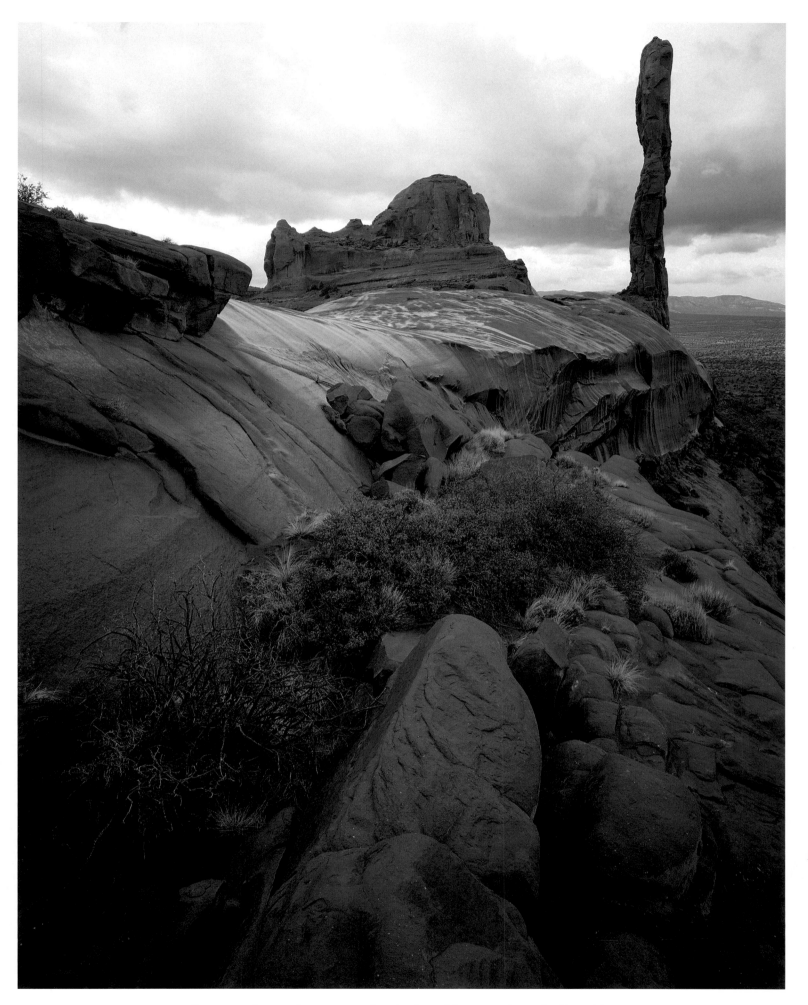

◄ Summer rain envelops a natural arch viewed from an alcove in Cove Mesa. With an opening more than sixty feet high, this arch is one of the most spectacular in Arizona. ▲ Rain streams off the sandstone of Cove Mesa. The de Chelly Formation has eroded into deep canyons, huge monoliths, and stately buttes.

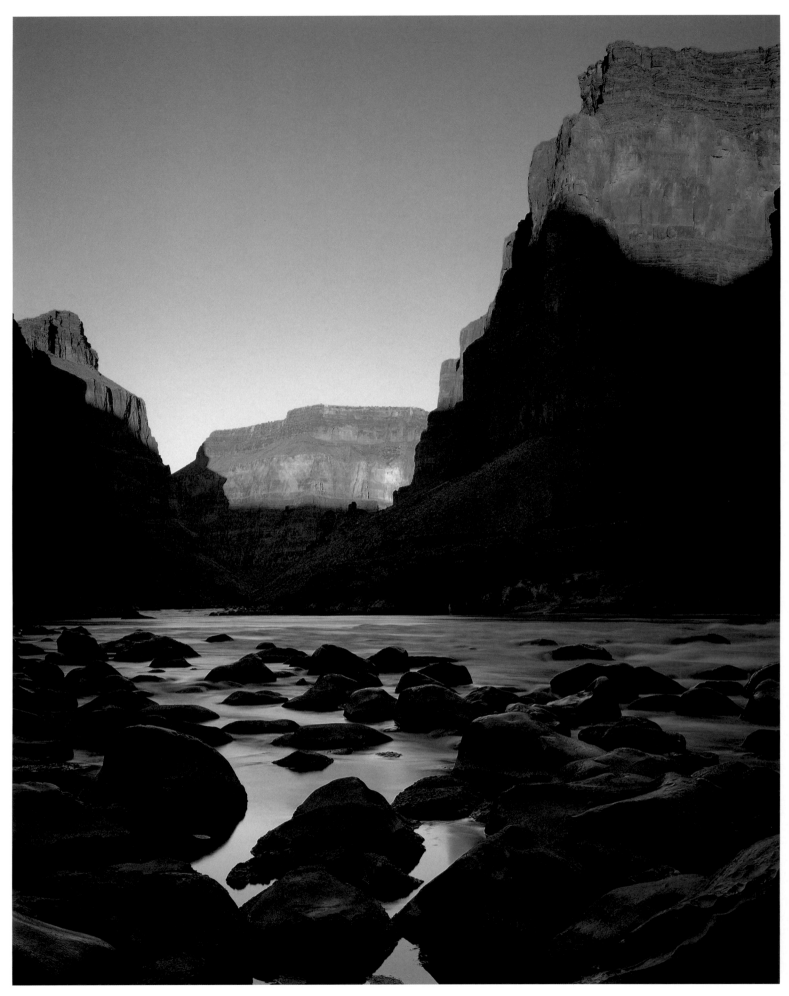

▲ Downstream from Lava Falls, the Colorado River placidly flows past boulders as the setting sun illuminates the Grand Canyon's towering walls. ▶ Deep within the narrows of Stone Canyon, a waterfall plummets into a colorful corridor. The numerous side canyons of the Grand Canyon hold many scenic treasures.

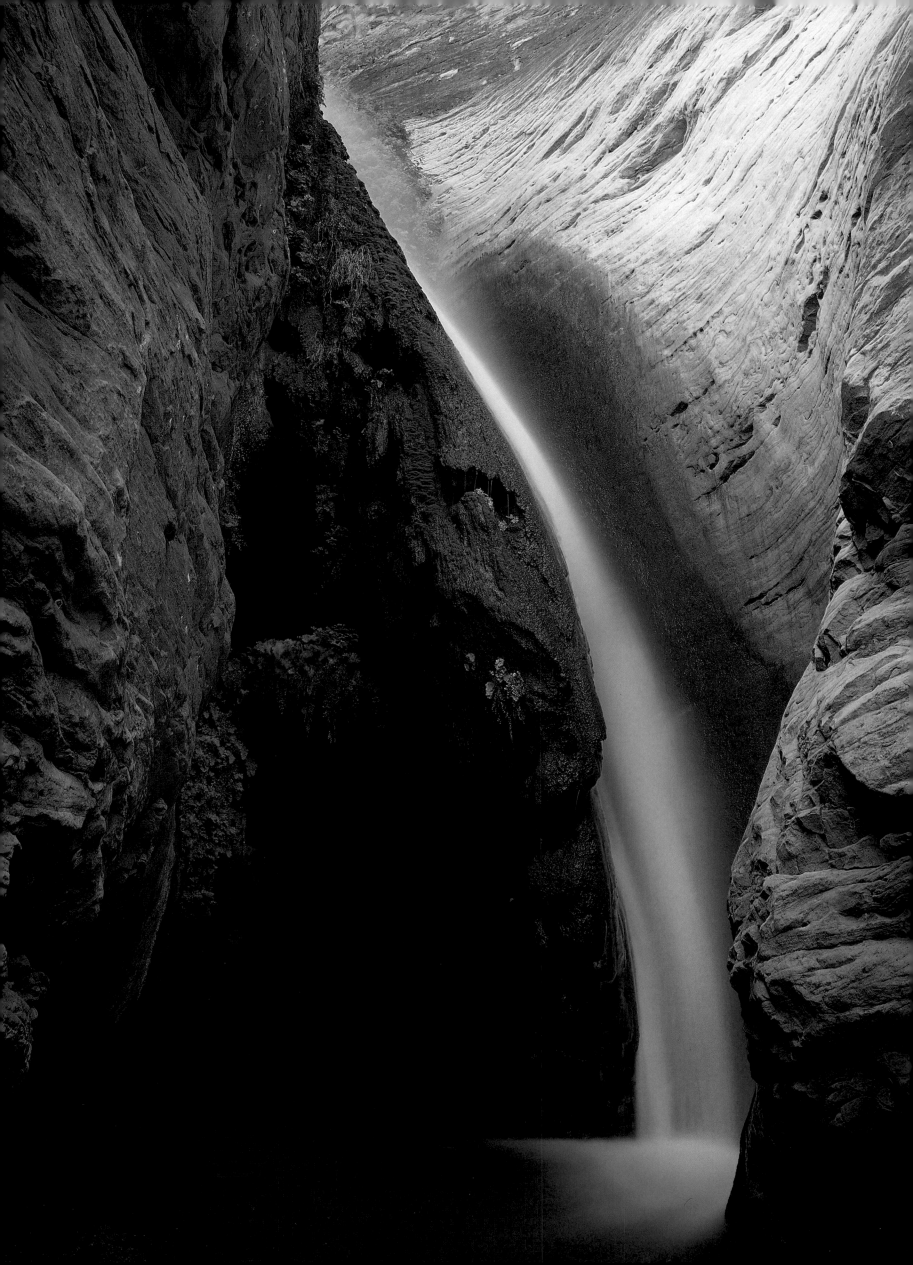

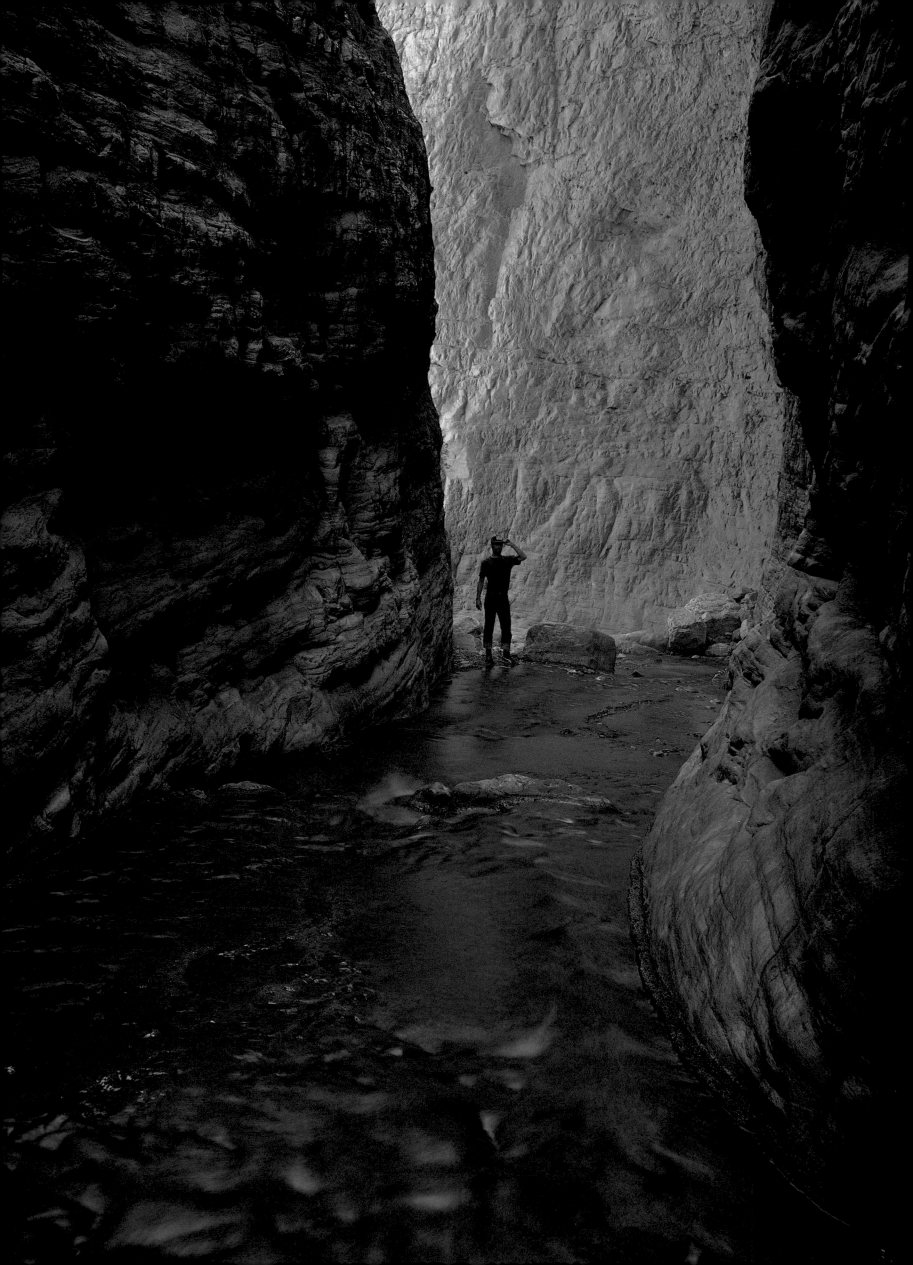

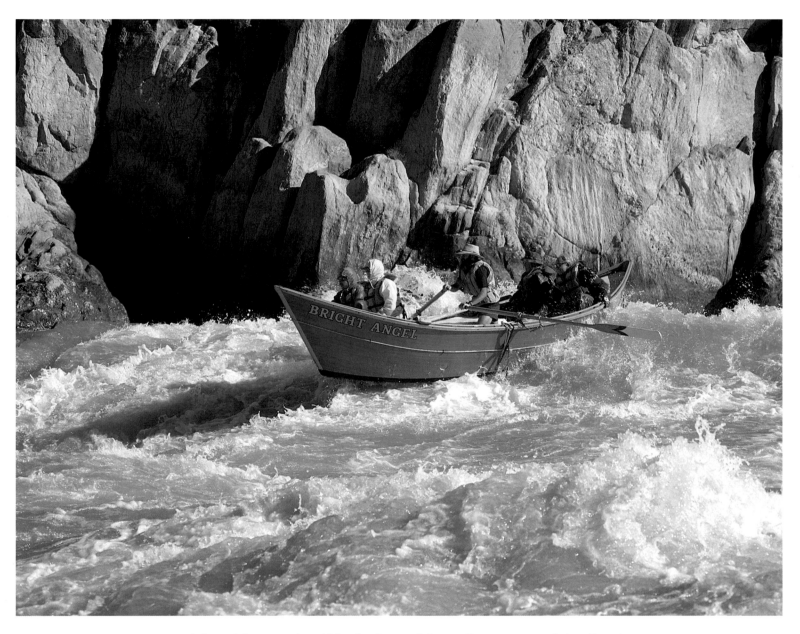

◄ A lone hiker stands within the jaws of Stone Canyon, part of the Grand Canyon National Park. ▲ A Grand Canyon Dories boatman, Kenton Grua, safely rows passengers through Granite Rapids. More than 160 rapids greet whitewater enthusiasts as the Colorado River drops a total of nineteen hundred feet in the 238 miles from Lees Ferry to the placid waters of Lake Mead.

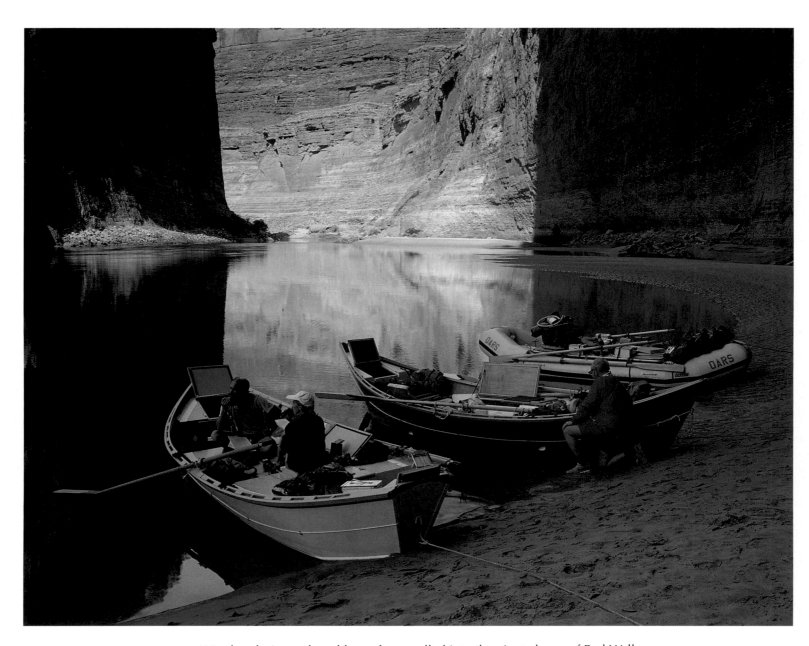

▲ Wooden dories and a rubber raft are pulled into the giant alcove of Red Wall Cavern. Approximately fifteen thousand people take the wild ride down the Colorado in Grand Canyon National Park each year. ▶ A winter sunset's last light illuminates the Grand Canyon viewed from Moran Point on the South Rim.

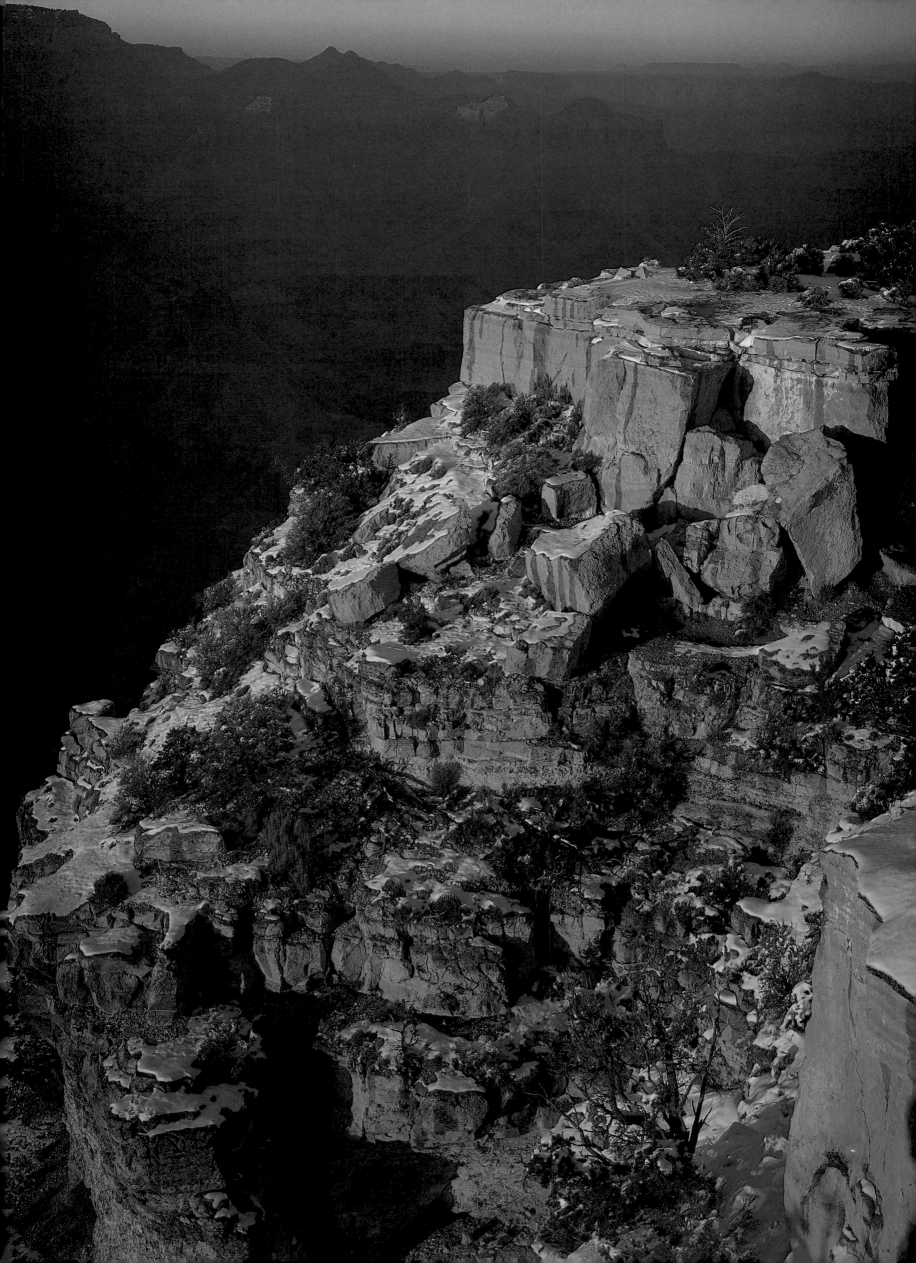

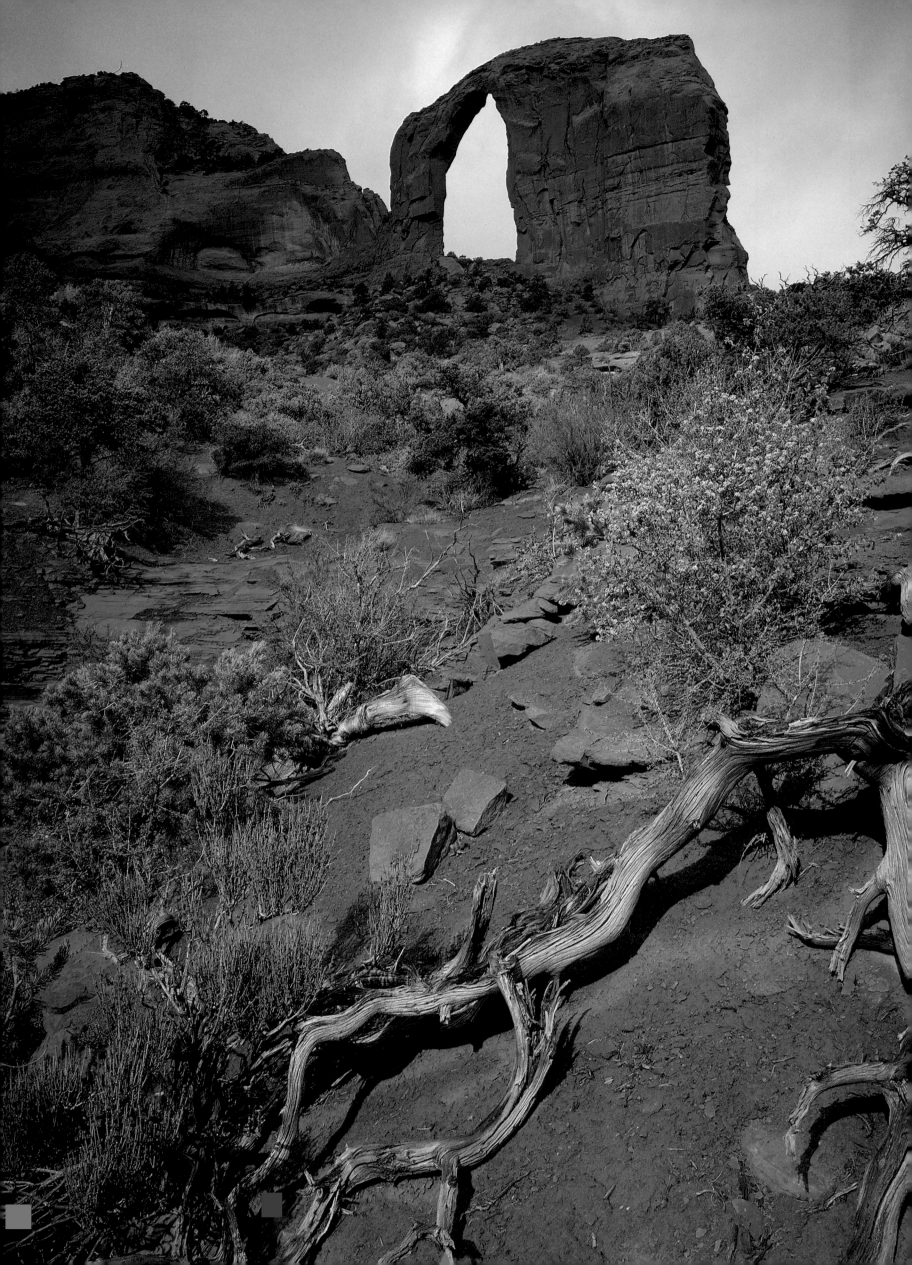

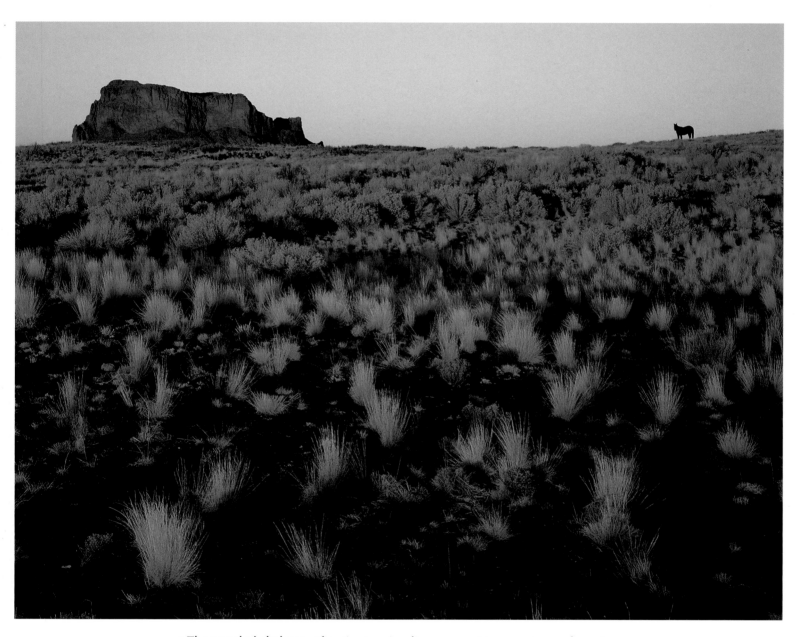

◄ The toppled skeleton of a pinyon pine lies among Mormon tea and service-berry growing below a magnificent arch on Cove Mesa. ▲ A Navajo's horse pauses while grazing on the short-grass prairie near Bidahochi. Navajolands, which comprise the largest Indian reservation in the United States, spread across more than sixteen million acres in Arizona, Utah, and New Mexico.

▲ Aspens catch the fiery glow of sunset on the Kaibab Plateau. September brings the peak of fall colors in the high country.　▶ In spring, Indian paintbrush adds a spot of red to a slickrock mesa on the Arizona Strip.　▶ ▶ The Paria River slices through the Moenave Formation in the Paria Canyon-Vermilion Cliffs Wilderness.

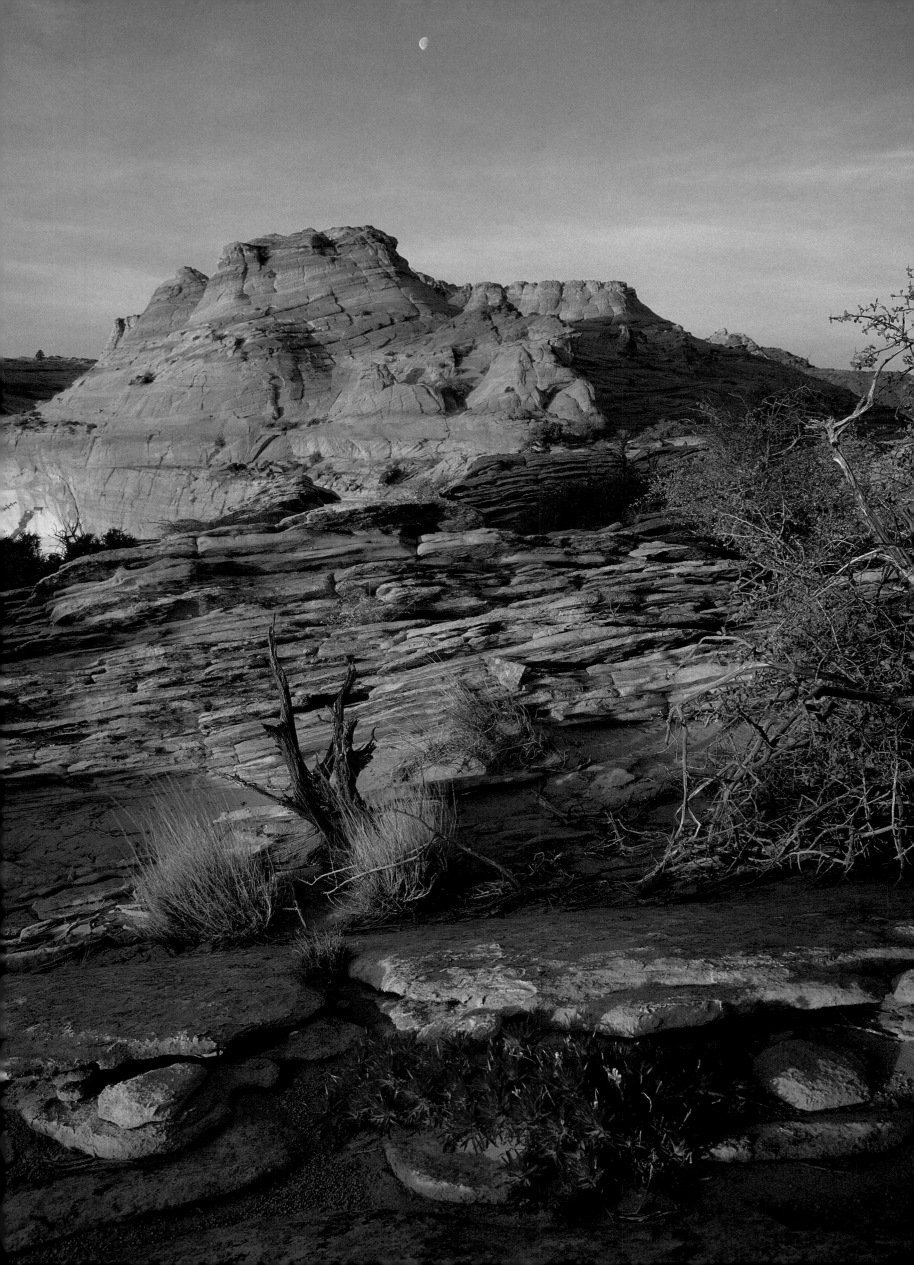

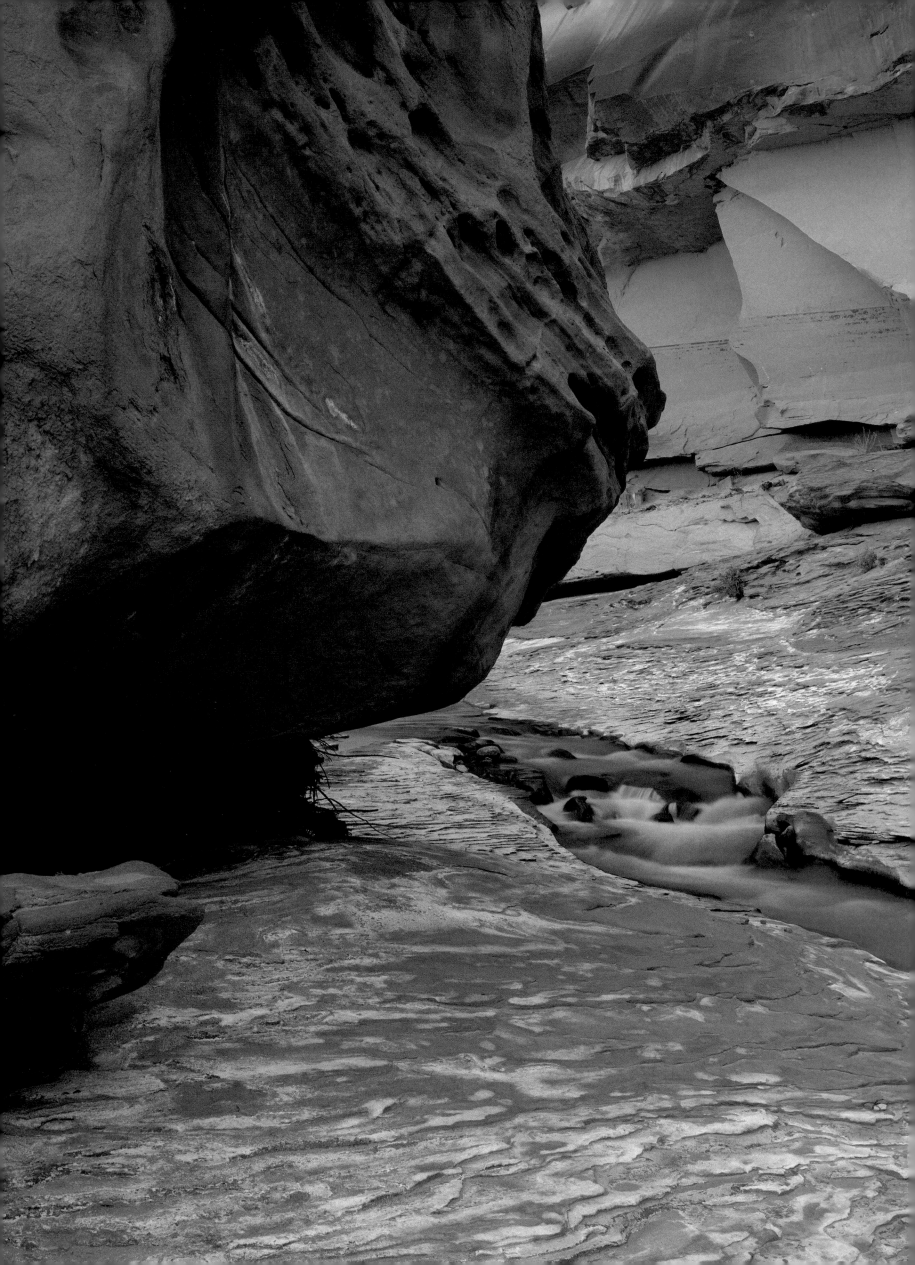

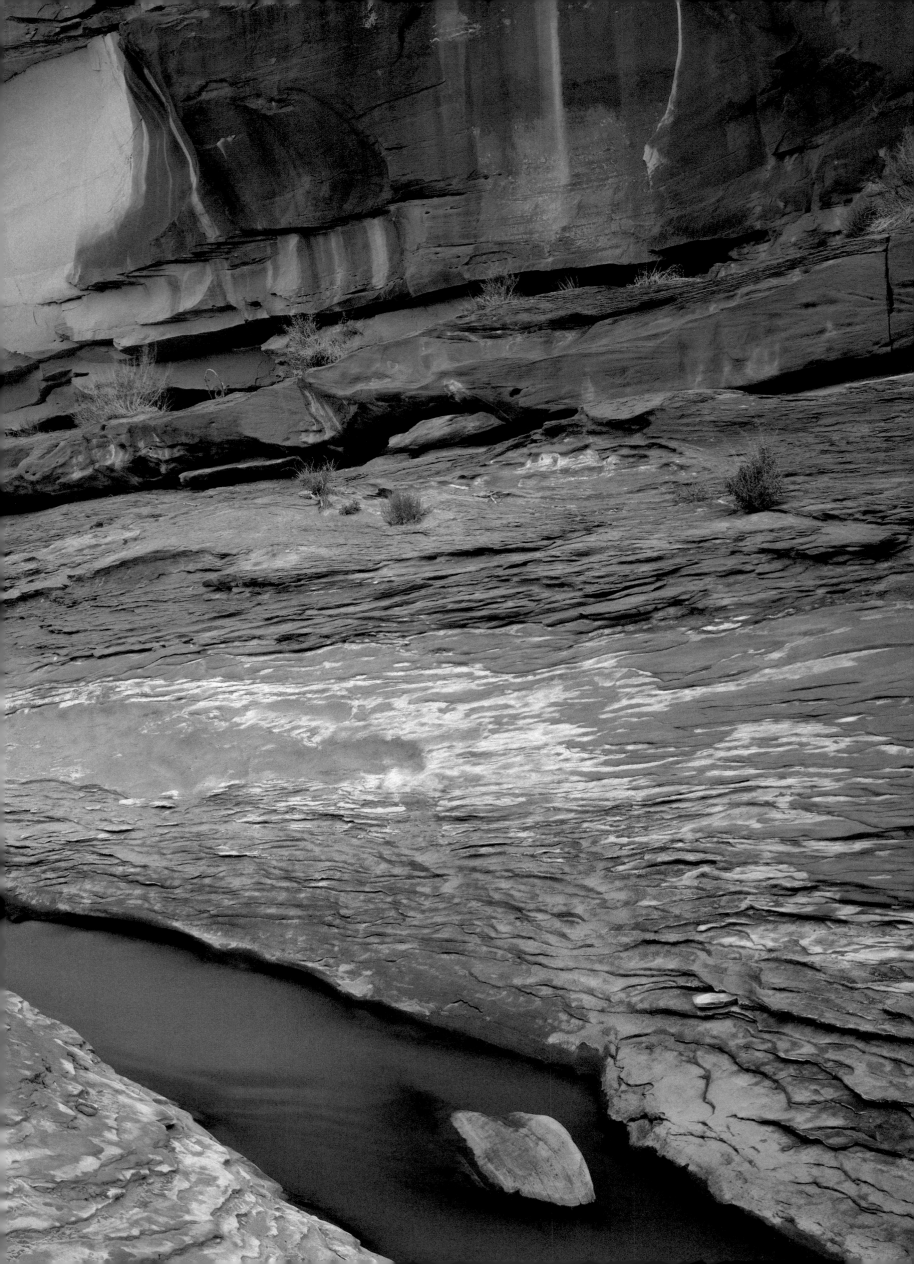

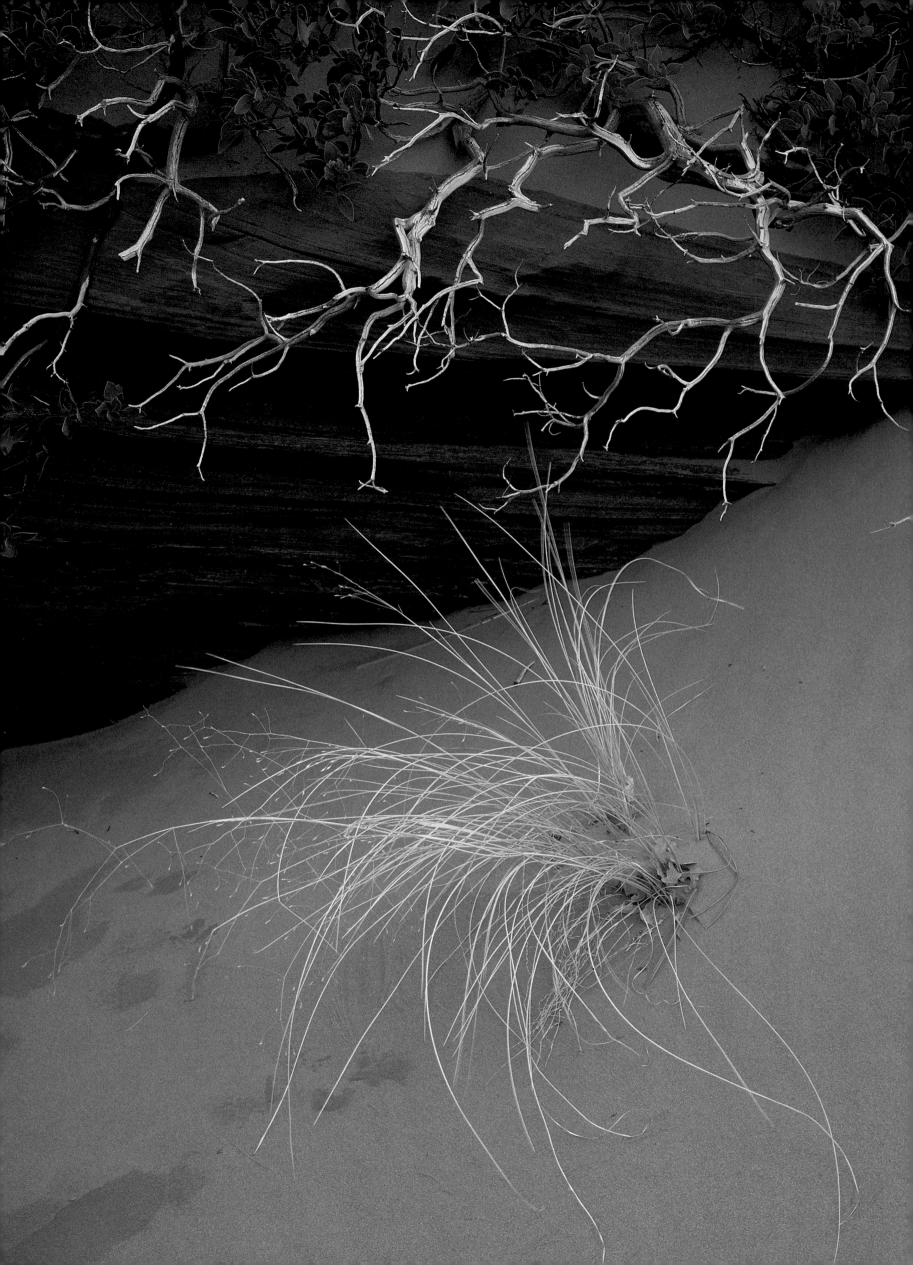

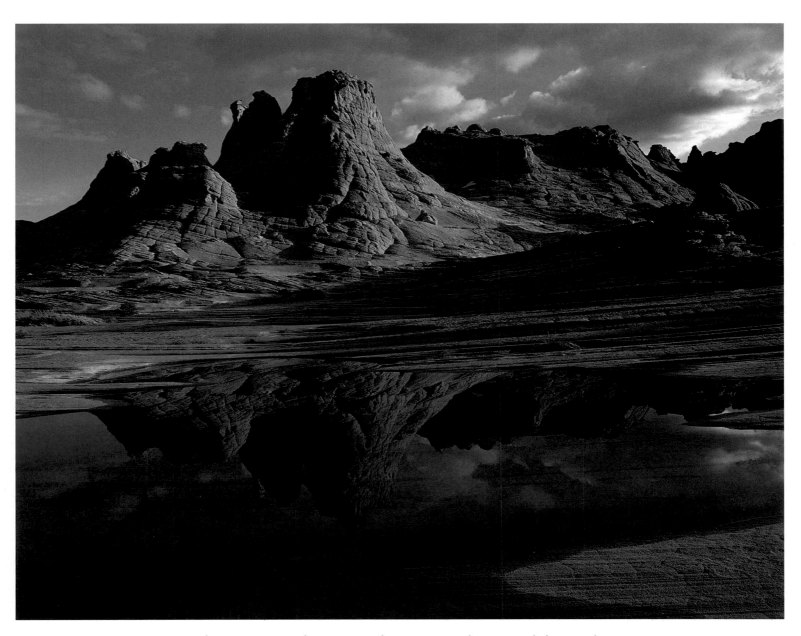

◄ Indian ricegrass and manzanita decorate a windswept sand dune and outcrop of Navajo Sandstone on the public lands of northern Arizona. Arizona contains magnificent beauty. The twenty-one national parks, monuments, and recreation areas in the state embrace only a fraction of the superlative landscapes. ▲ A shallow, slickrock pool filled by snowmelt reflects sandstone beehives.

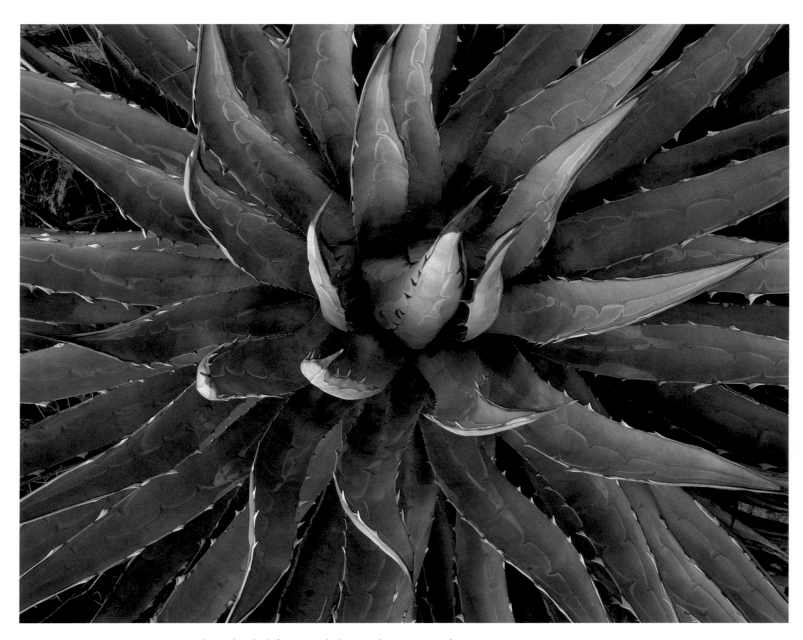

▲ The whorled leaves of the Utah century plant create an intricate pattern at Nankoweap Canyon within Grand Canyon National Park. ▶ Tributaries entering the Grand Canyon hold innumerable surprises. A quiet pool in the North Canyon reflects terraced walls that have been carved by countless floods.

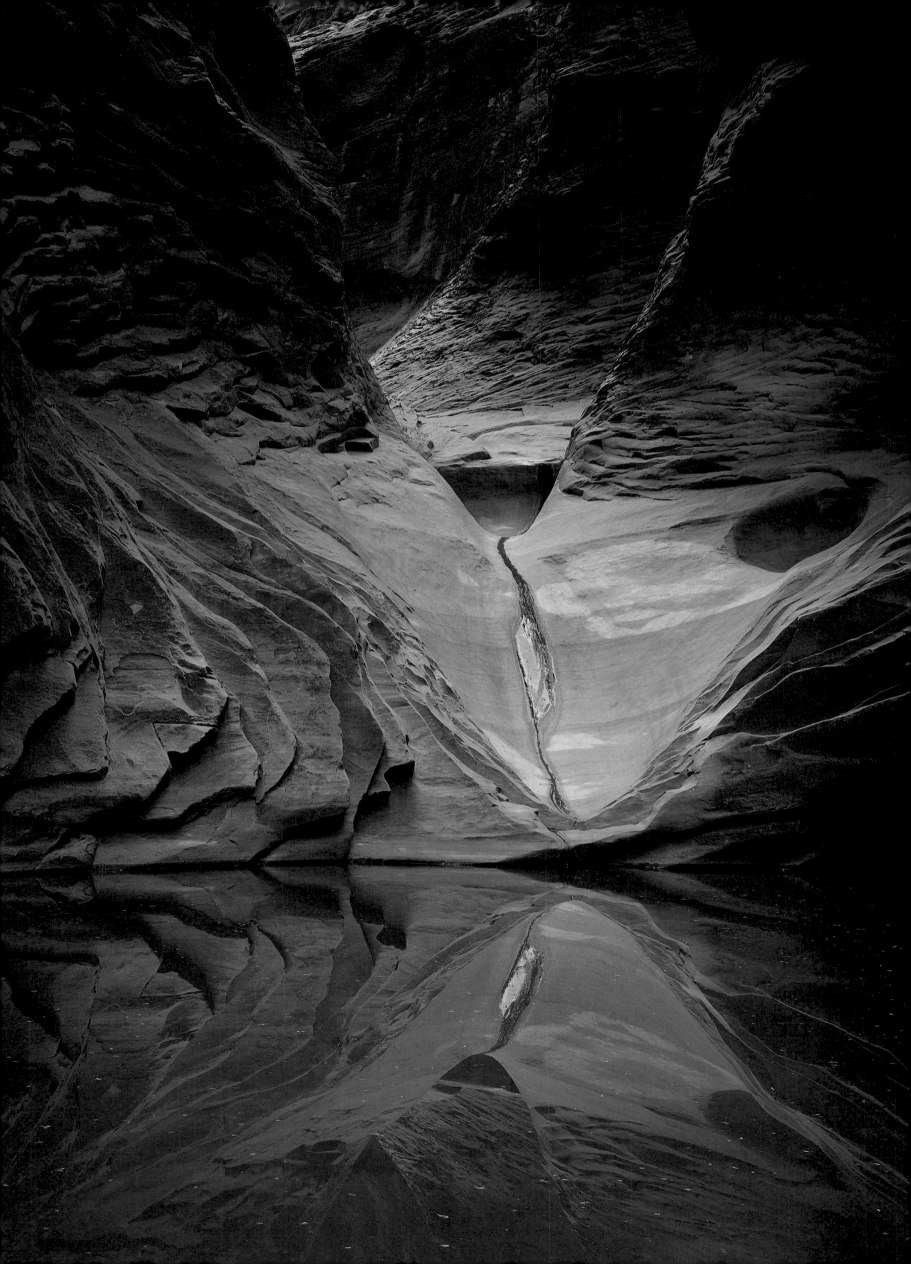

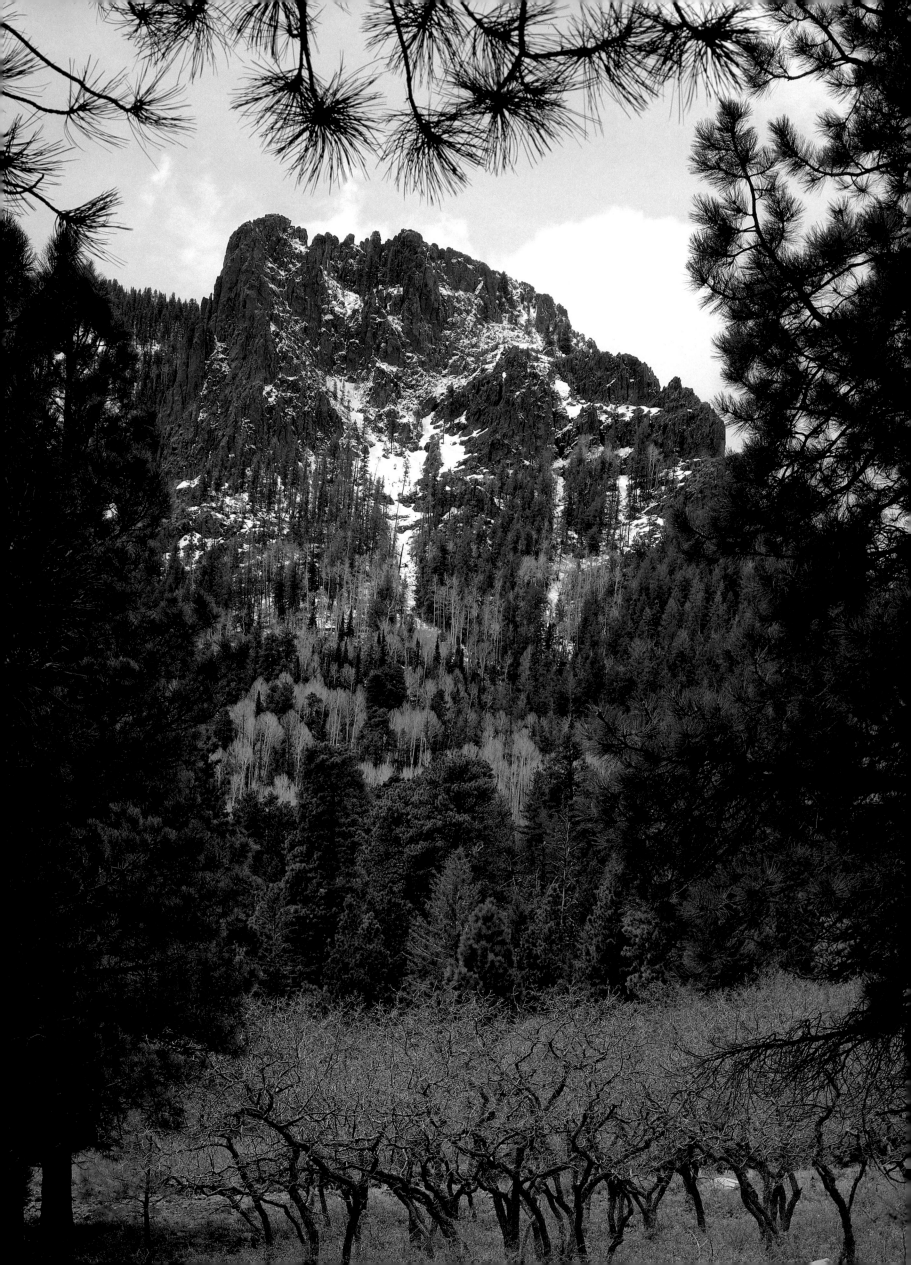

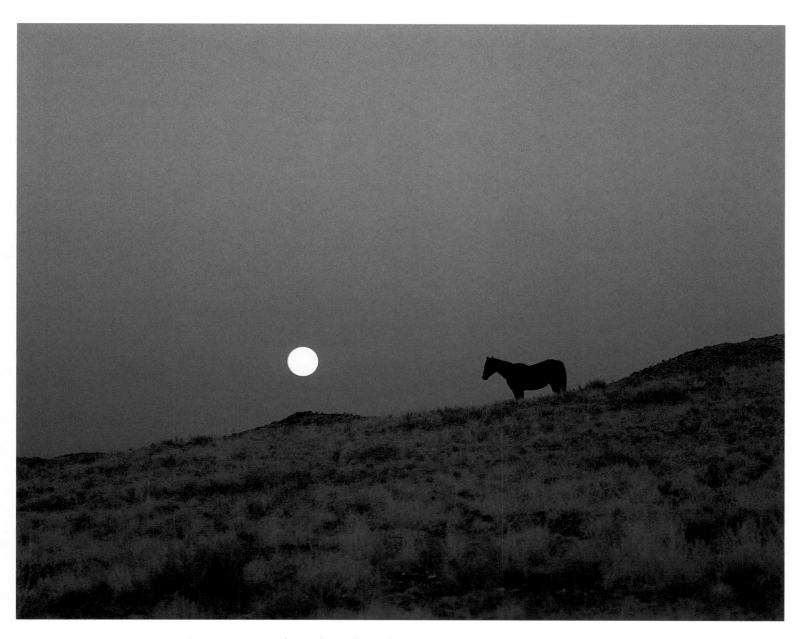

◄ A spring snow dusts the Lukachukai Mountains in northeastern Arizona. Ponderosa pine and oak give way to aspen, spruce, and fir at higher elevations.
▲ A full moon rises behind a horse on the Navajo Reservation. Horses—brought to the Southwest by Spanish explorers, soldiers, and missionaries who first came in the sixteenth century—were soon utilized by the Native peoples of Arizona.

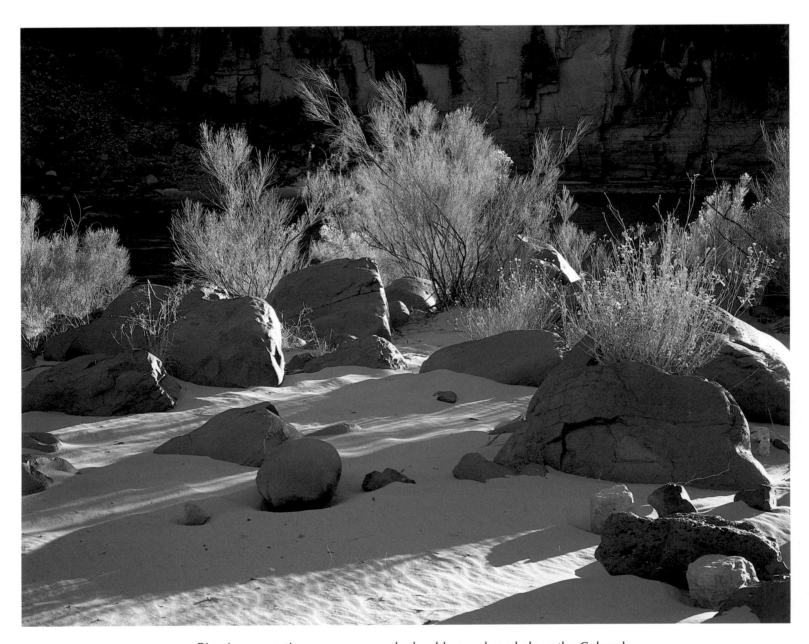

▲ Riparian vegetation grows among the boulders and sand along the Colorado River in the Grand Canyon. ▶ *Keet Seel*, the Navajo words meaning "broken pieces of pottery," is the best preserved large Anasazi ruin in Arizona. Permits available at Navajo National Monument allow visitors to hike eight miles to this ancient village, which was occupied from approximately A.D. 950 to 1300.

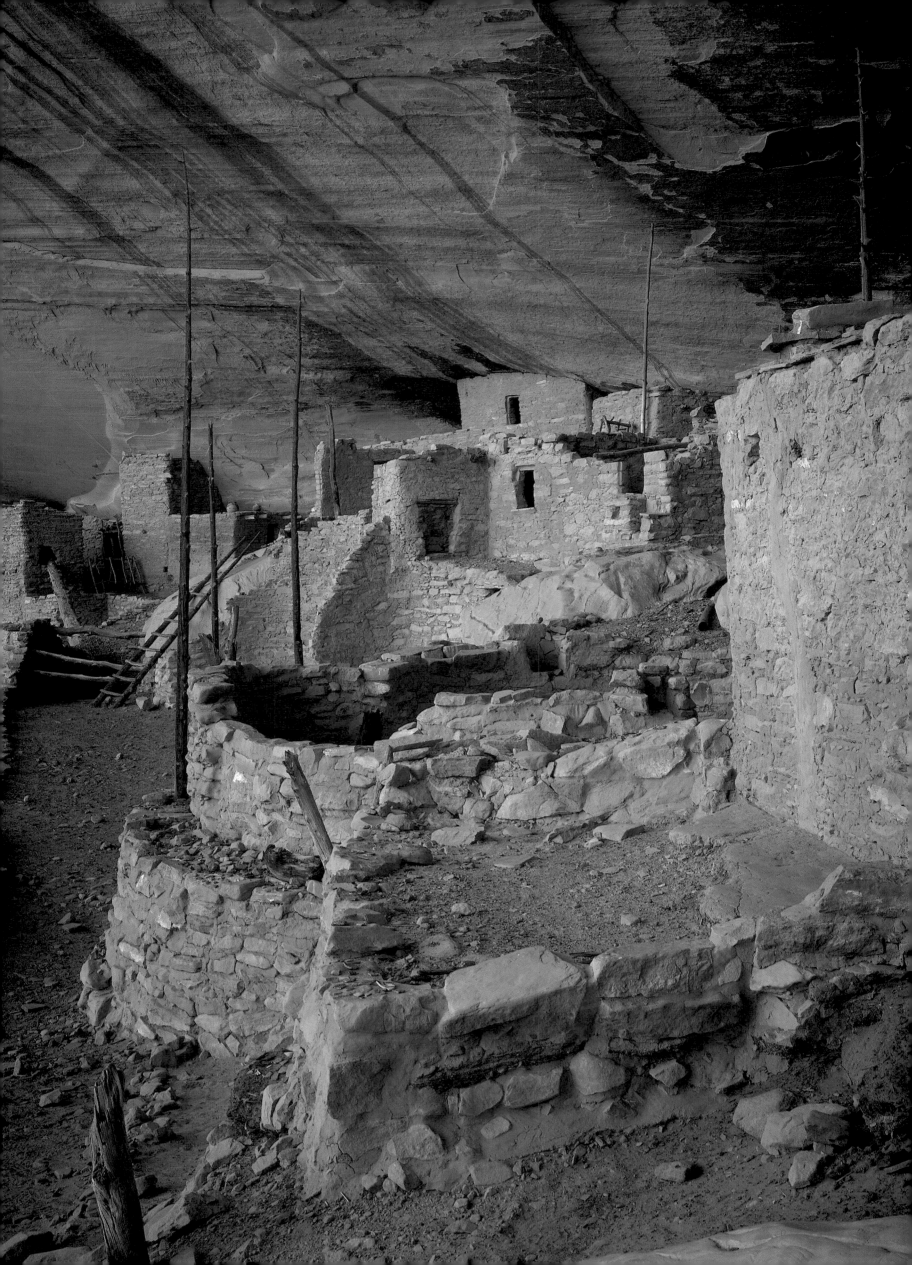

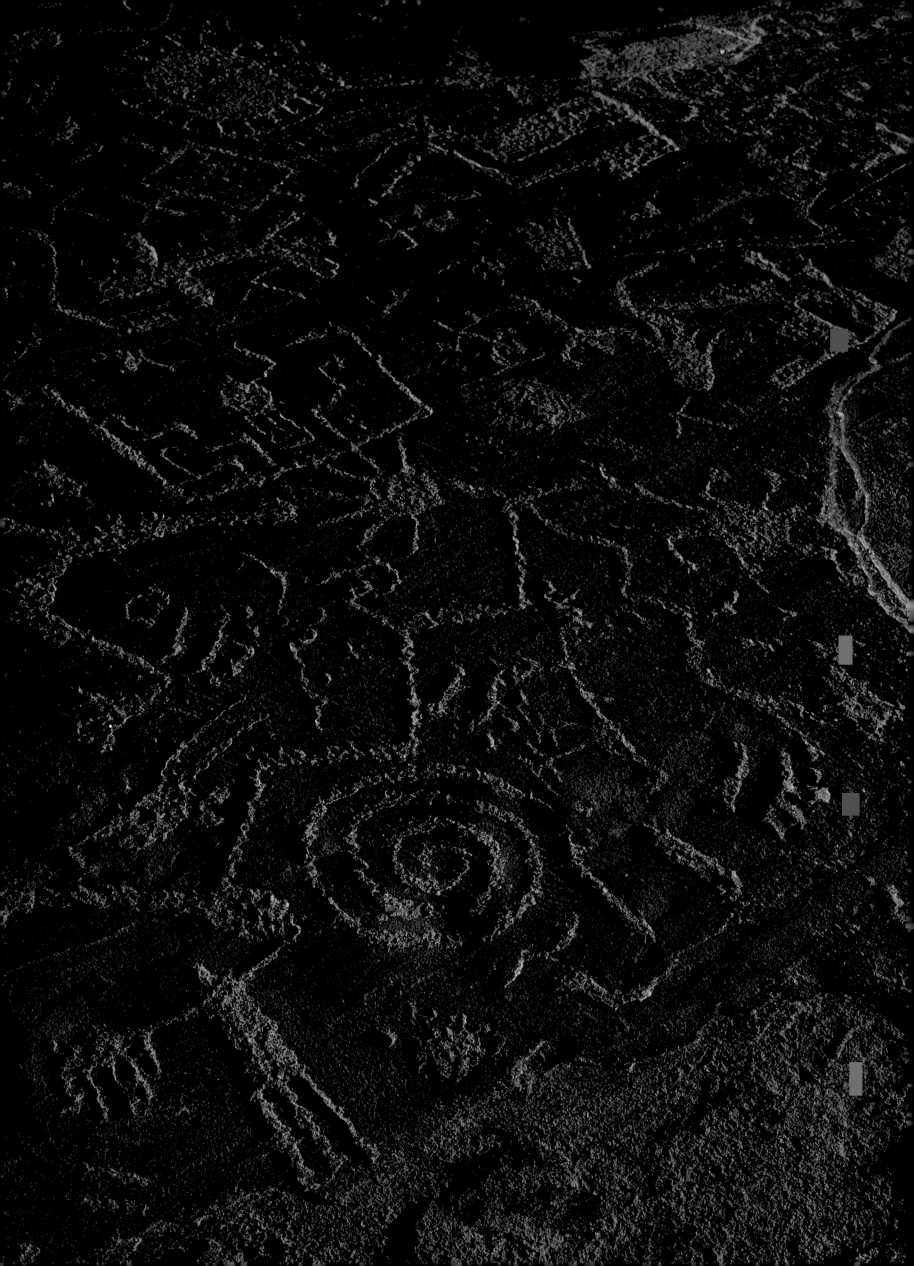

◄ Petroglyphs incised on a flat boulder in Petrified Forest National Park's back-country speak eloquently for Anasazi farmers of long ago. Corn, squash, and beans grown on desert lands were their staples. ▲ Sand dunes of early Jurassic times have been preserved in the cross-bedded Navajo Sandstone Formation.

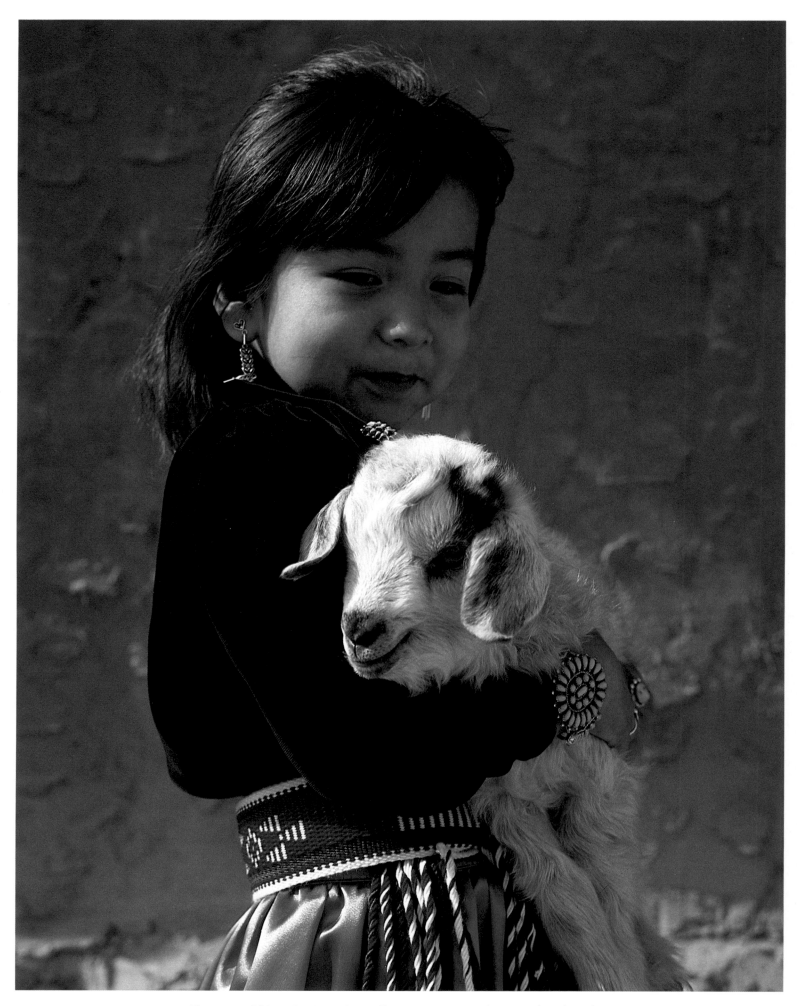

▲ Five-year-old Leatrice Mannie cradles a young goat at her grandmother's house on the Navajo Reservation near Ganado. Thousands of families run sheep and goats, the wool destined to become Navajo rugs. ▶ Five lupines sprout from a straight-running root beneath a sand dune in Monument Valley Tribal Park.

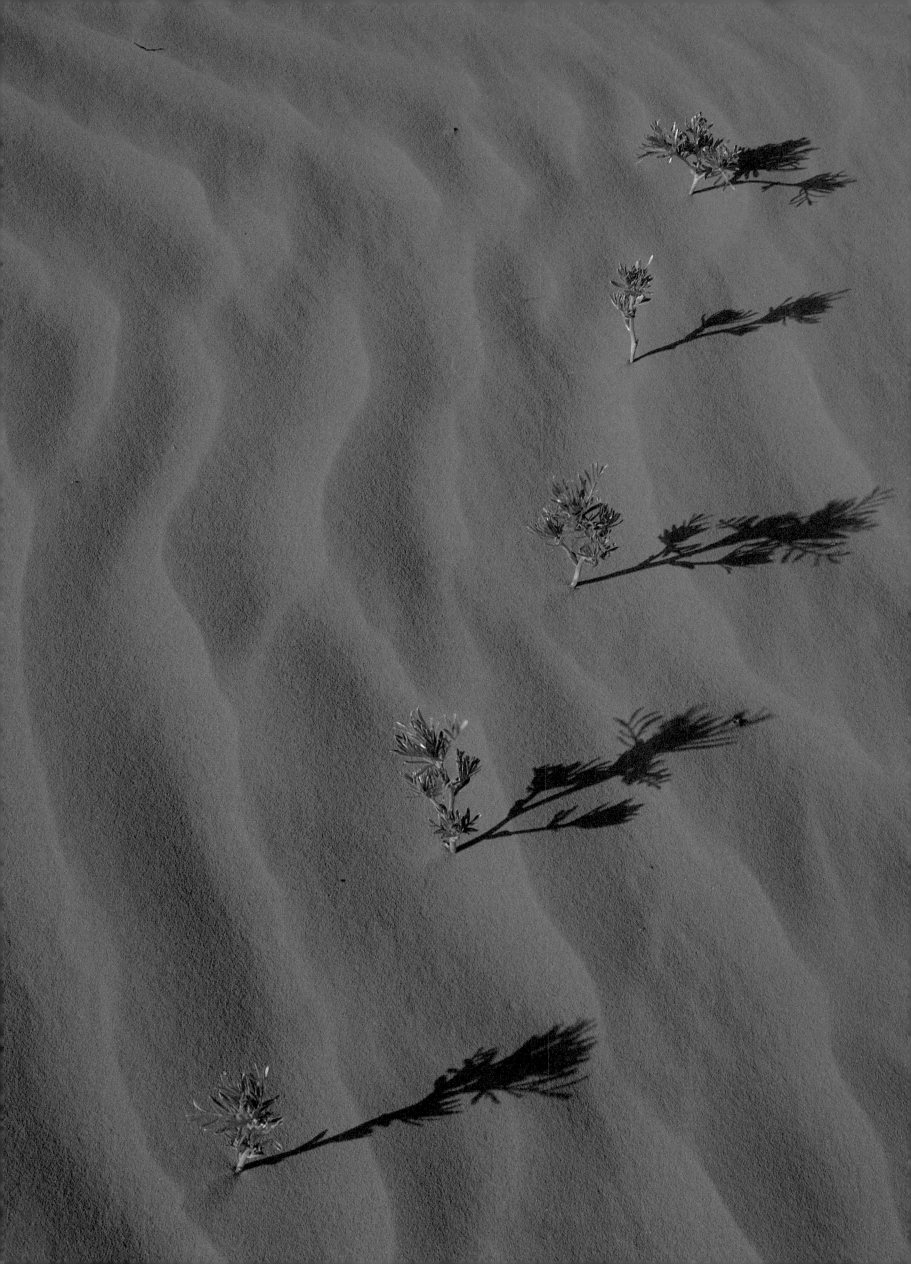

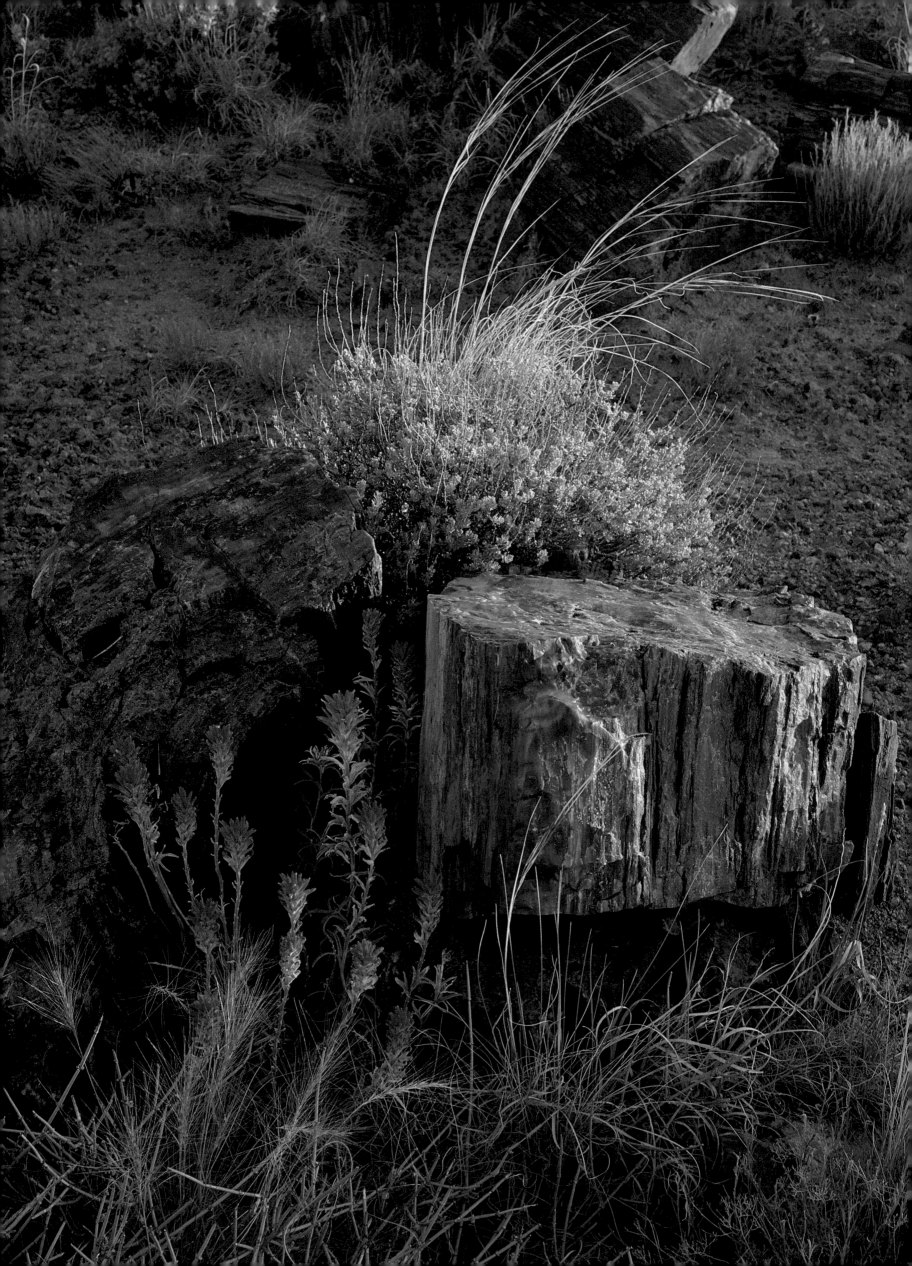

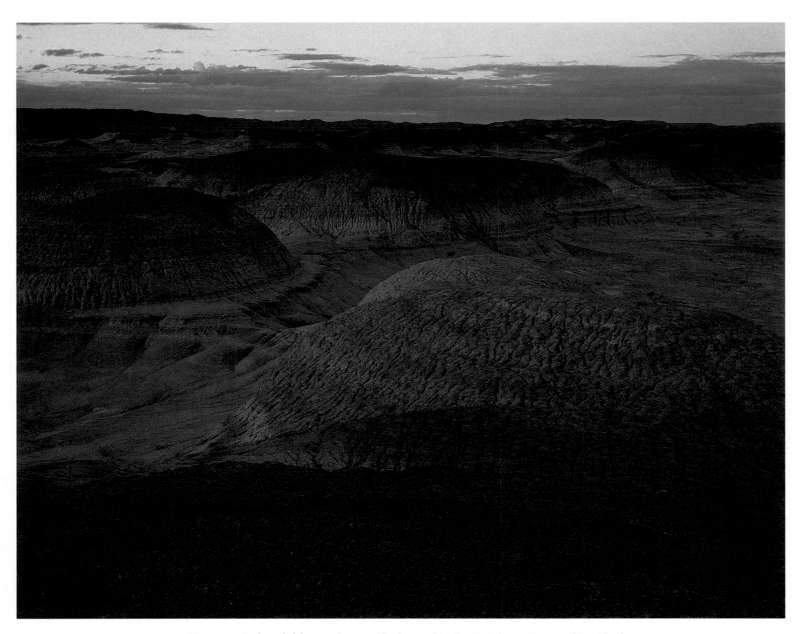

◄ Desert paintbrush blooms by petrified wood in the Rainbow Forest of Petrified Forest National Park. ▲ Volcanic deposits of Black Forest Tuff glow as sunset strikes Painted Desert badlands at Petrified Forest National Park. ► ► Snow blankets Aspen Lake's shore during May green-up in Sitgreaves National Forest.

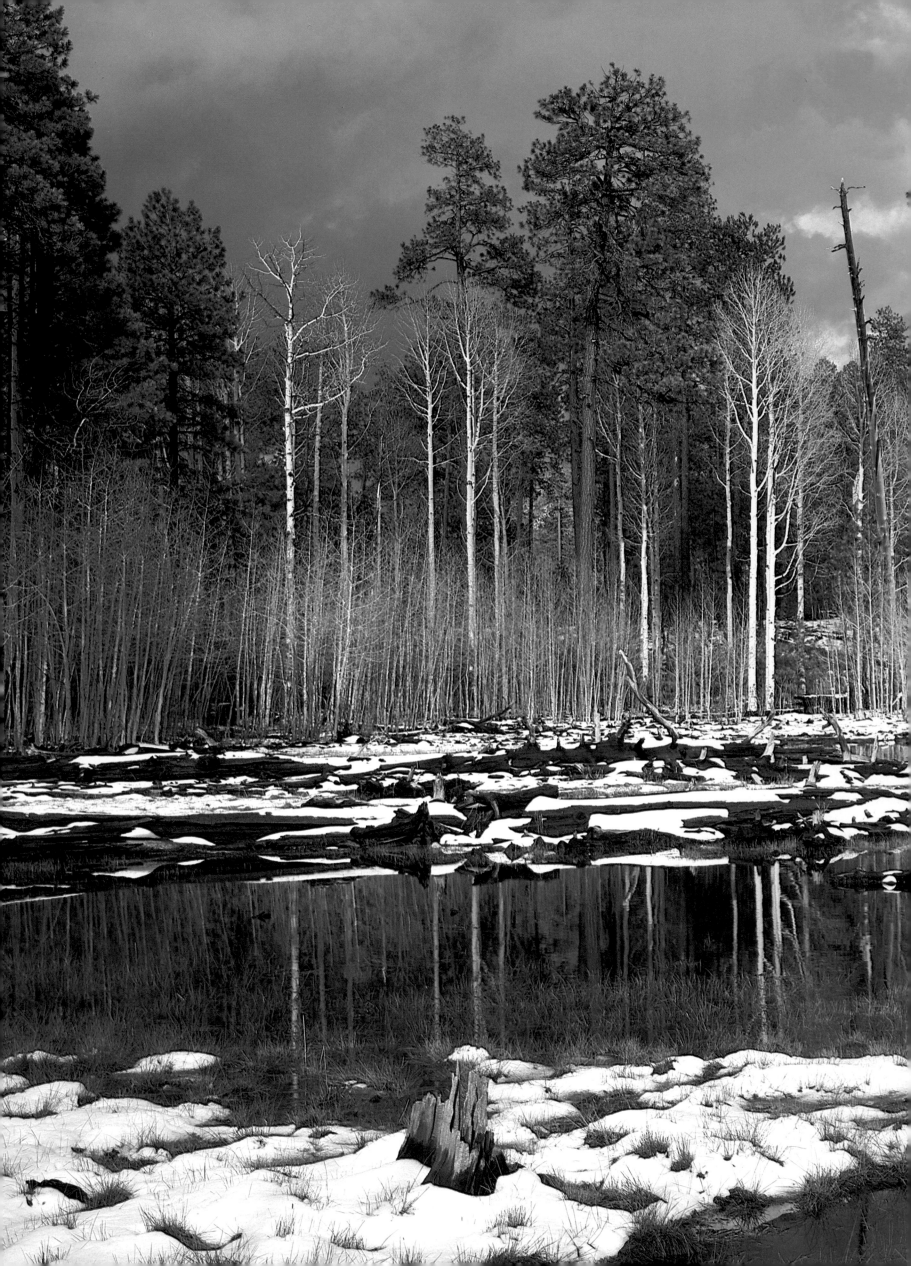

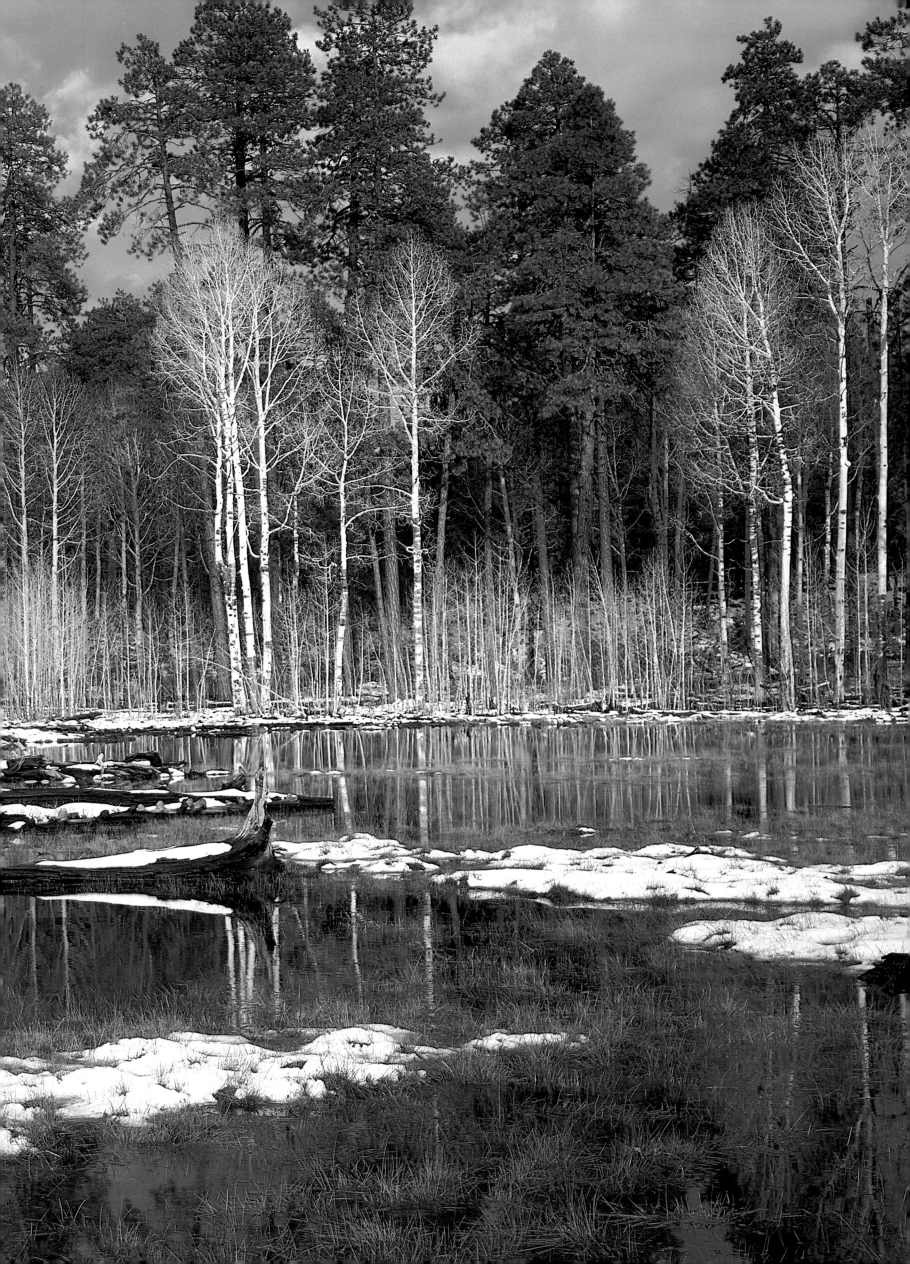

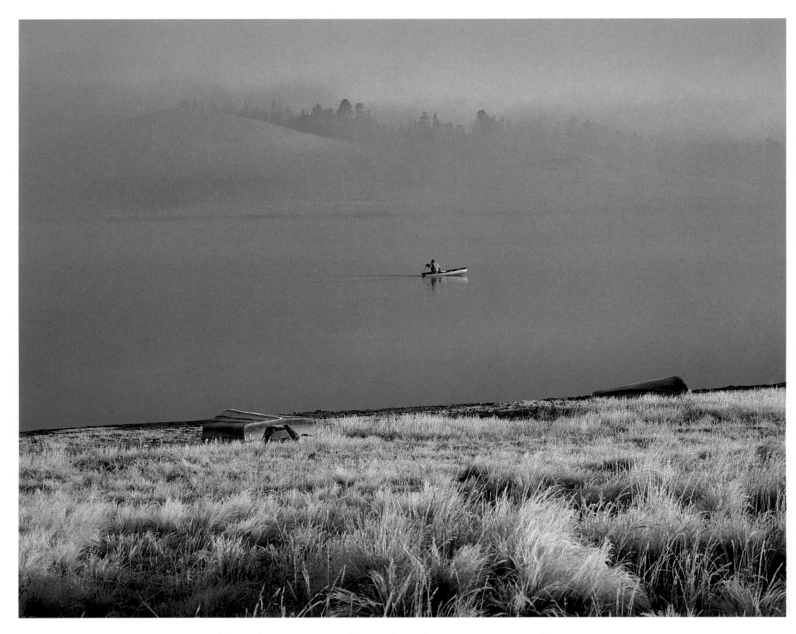

▲ Fog lifting from Sunrise Lake on the White Mountain Apache Reservation reveals a lone fisherman trying his early morning luck. ▶ Calling cards left by a winter storm, rime coats the ponderosa pines near the edge of the Mogollon Rim in the Sitgreaves National Forest. At an elevation of more than seventy-five hundred feet, the Arizona winter is at the same time both severe and beautiful.

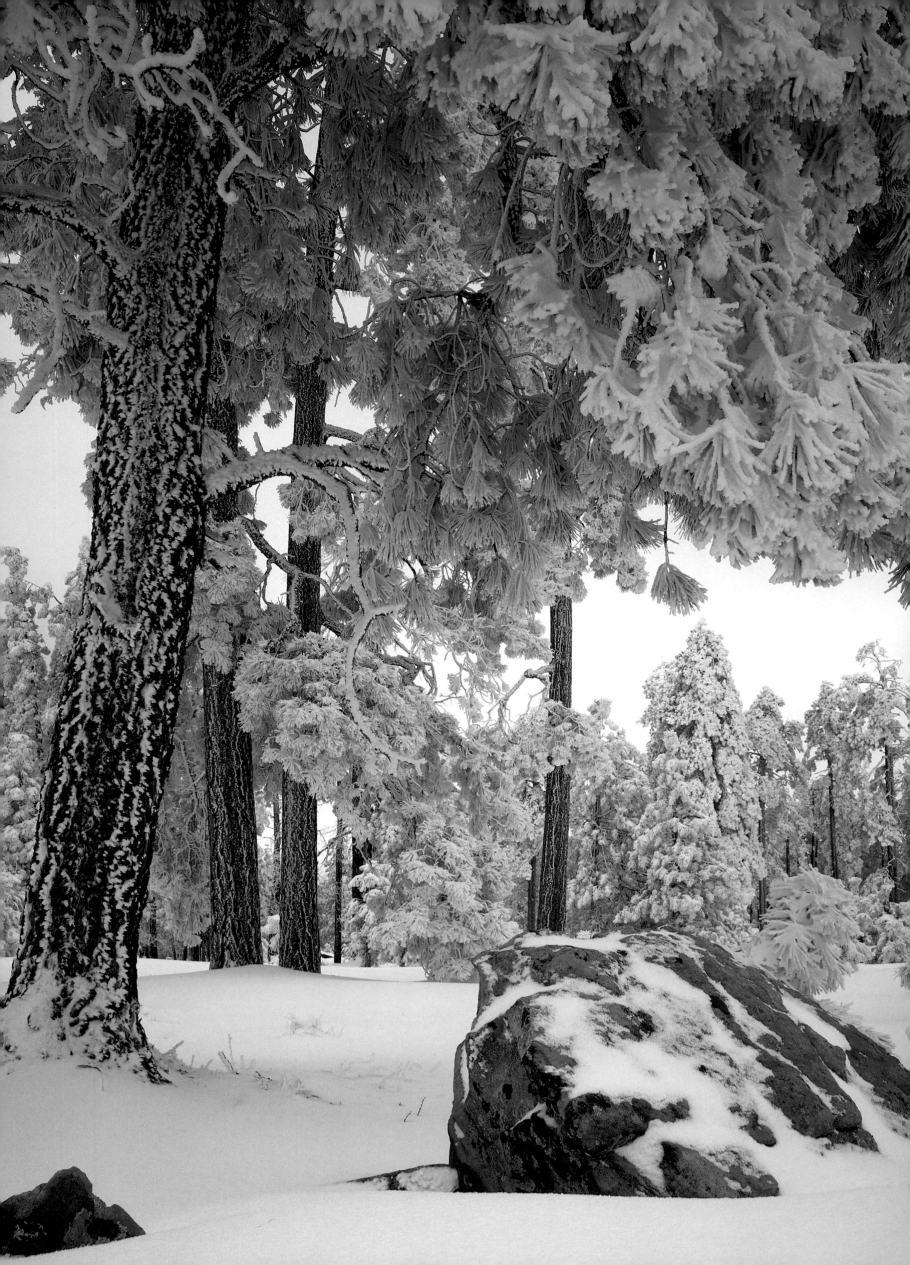

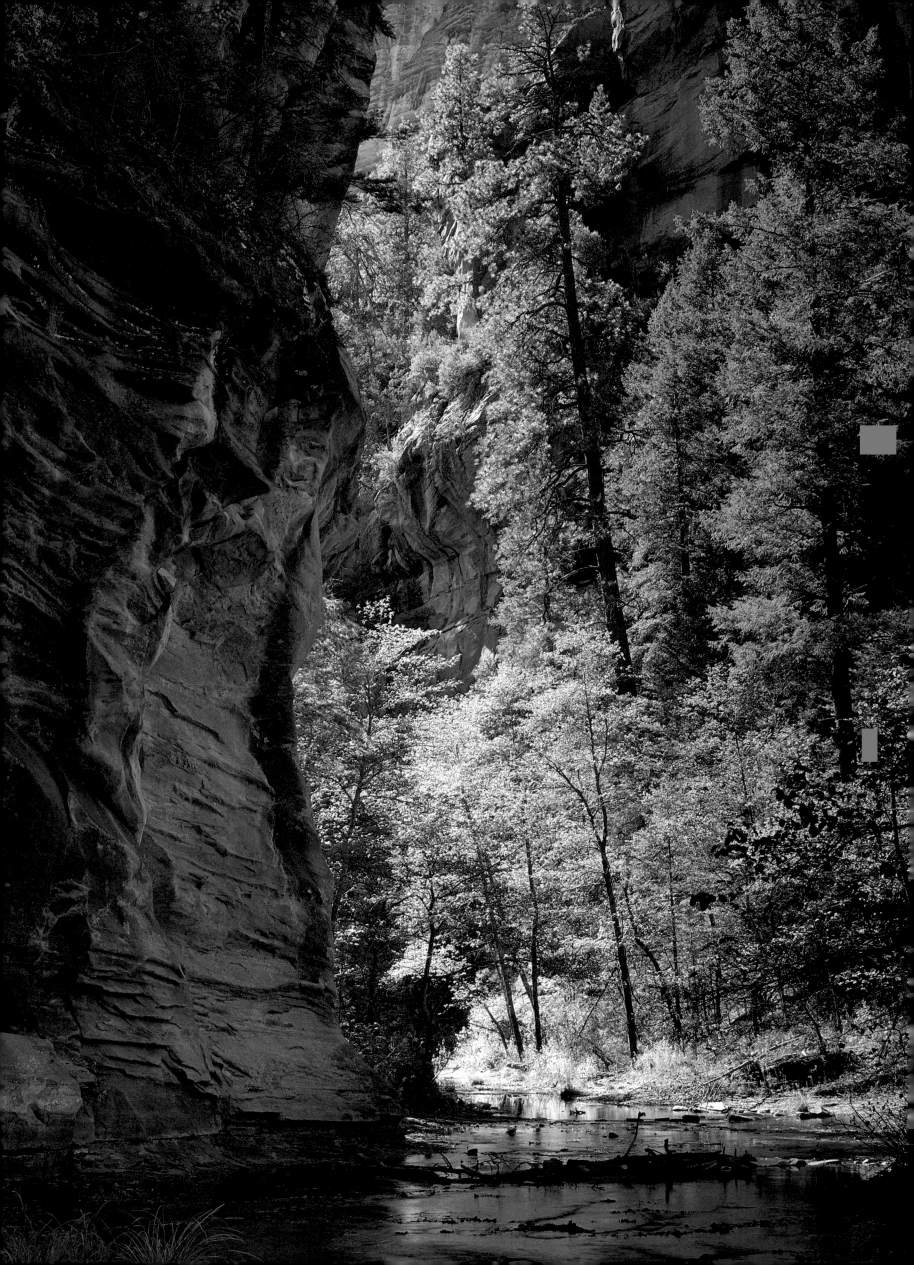

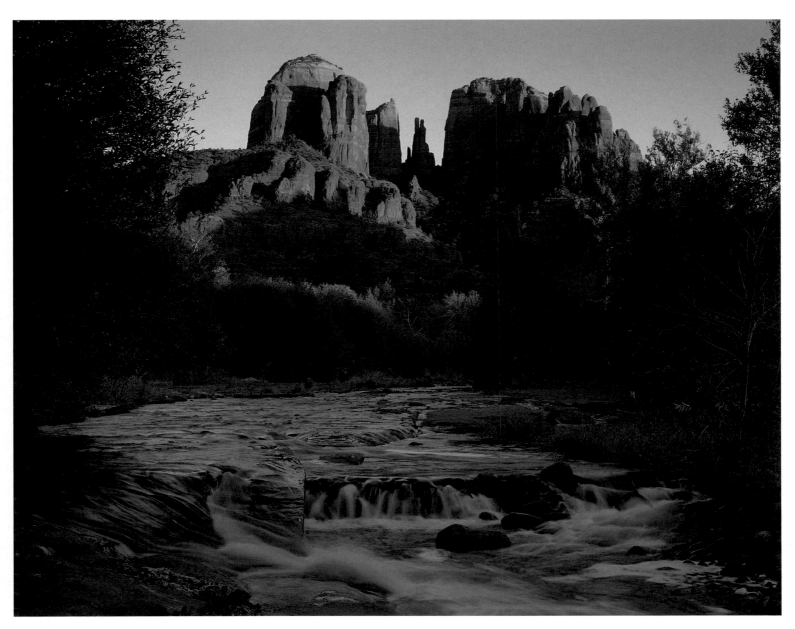

◄ Sandstone cliffs tower above the West Fork of Oak Creek in Coconino National Forest's Red Rock-Secret Mountain Wilderness. The Sedona area on the Colorado Plateau's southern edge has striking red rock scenery.　▲ At Red Rock Crossing, Cathedral Rock catches the autumn light as water tumbles down Oak Creek.

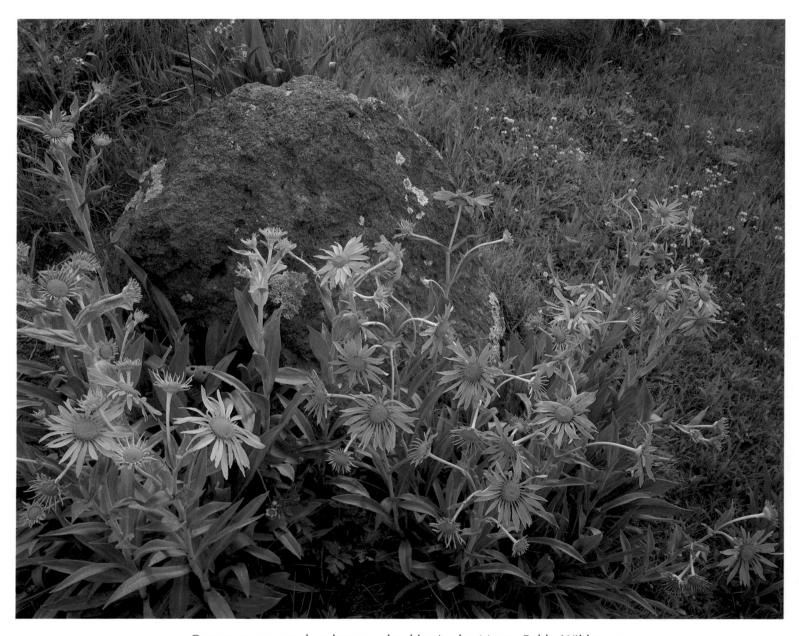

▲ Orange sneezeweed embraces a boulder in the Mount Baldy Wilderness of the Apache National Forest. Spruce and fir, typical of the Canadian life zone, inhabit the high elevations of the White Mountains. ▶ Tuzigoot's stone masonry withstands the weathering of time in the lush Verde Valley. People of the Sinagua Tradition occupied this village of ninety-two rooms until about A.D. 1450.

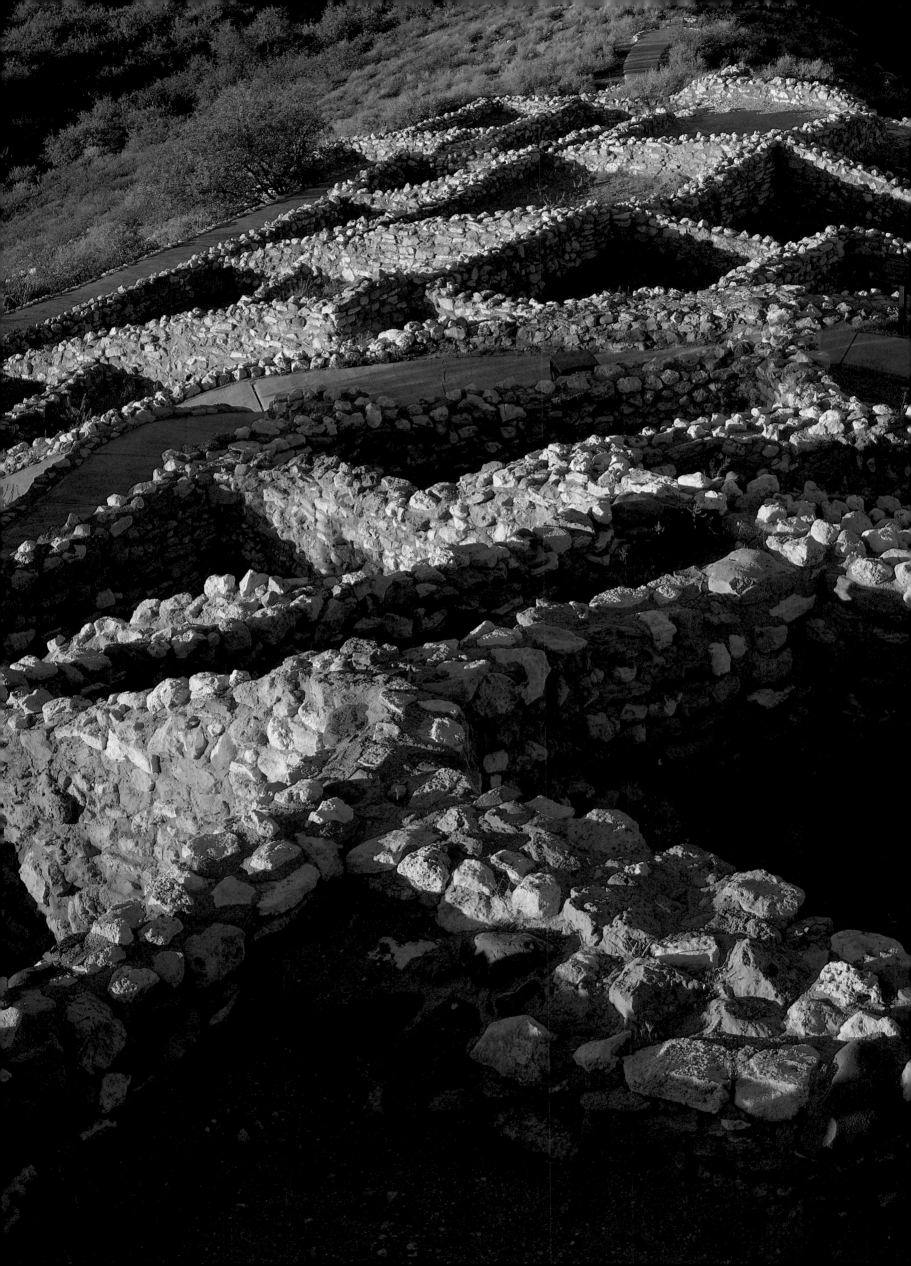

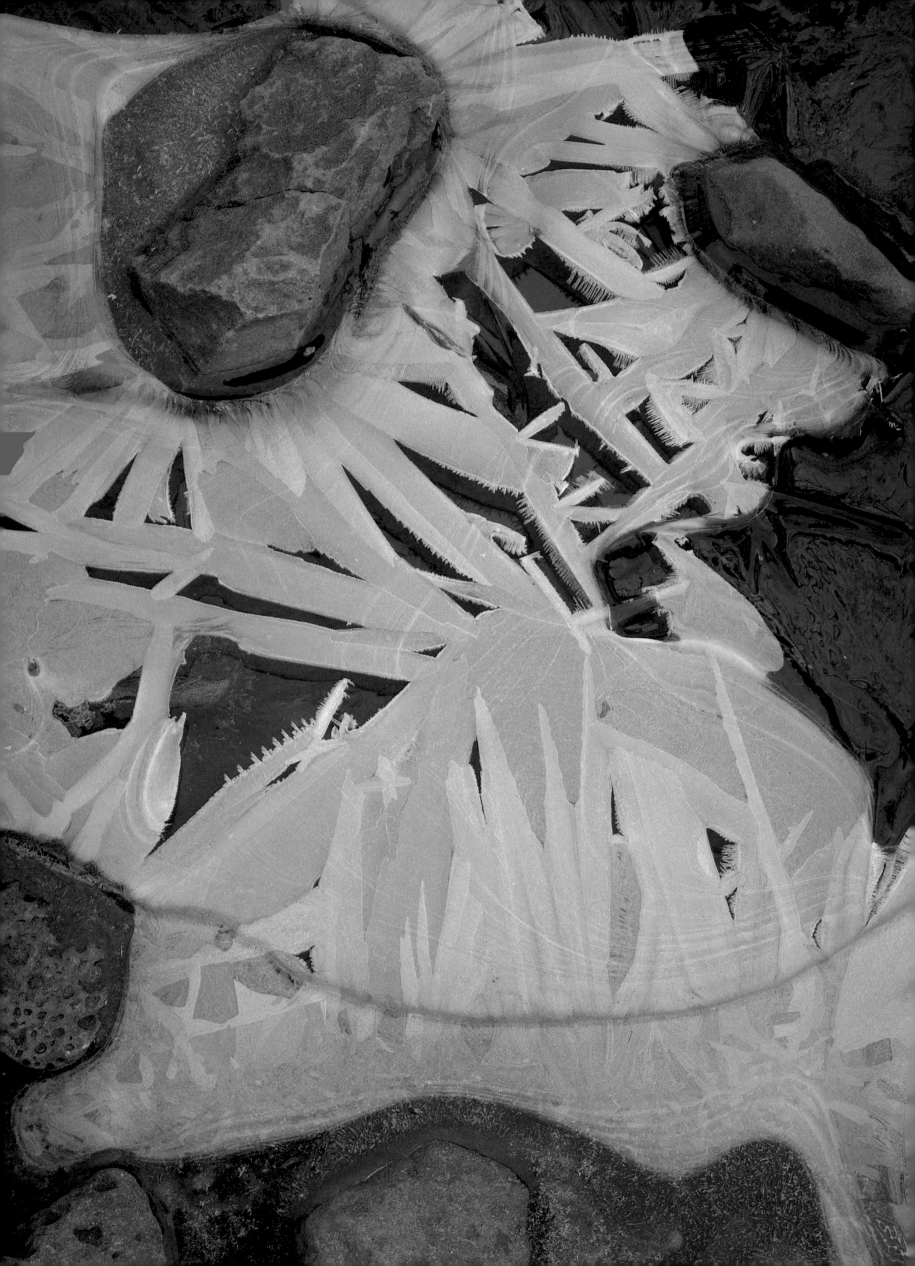

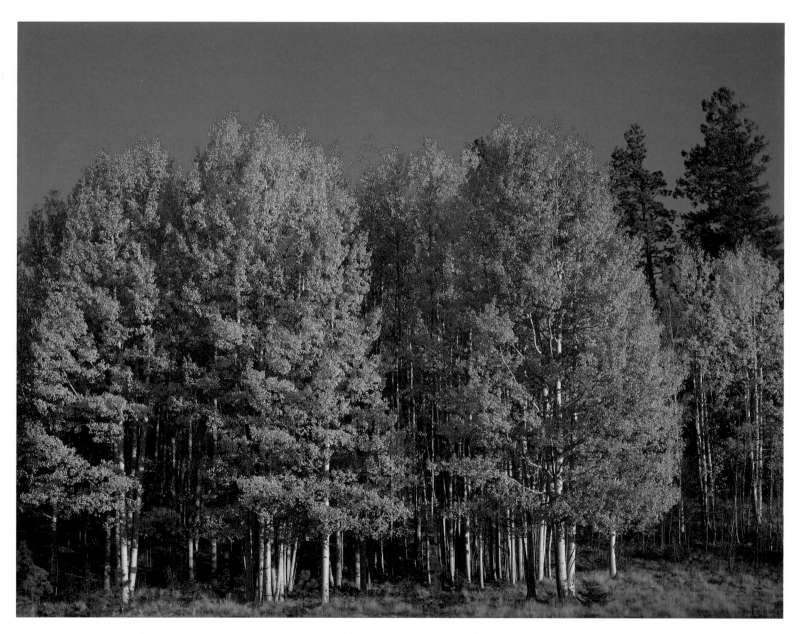

◄ Ice and frost surround cobbles in the West Fork of the Little Colorado River. Near its headwaters in the White Mountains, the Little Colorado is a clear trout stream. ▲ Stately aspens turn gold in autumn splendor near Hay Lake in Apache National Forest. Hay Lake is one of Arizona's few natural lakes.

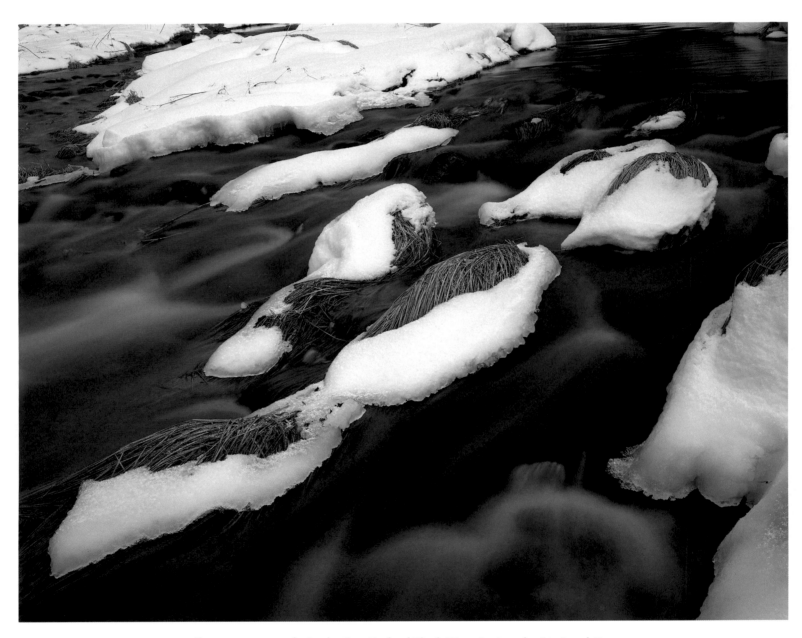

▲ Snow tops tussocks in the East Fork of Black River in Apache National Forest.
► Dark trunks of ponderosa pine contrast with fresh snow near Woods Canyon Lake in Sitgreaves National Forest. One-fourth of Arizona is forested. A band of coniferous forest stretches three hundred miles across Arizona into New Mexico.

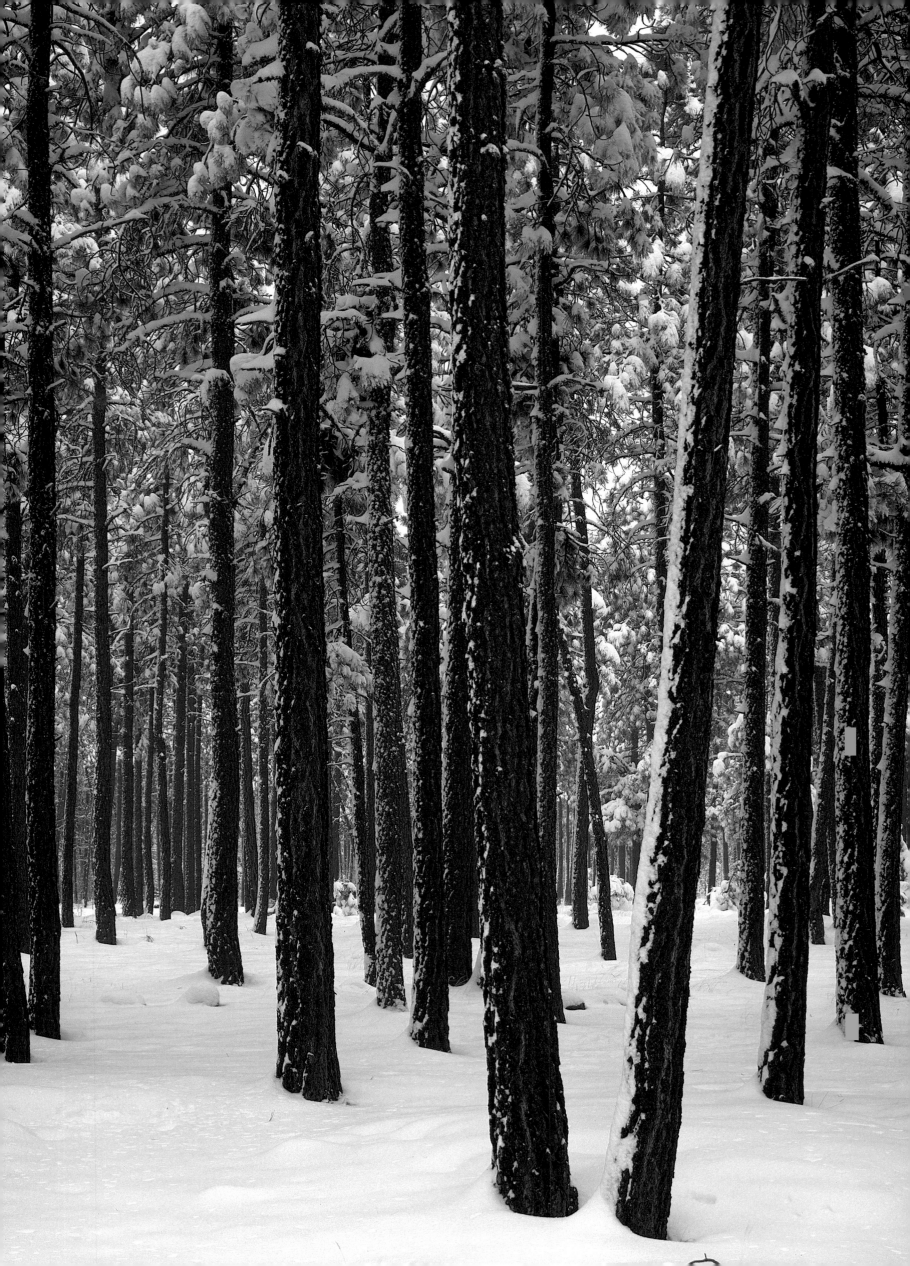

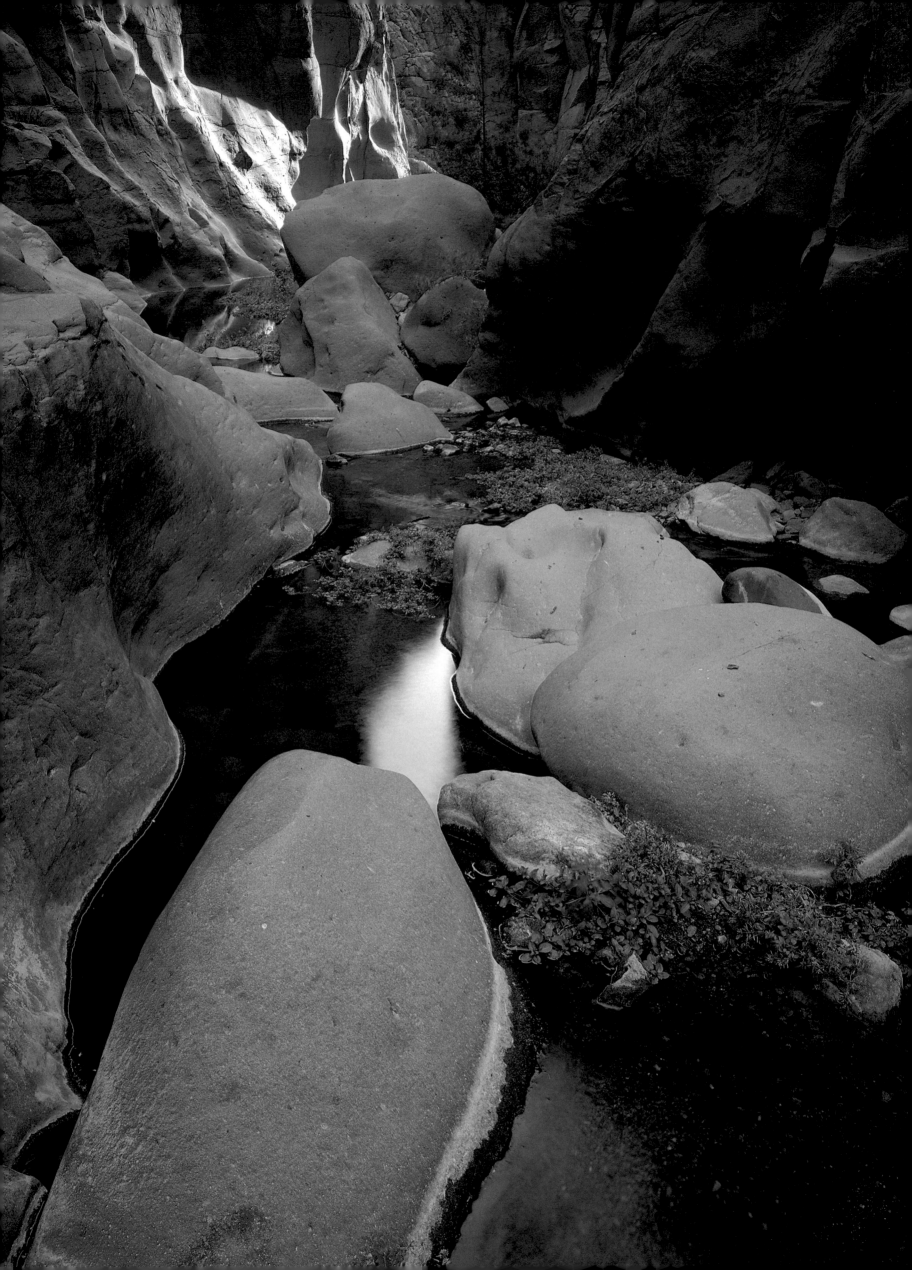

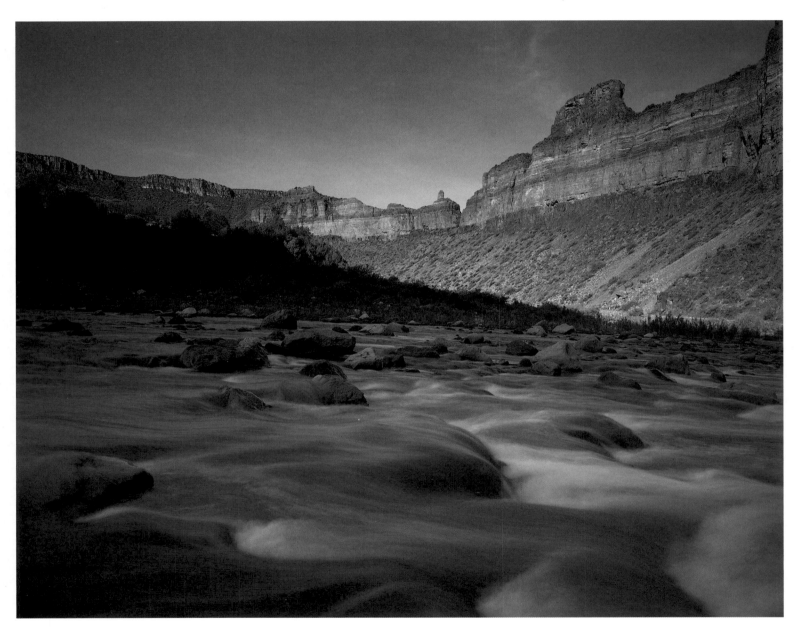

◄ Mineral Creek meanders through a boulder-strewn narrows in the volcanic rocks of the Dripping Springs Mountains. ▲ The Salt River dances over huge boulders on the White Mountain Apache Reservation. Rafters and kayakers test the treacherous rapids of the Salt River during the periods of high water that follow winters with heavy snows. The Salt can be as difficult as the Colorado.

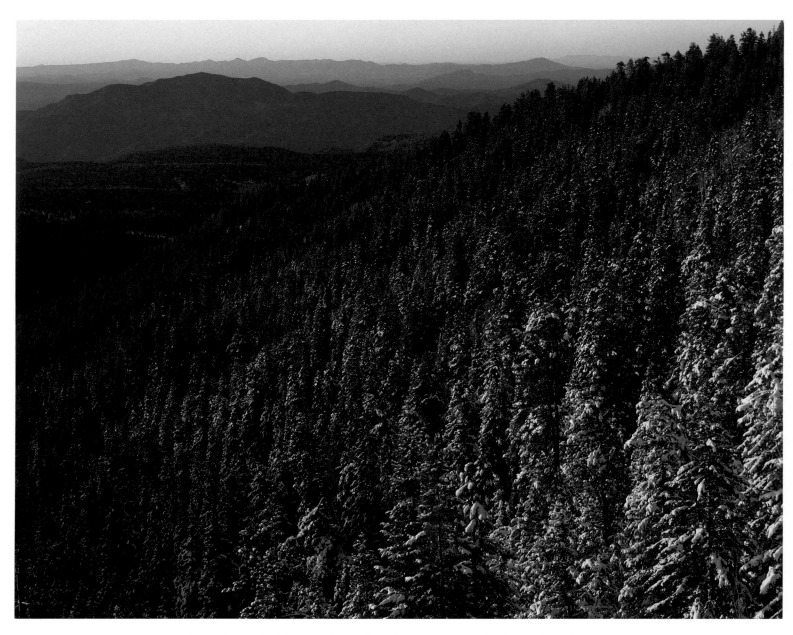

▲ The Coronado Highway, U.S. 666, winds past forested ridges of the Blue Range near Salt House Vista. Labeled the nation's least-traveled federal highway, more than 460 curves greet motorists between Alpine and Morenci. ▶ On the White Mountain Apache Reservation, Cibecue Creek flows toward the Salt River.

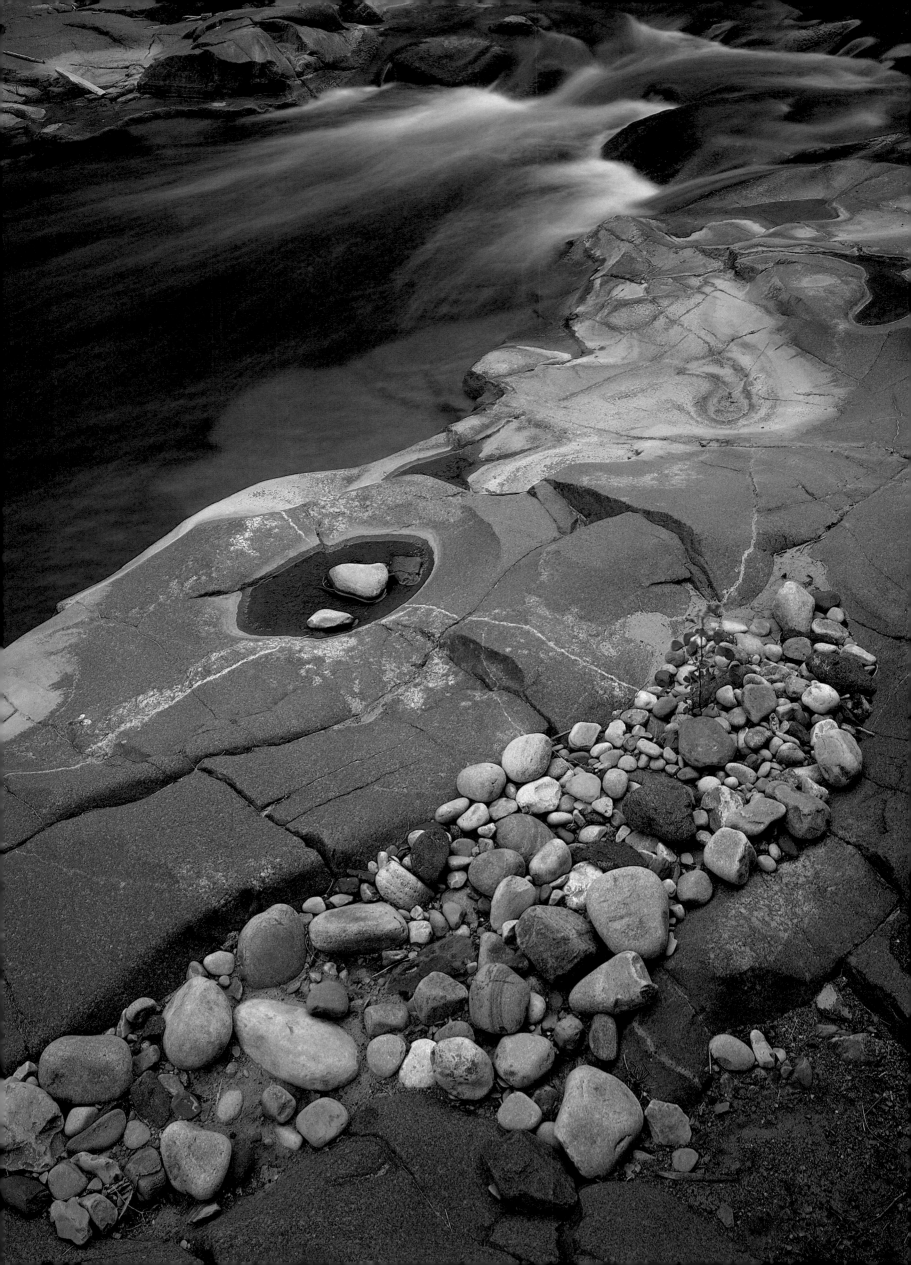

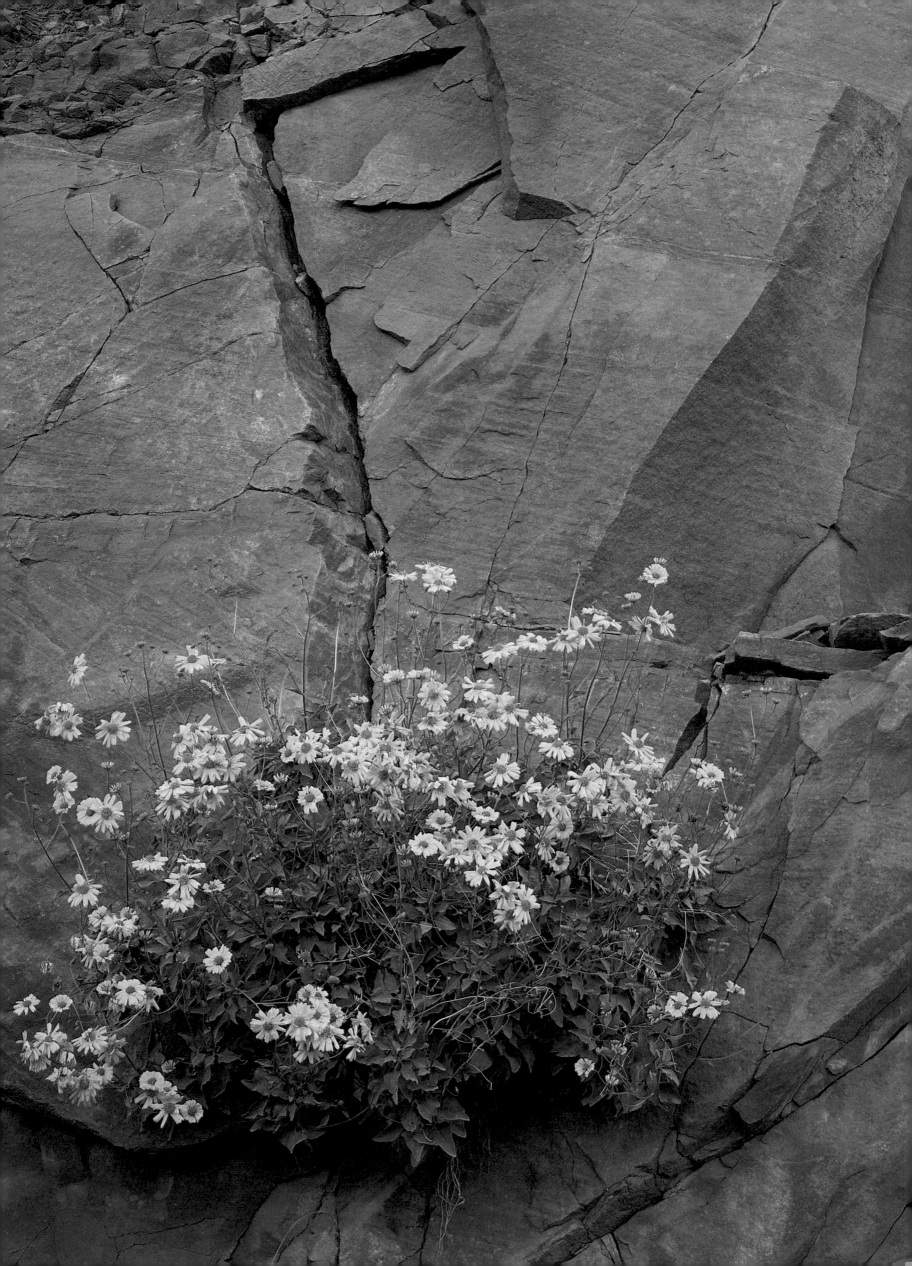

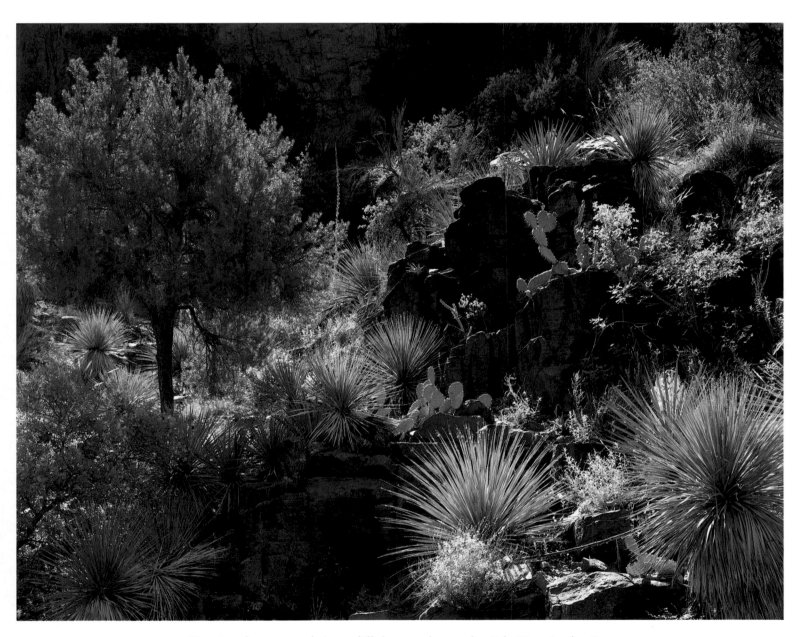

◄ Growing from a crack in a cliff that overhangs the Salt River in the Tonto
National Forest, brittlebush somehow finds sufficient nourishment and water.
▲ Sotol, prickly pear, and juniper crowd together on tiny ledges in Cibecue
Canyon. Where the Sonoran Desert of the lowlands meets the pinyon-juniper
forests of the higher elevations, plant communities of wide diversity converge.

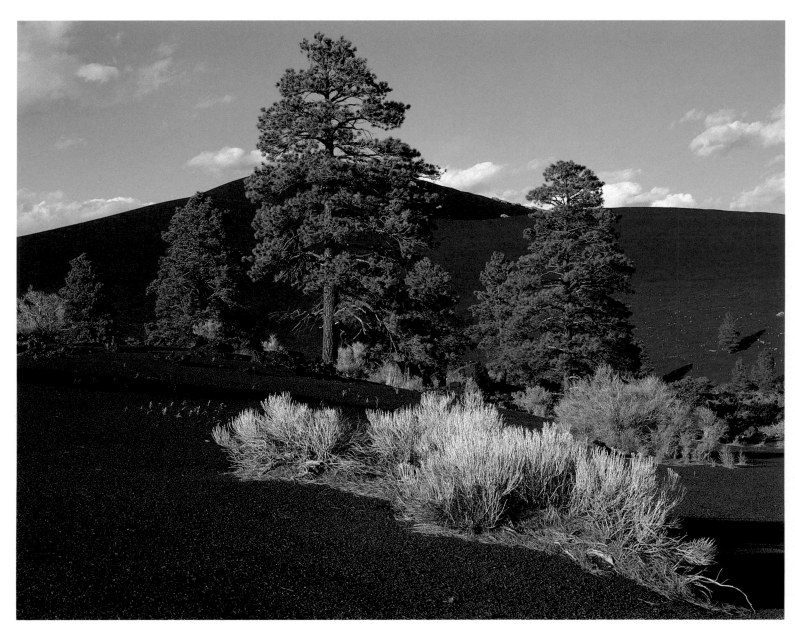

▲ Black cinders from volcanic eruptions as recent as A.D. 1064 to 1065 contrast with ponderosa pines at Sunset Crater National Monument. Much of Arizona has roots in fiery volcanism. ▶ Seeping water in Rock Canyon, a tributary of the Salt River, supports a lush oasis. Scarlet hedge-nettle adds a splash of color to spring.

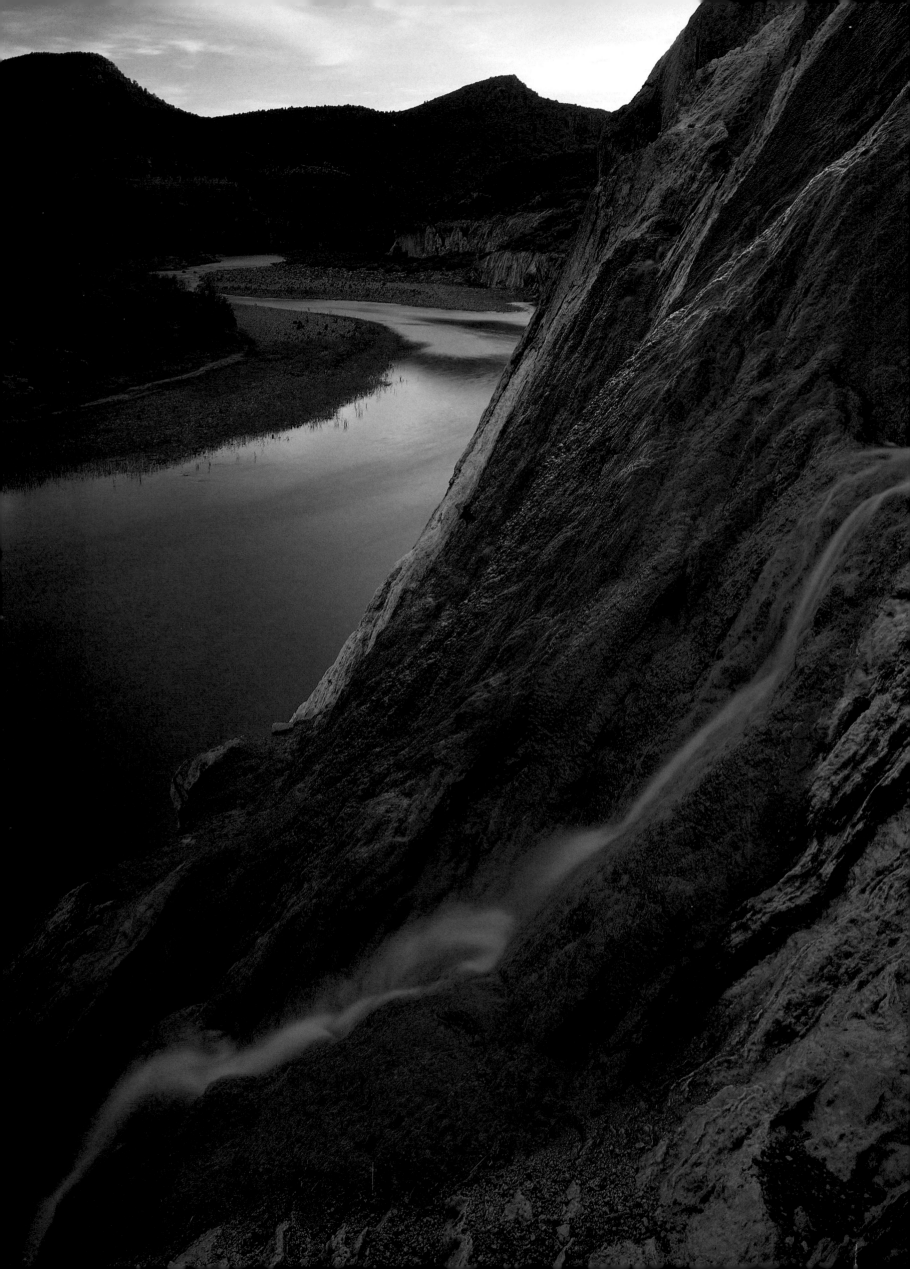

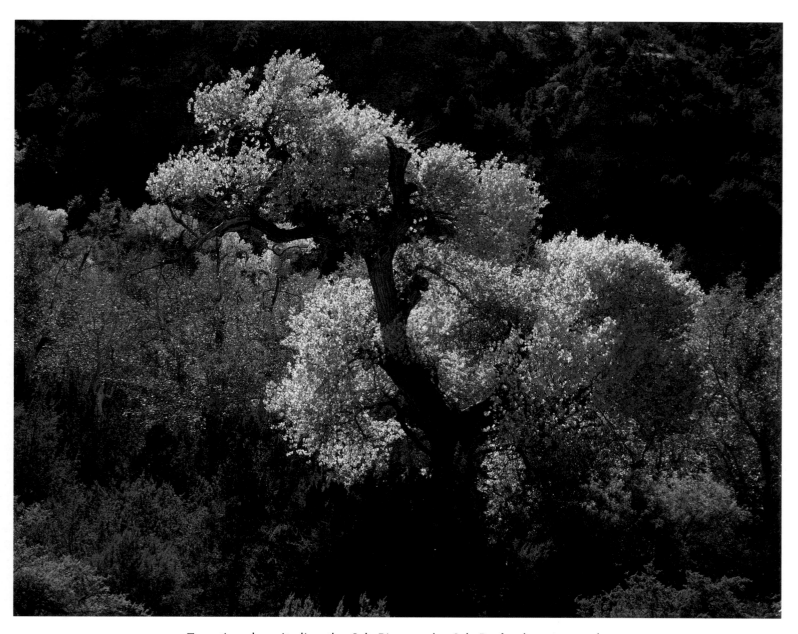

◄ Travertine deposits line the Salt River at the Salt Banks downstream from Cibecue Creek. Apache oral history tells of a young girl, lost from her family, whose tears gave the Salt River its salty taste. ▲ Autumn colors of cottonwood and sycamore gild the flood plain of West Clear Creek below the Mogollon Rim.

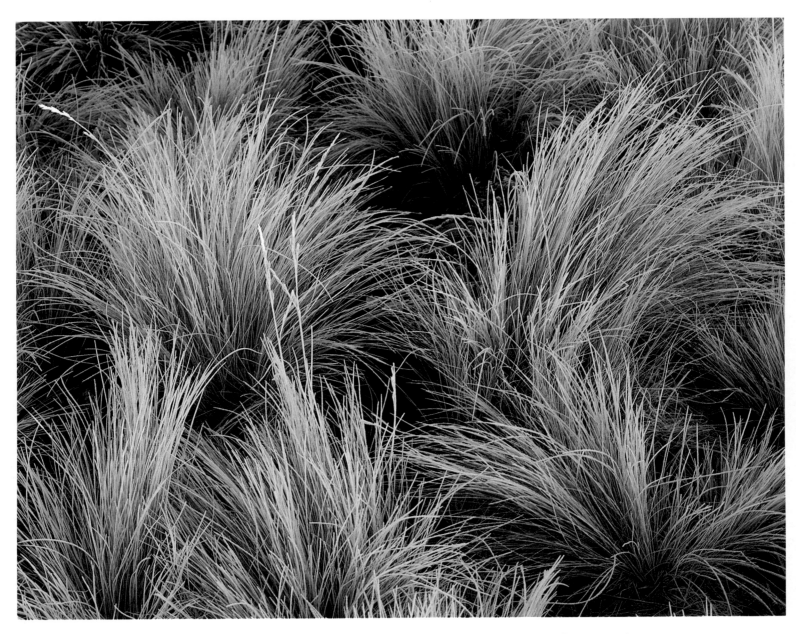

▲ Morning frost highlights a pine bunch grass prairie in the upper elevations of the White Mountains. ▶ Fog hangs in a quaking aspen and spruce forest as an autumn storm departs from the Mount Baldy Wilderness. Rhyolite hoodoos stand sentinel above the trees. Mount Baldy, at an elevation of 11,590 feet, stands second only to the San Francisco Peaks as the highest point in the state.

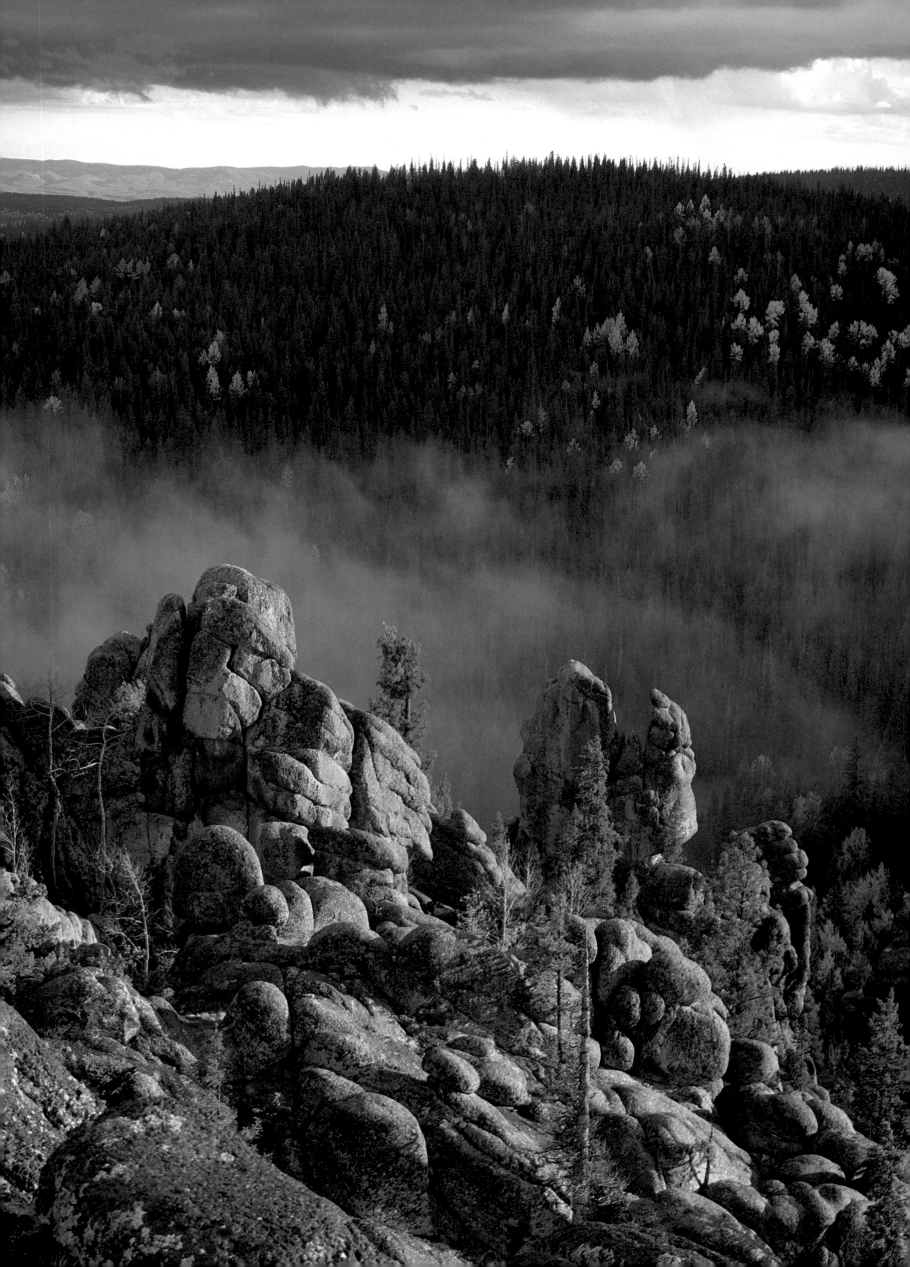

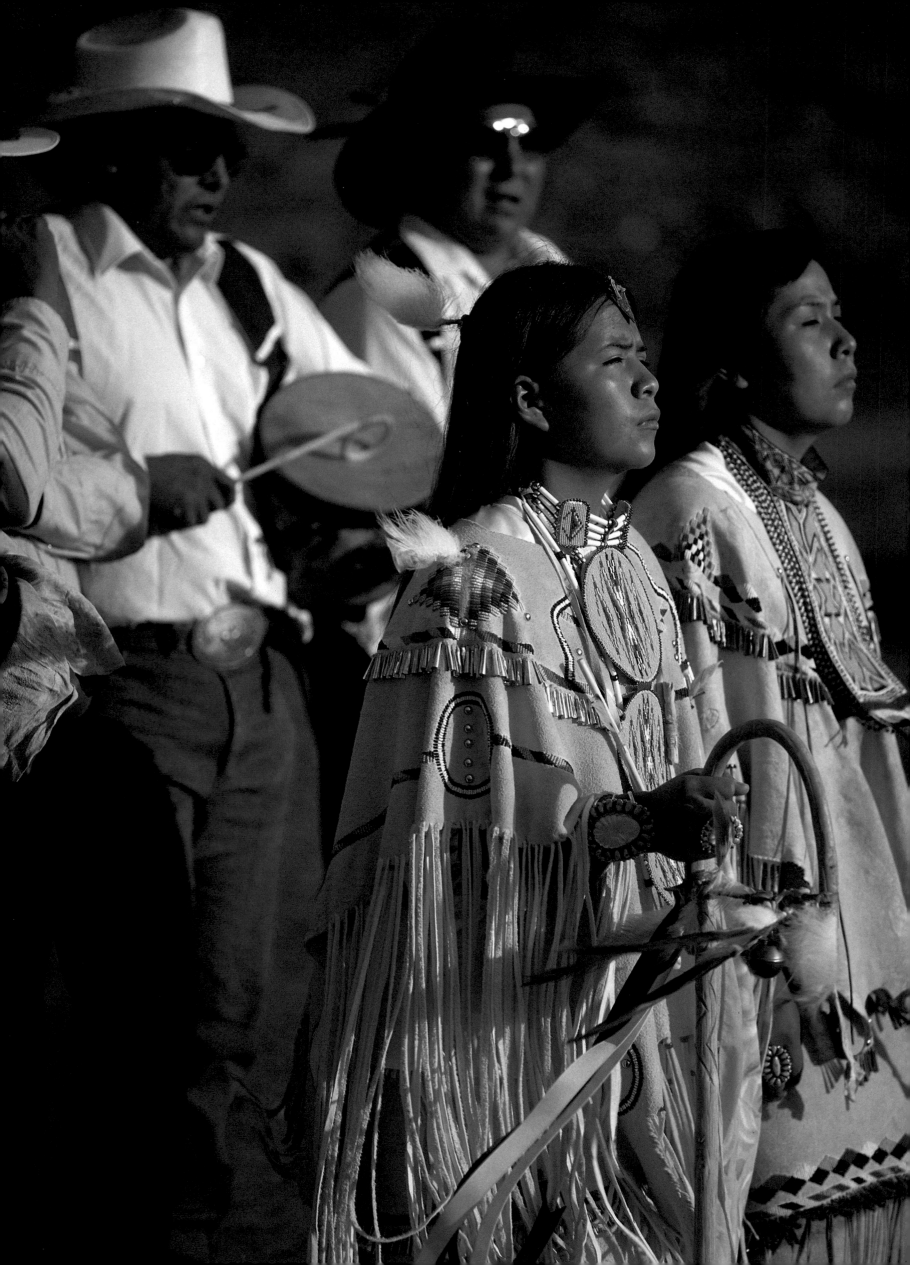

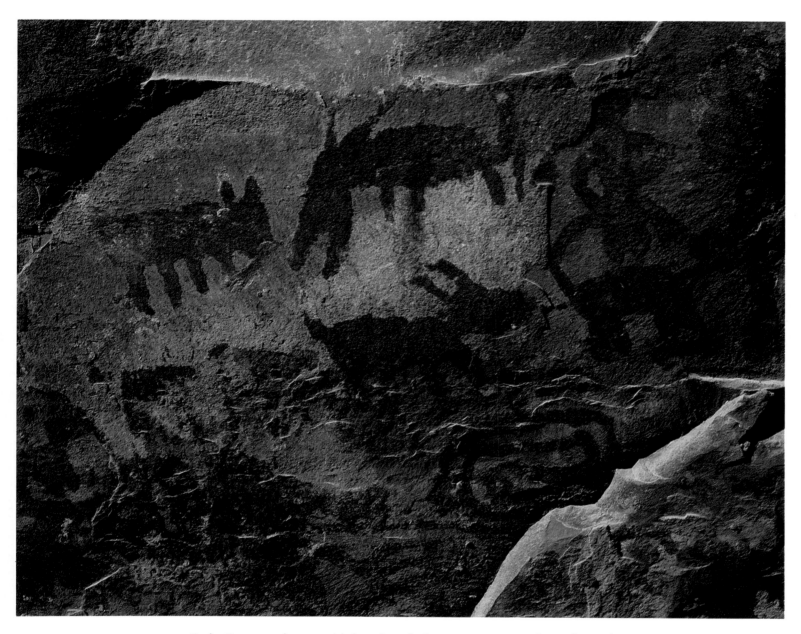

◄ Carla Goseyun dances with her sister before singers at a traditional Apache Sunrise Ceremony in Whiteriver. The four-day ceremony will bring eleven-year-old Carla into womanhood. ▲ Near Palatki Ruin in the Red Rocks area of Coconino National Forest, Southern Sinagua pictographs peer across centuries.

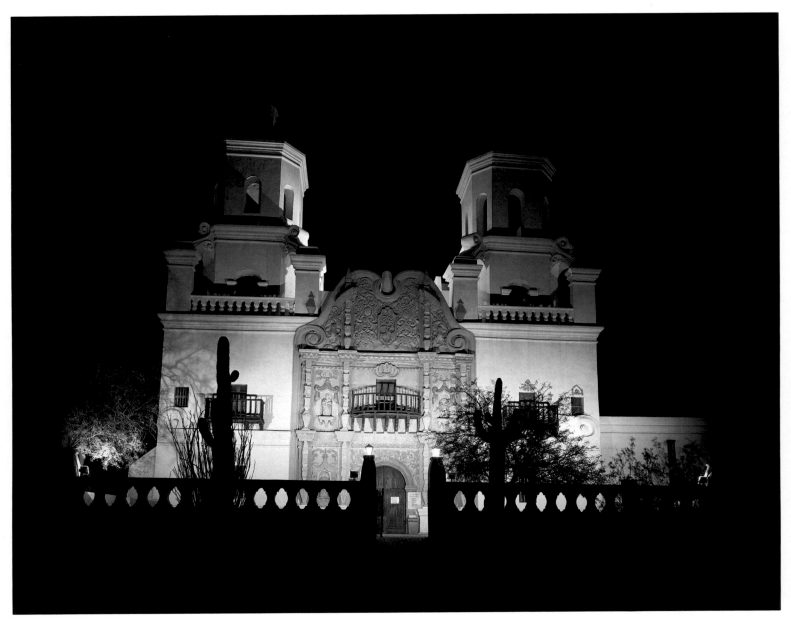

▲ Acclaimed as the finest example of mission architecture in the United States, Mission San Xavier del Bac was constructed by the Sons of St. Francis of Assisi in the late eighteenth century. ▶ Luminarios outline the two-hundred-year-old Tumacacori Mission on Christmas Eve. The lighting of the luminarios is a Southwest tradition that has been continued by the National Park Service.

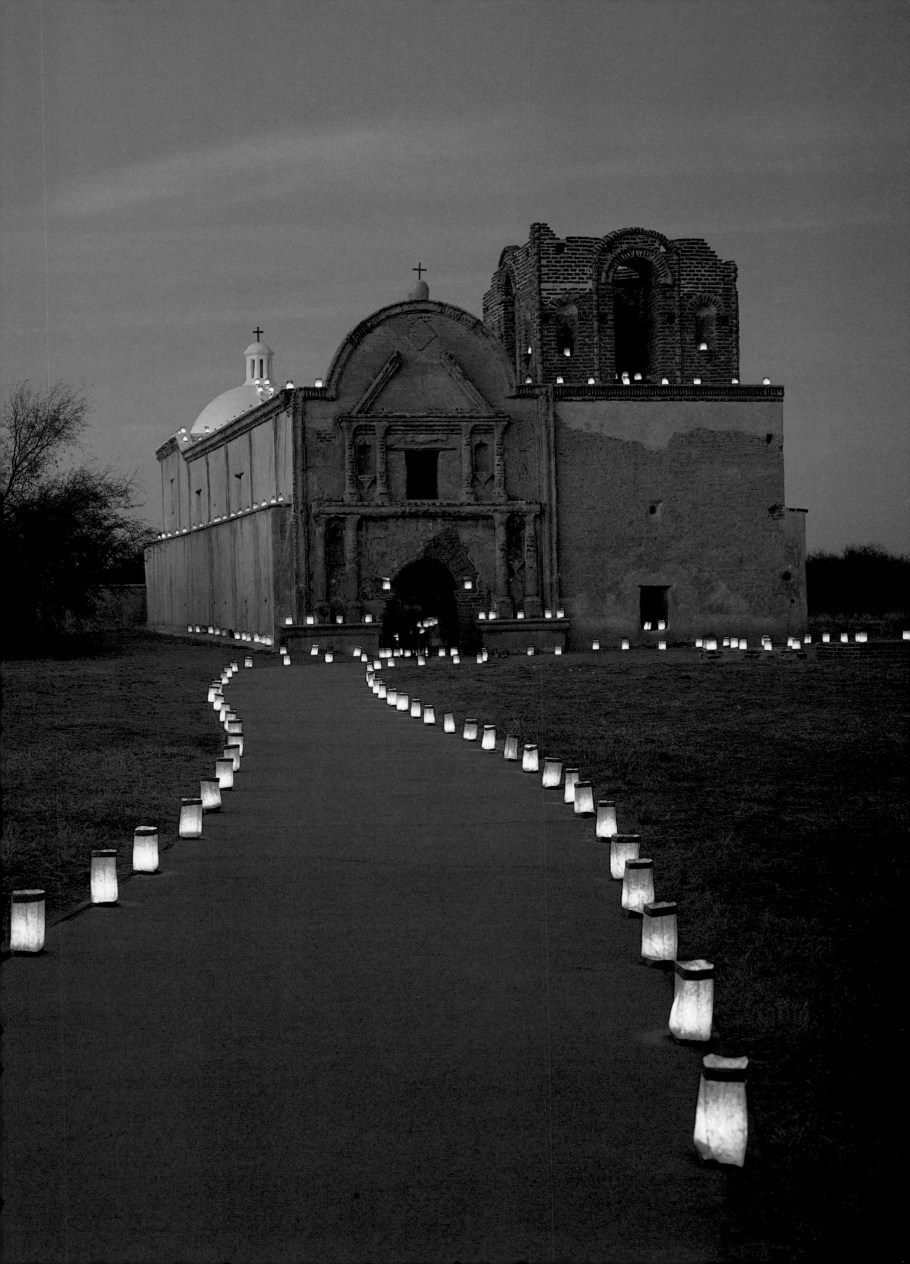

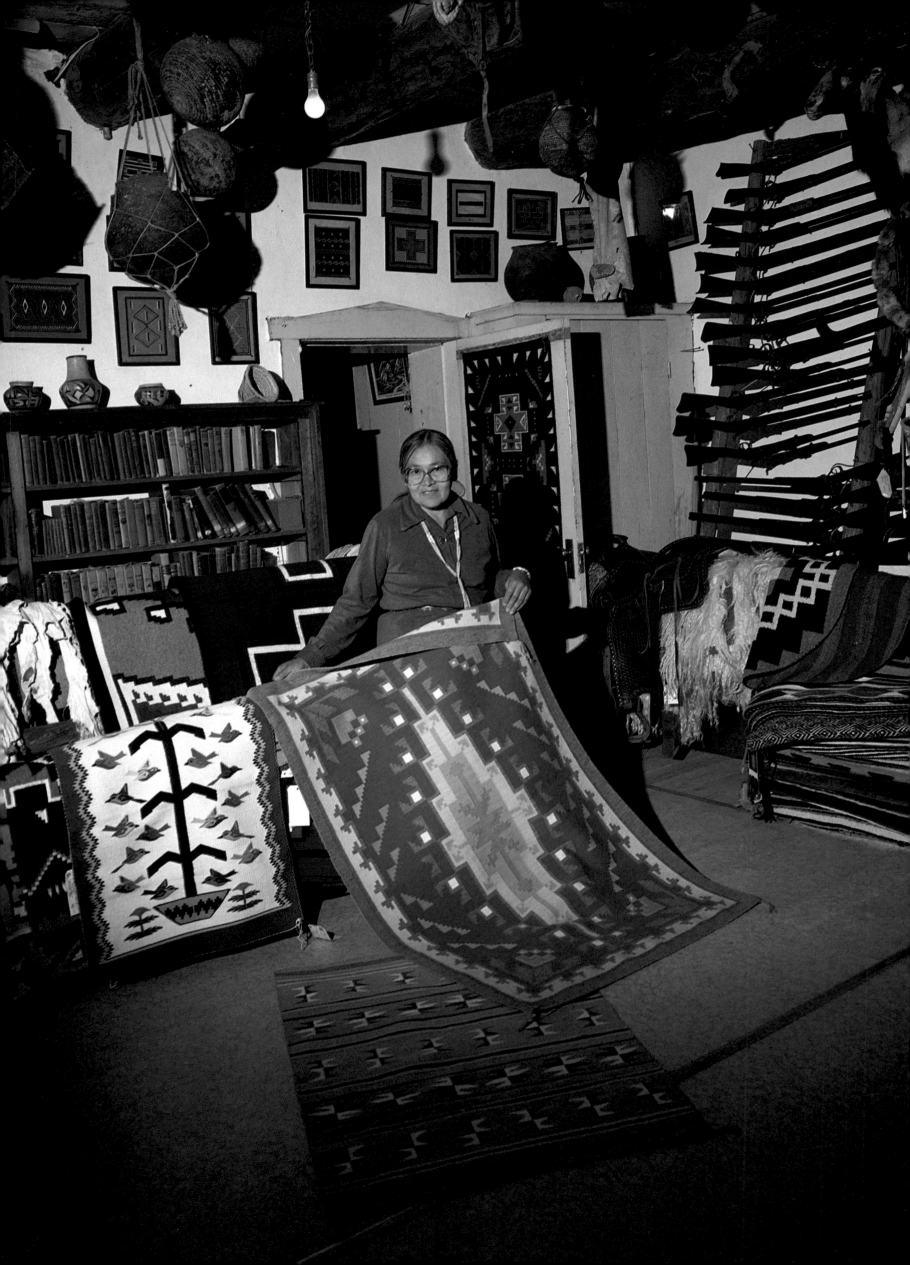

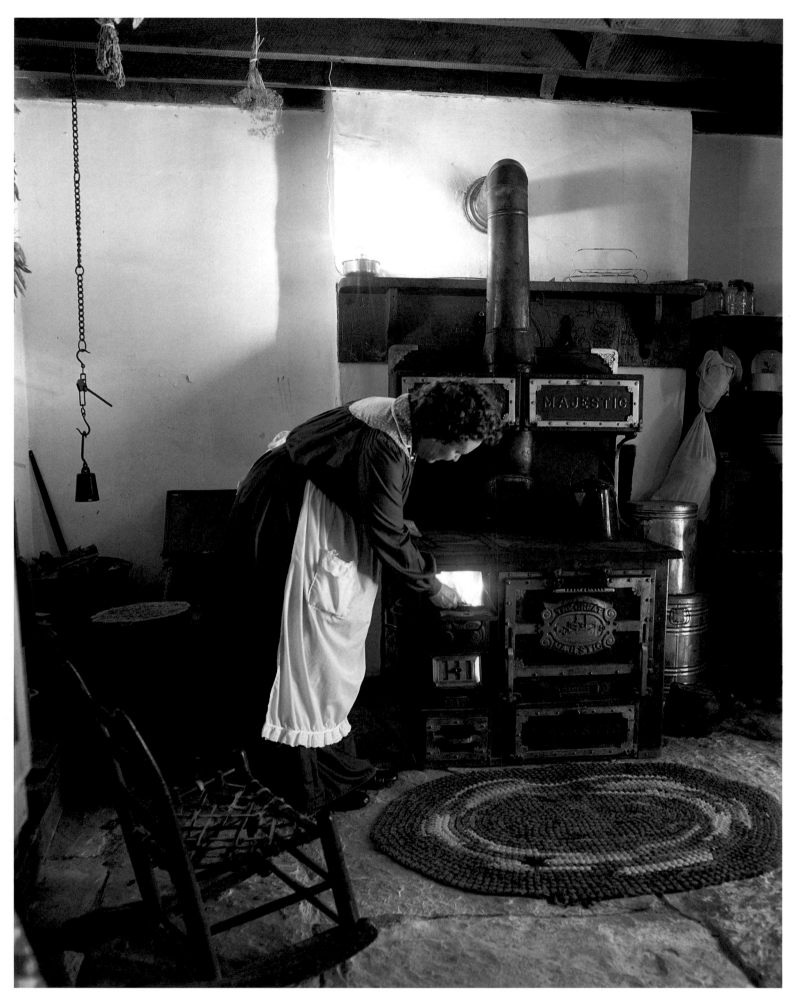

◄ Mary Lee Begay displays vegetable-dye rugs at Hubbell Trading Post. People from around the world visit this National Historic Site to buy Native American art and learn of Navajo life. ▲ Yvonne Heaton bakes cookies in Winsor Castle as she gives a Mormon living-history talk at Pipe Springs National Monument.

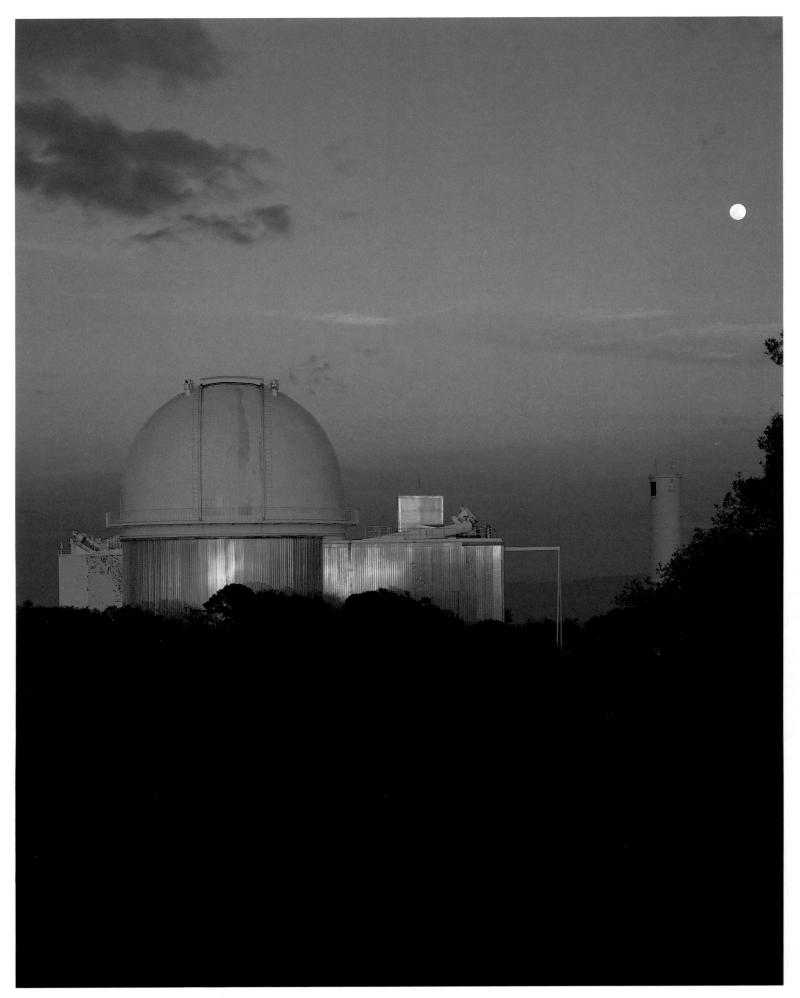

▲ The moon rises above 6,875-foot Kitt Peak as the setting sun illuminates the 2.1-meter telescope dome. Kitt Peak National Observatory houses the world's largest collection of telescopes. Good air quality, few cloudy nights, high elevation, and little surrounding light pollution make Kitt Peak ideal for astronomy.

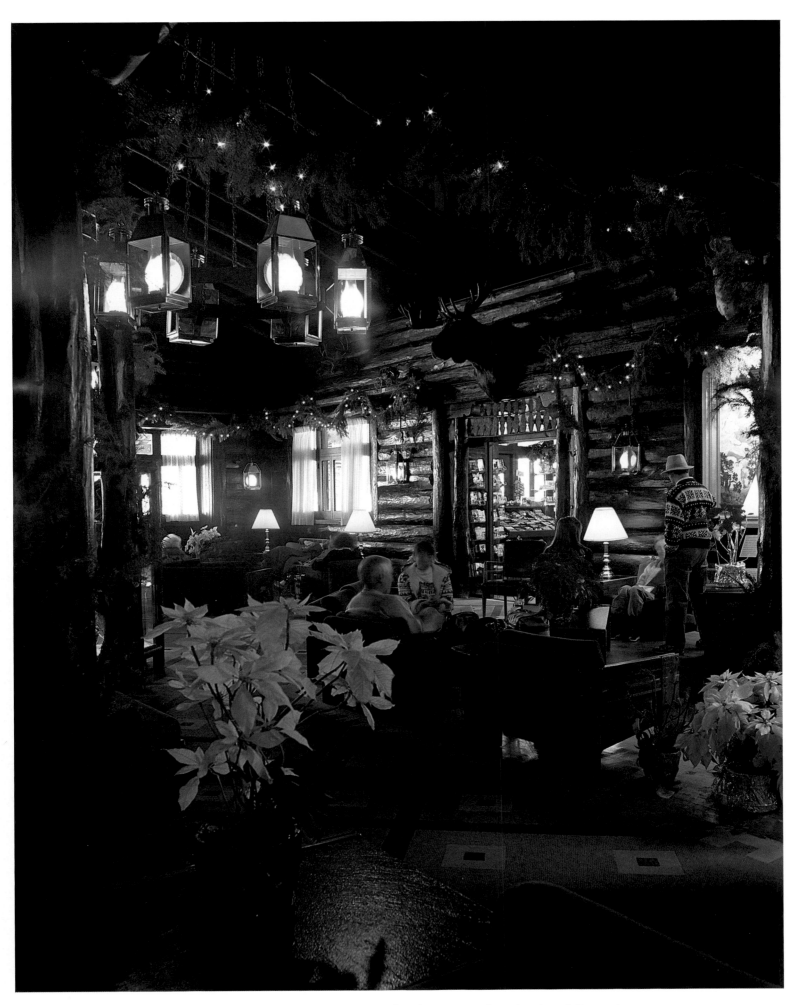

▲ Holiday decorations bring cheer to the El Tovar Hotel on the Grand Canyon's South Rim. Completed in 1905, the El Tovar was constructed from local stone and Douglas fir logs from Oregon. The canyon's South Rim remains open all year, whereas snow typically closes the North Rim from October through mid-May.

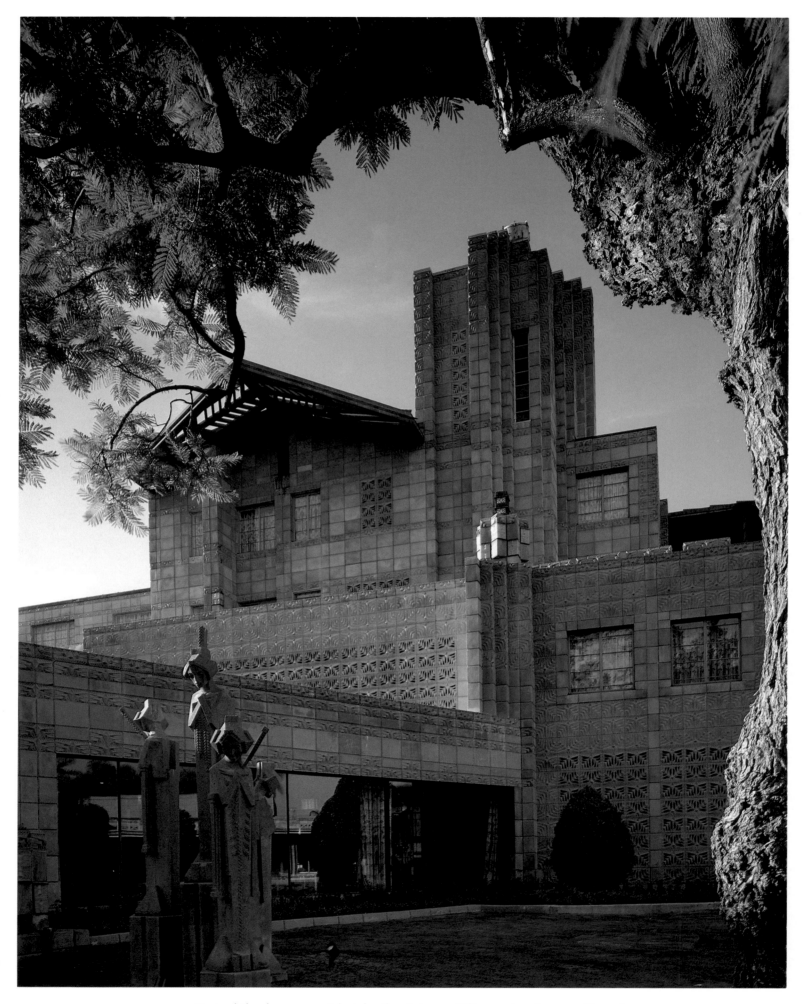

▲ First of the large resort hotels, the Arizona Biltmore has been a Phoenix landmark since it was built in 1928 by Albert Chase McArthur, with Frank Lloyd Wright's assistance in design. During the Depression, it was sold to the Wrigleys.
► A downtown Tucson landmark, St. Augustine Cathedral was begun in 1896.

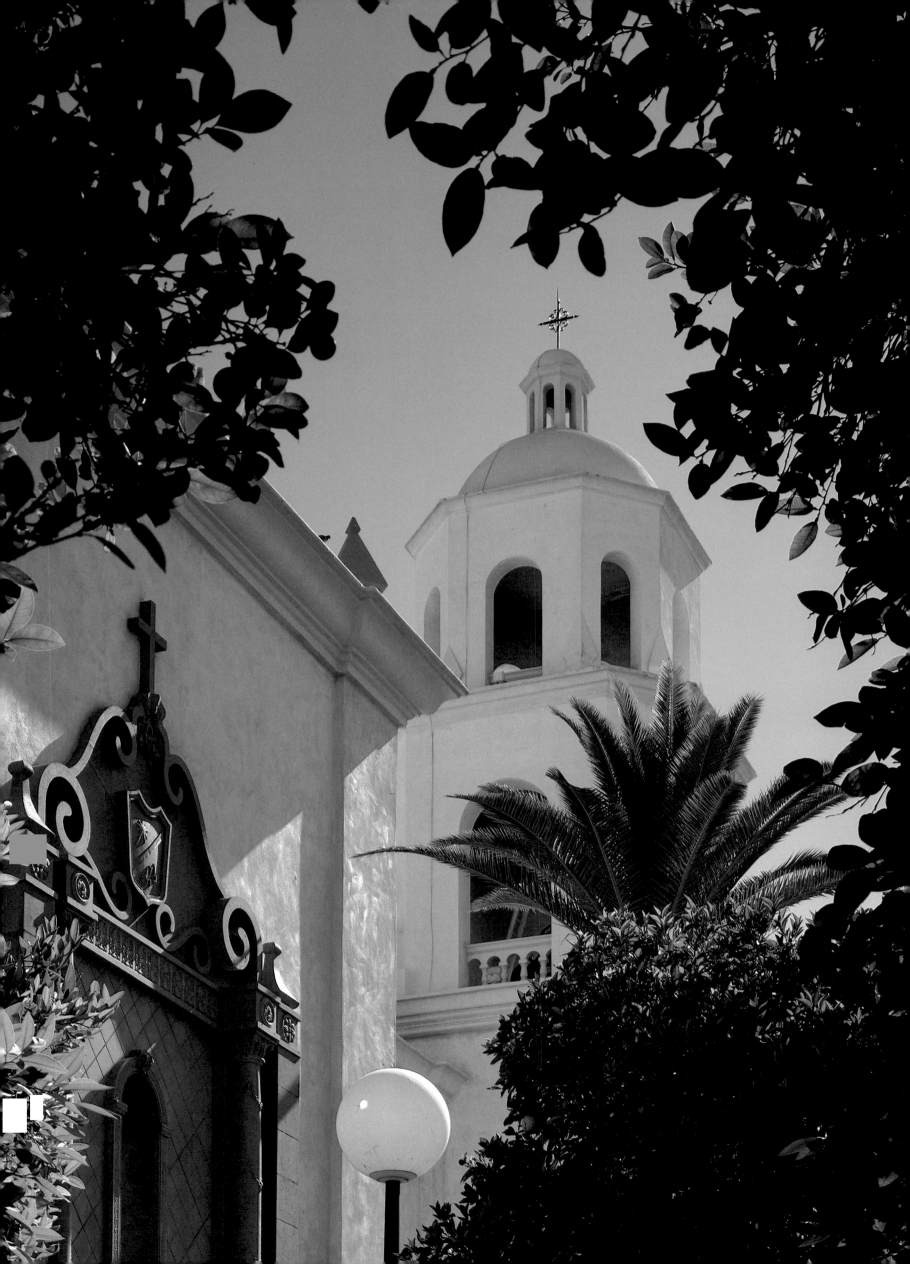

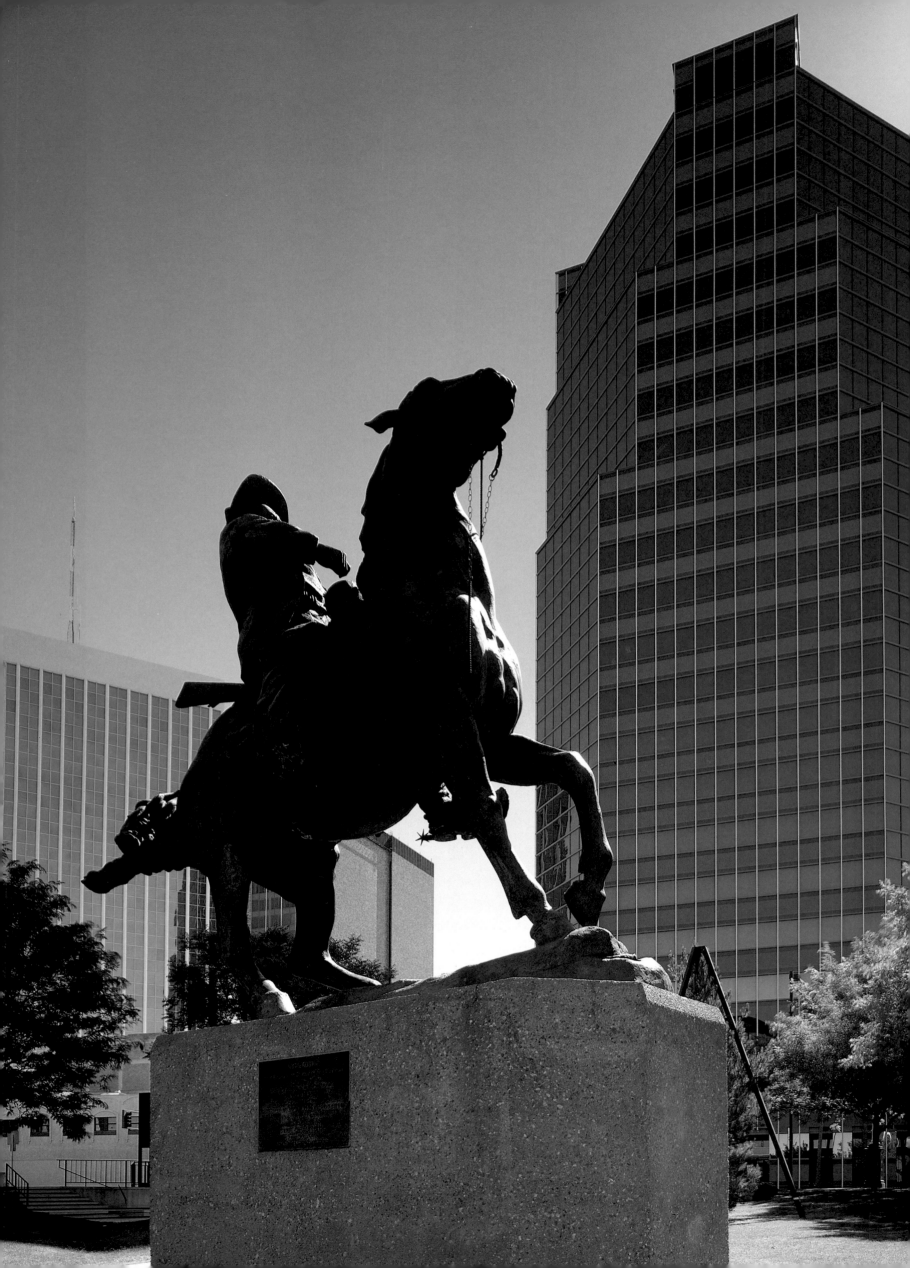

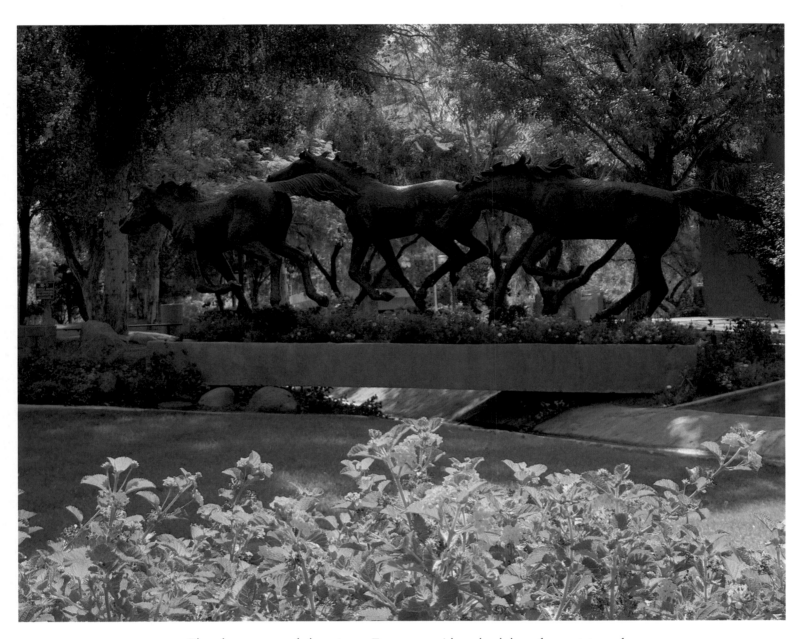

◄ The skyscrapers of downtown Tucson provide a backdrop for a statue of General Francisco Villa. Titled "In Friendship," this piece was given to the state of Arizona by the president of Mexico. ▲ Another statue, appearing to gallop through the Civic Center Mall in Scottsdale, is entitled "The Yearlings." This beautiful outdoor mall was created as part of an urban renewal project.

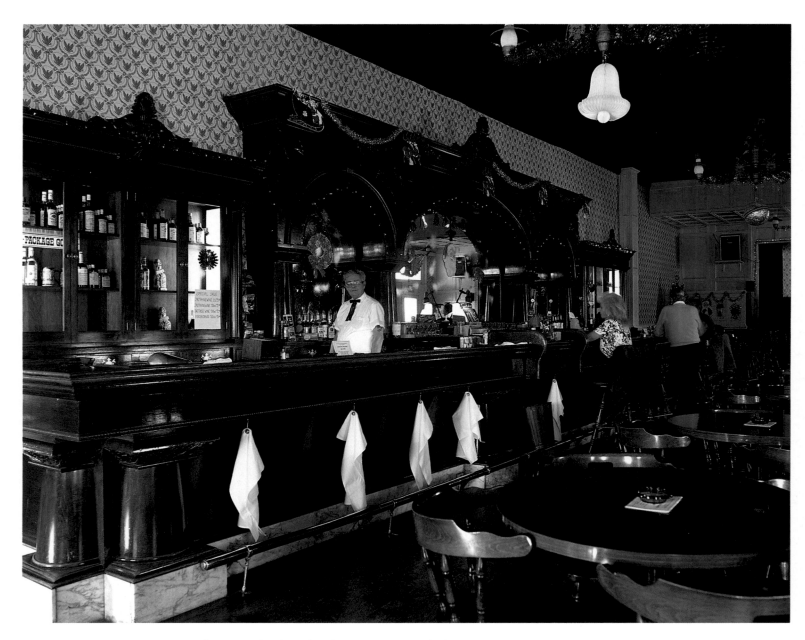

▲ The Crystal Palace has been a watering hole in Tombstone since 1880. The history of Tombstone is steeped in the rough-and-tumble life of a frontier silver and gold mining town. ▶ A windmill stands before the Dragoon Mountains. Access to water for livestock is a must for maintaining a successful ranch.

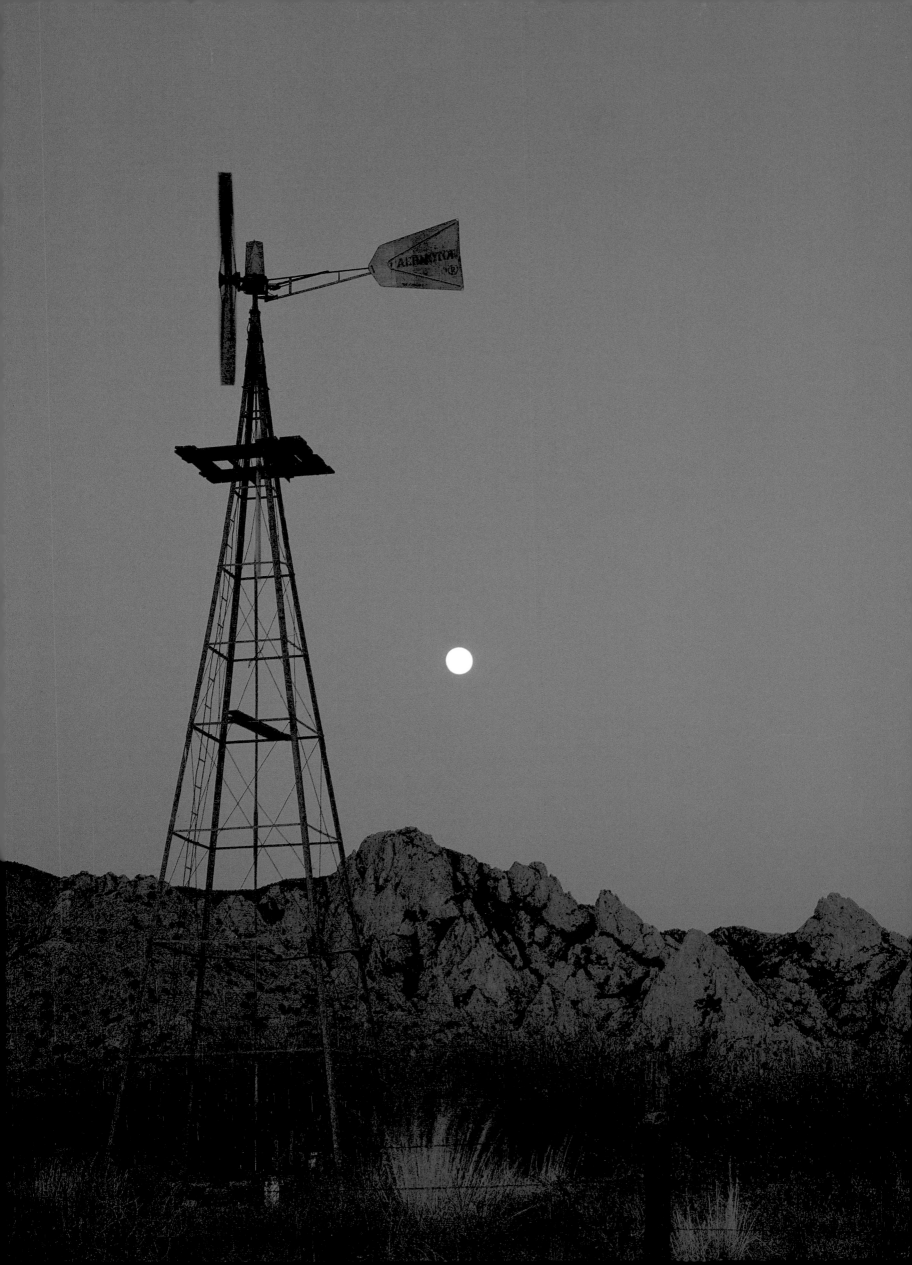

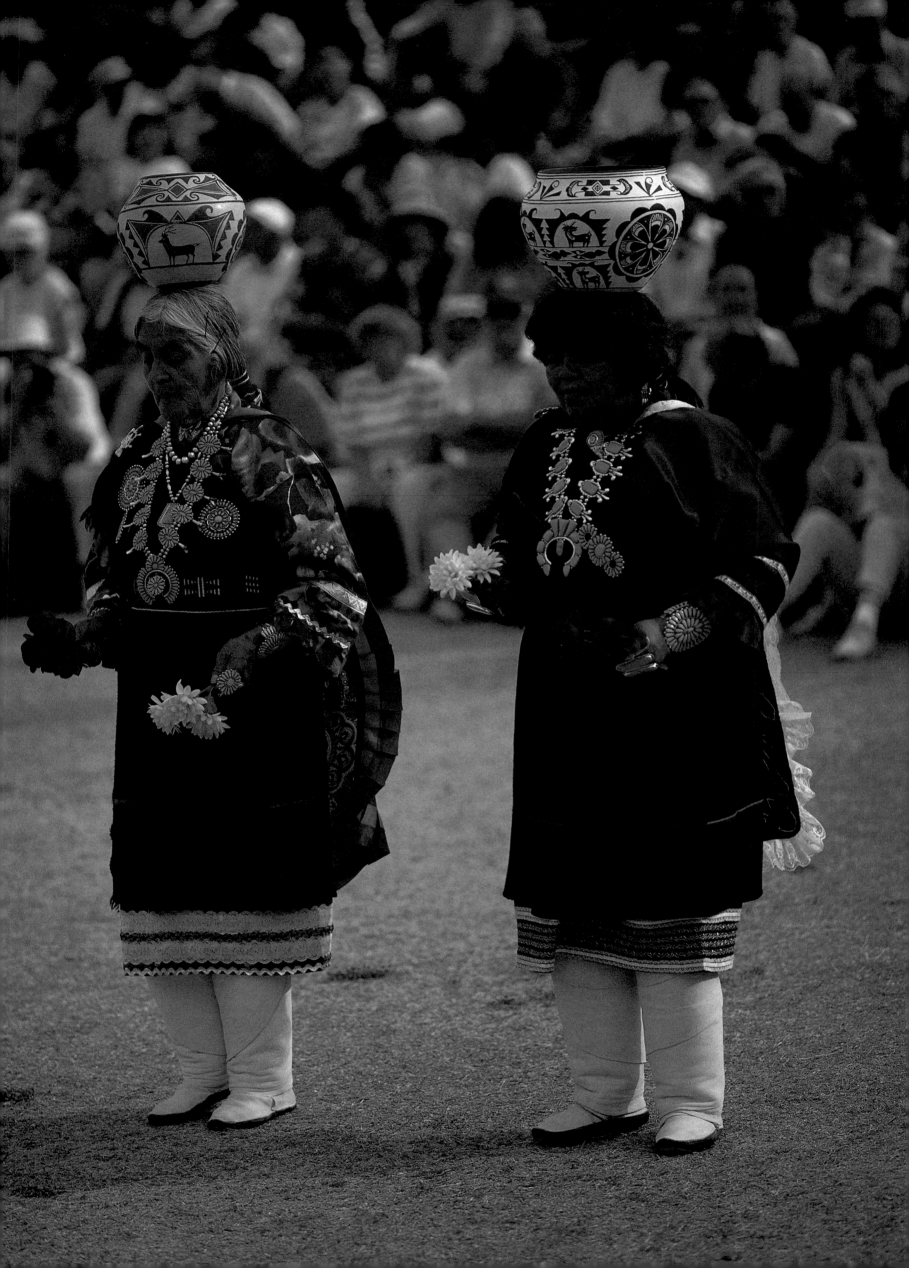

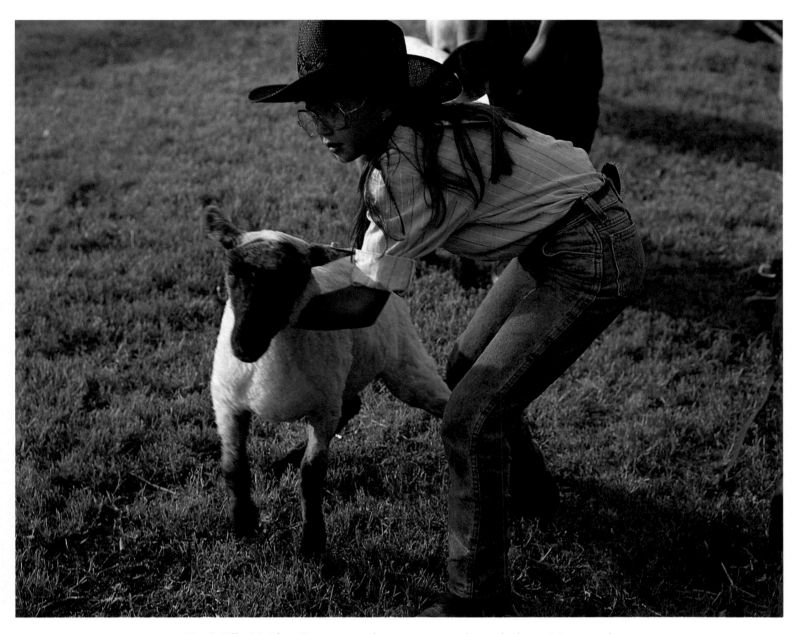

◄ Zuni Olla Maiden Dancers perform a pottery dance before visitors at the Heard Museum Guild Native American Fair in Phoenix. The Heard houses one of the finest collections of Native American art and artifacts in North America.
▲ Four-H Club members exhibit lambs at the Navajo County Fair in Holbrook.

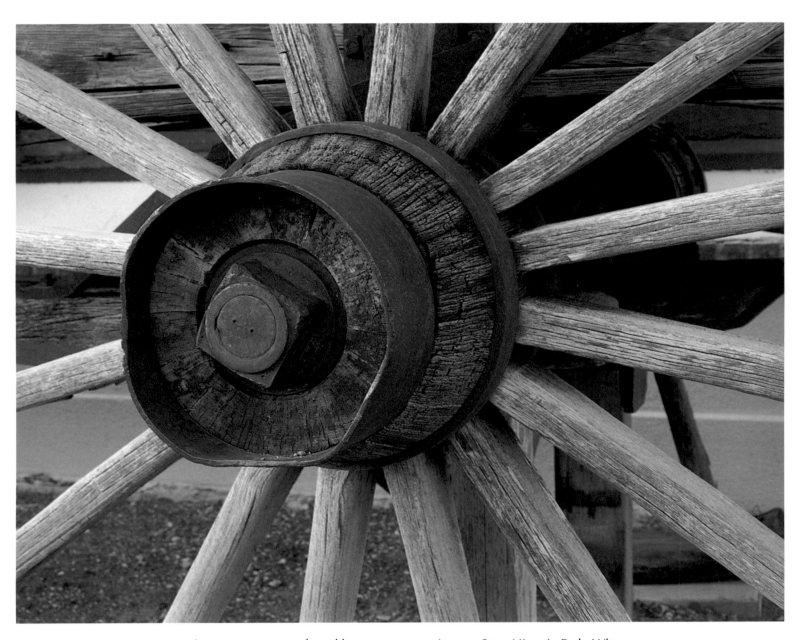

▲ An ore wagon, weathered by years, rests at Jerome State Historic Park. When Jerome hit its heyday in the early 1900s, the community was affectionately called "the billion-dollar copper camp." ▶ Irrigated farmlands appear to stretch to the horizon near Arizona City. Cotton is Arizona's most important commercial crop.

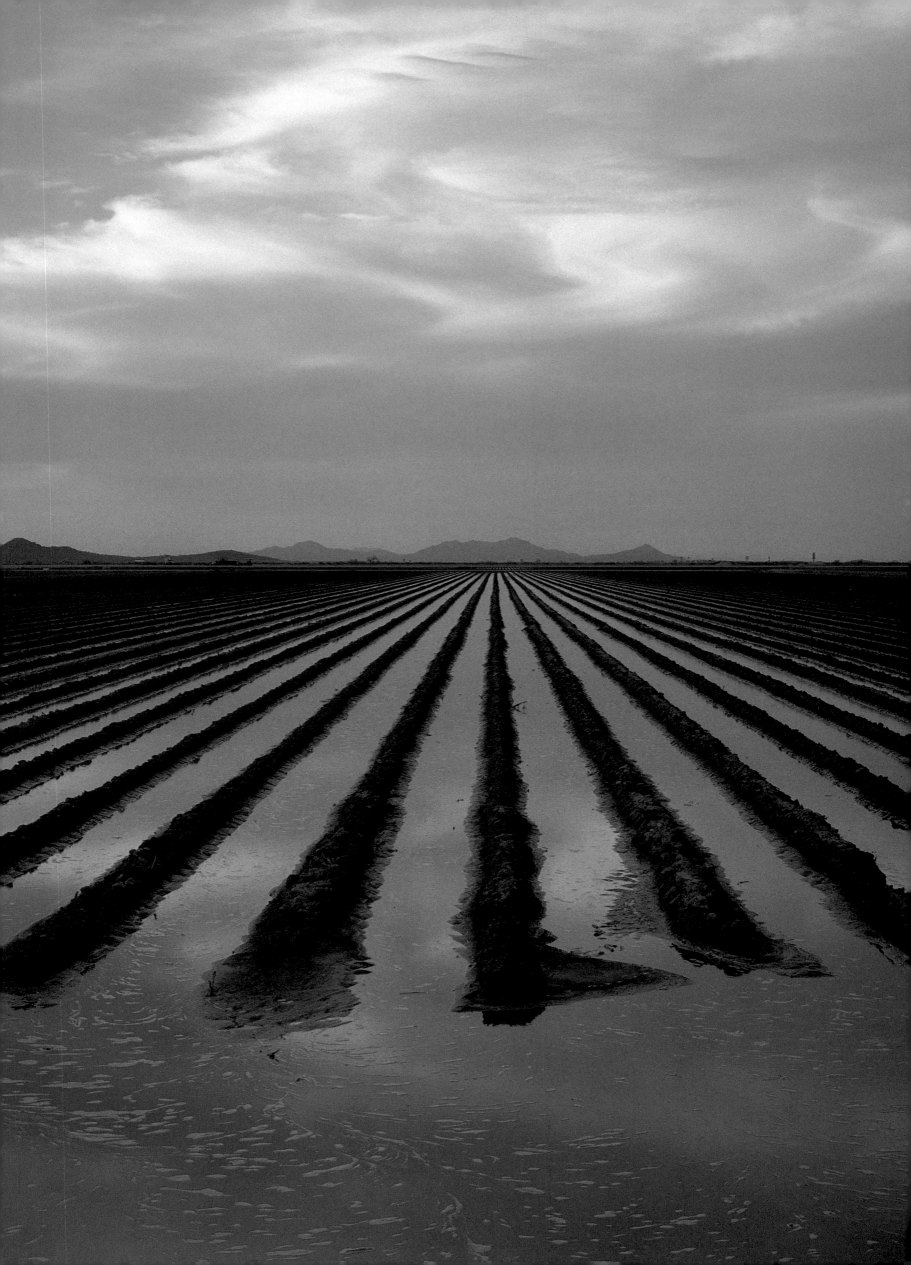

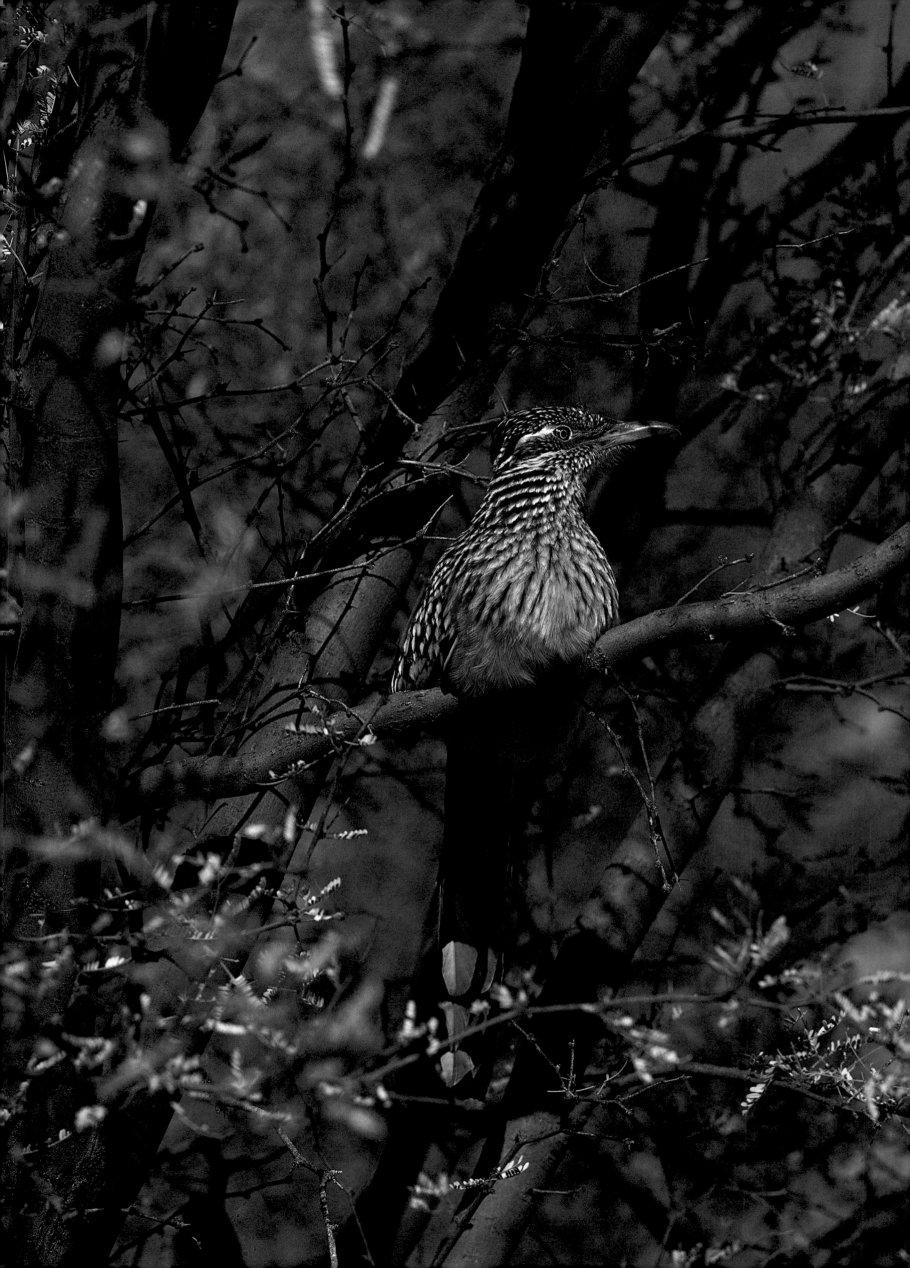

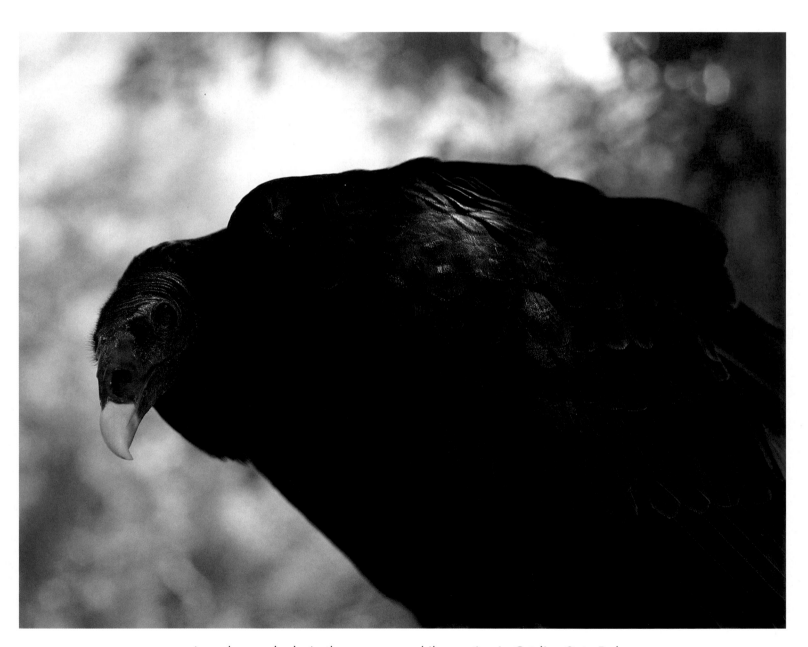

◄ A roadrunner basks in the warm sun while roosting in Catalina State Park.
▲ A turkey vulture watches over visitors during natural history talks by docents
at the Arizona-Sonora Desert Museum outside of Tucson. ► ► Cobbles that
have been evenly spaced over thousands of years create an interesting desert
pavement near Christmas Pass in the Cabeza Prieta National Wildlife Refuge.

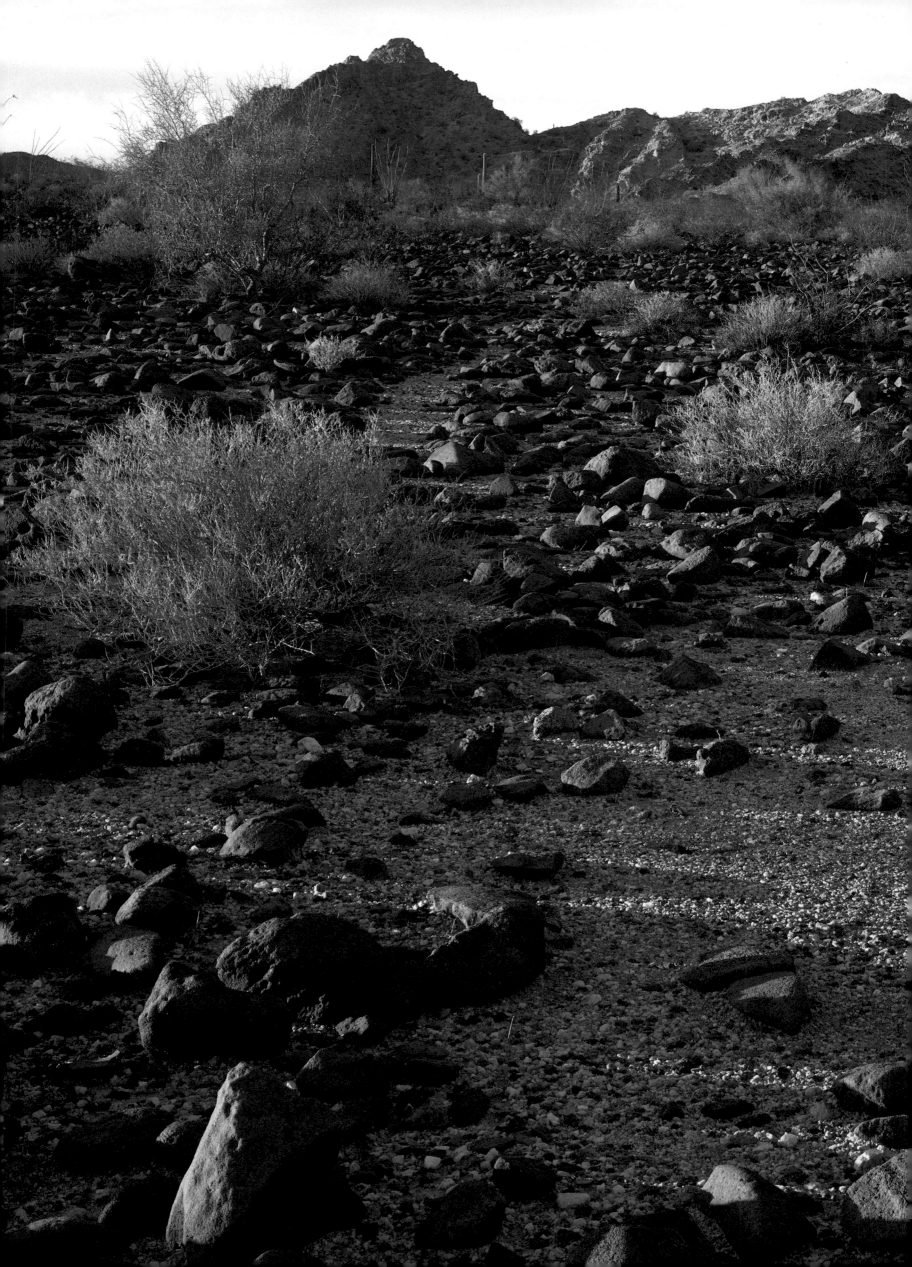

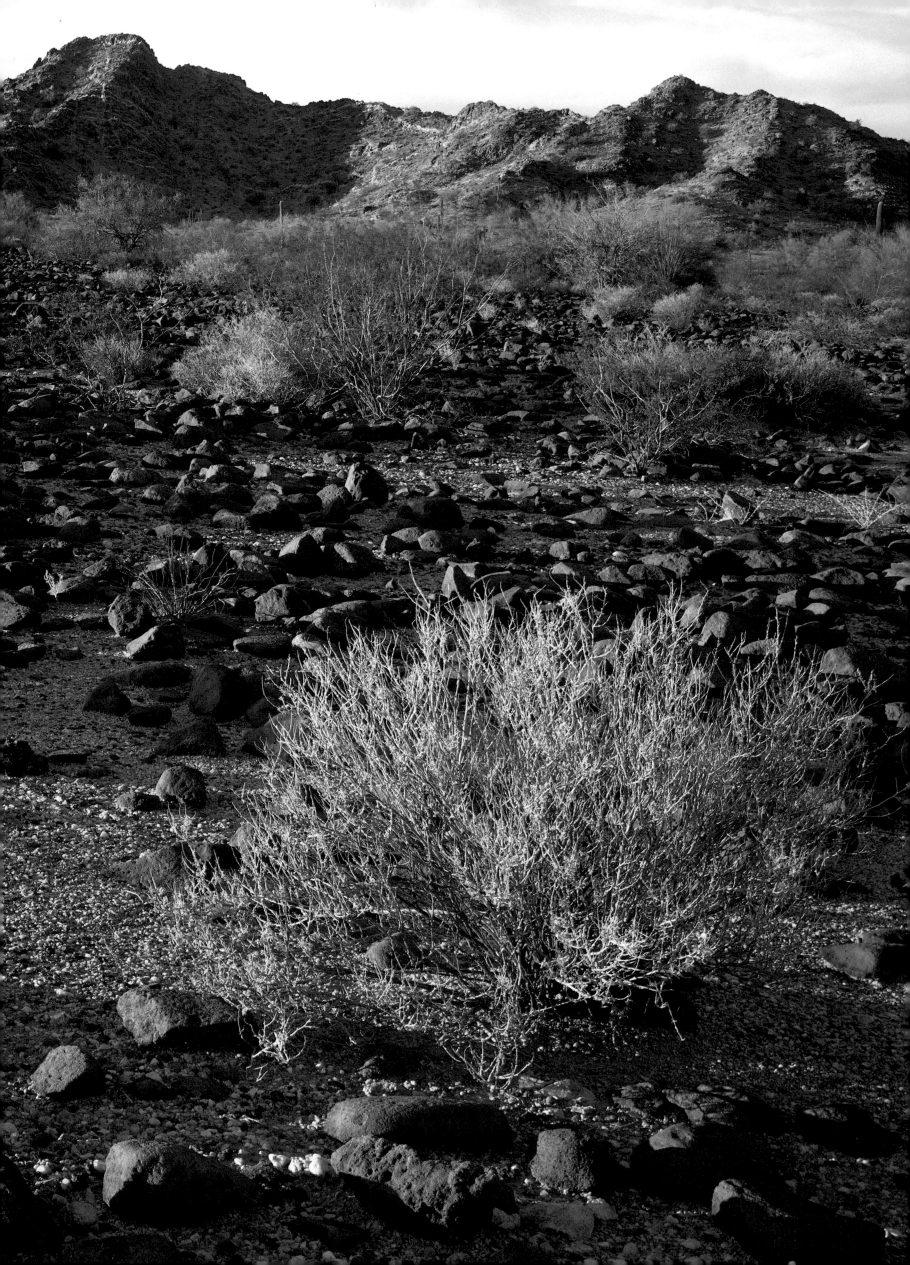

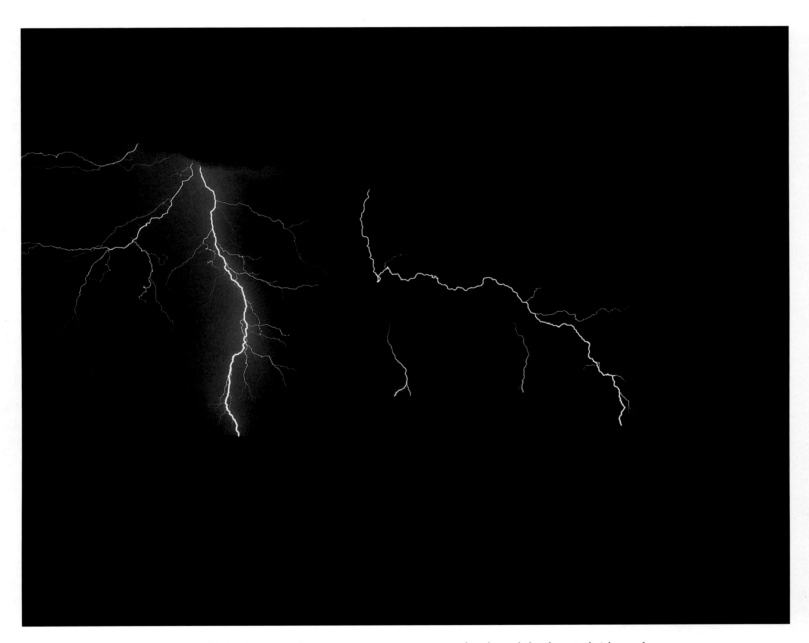

▲ Lightning races between summer monsoon clouds and the forested ridges of the Sierra Ancha Mountains. ▶ Brilliant blossoms of strawberry hedgehog cactus grace the Sonoran Desert in Organ Pipe Cactus National Monument. ▶ ▶ Oaks begin to turn golden brown during spring in the Atascosa Mountains. Coronado National Forest contains extensive, oak-covered hills north of Mexico.

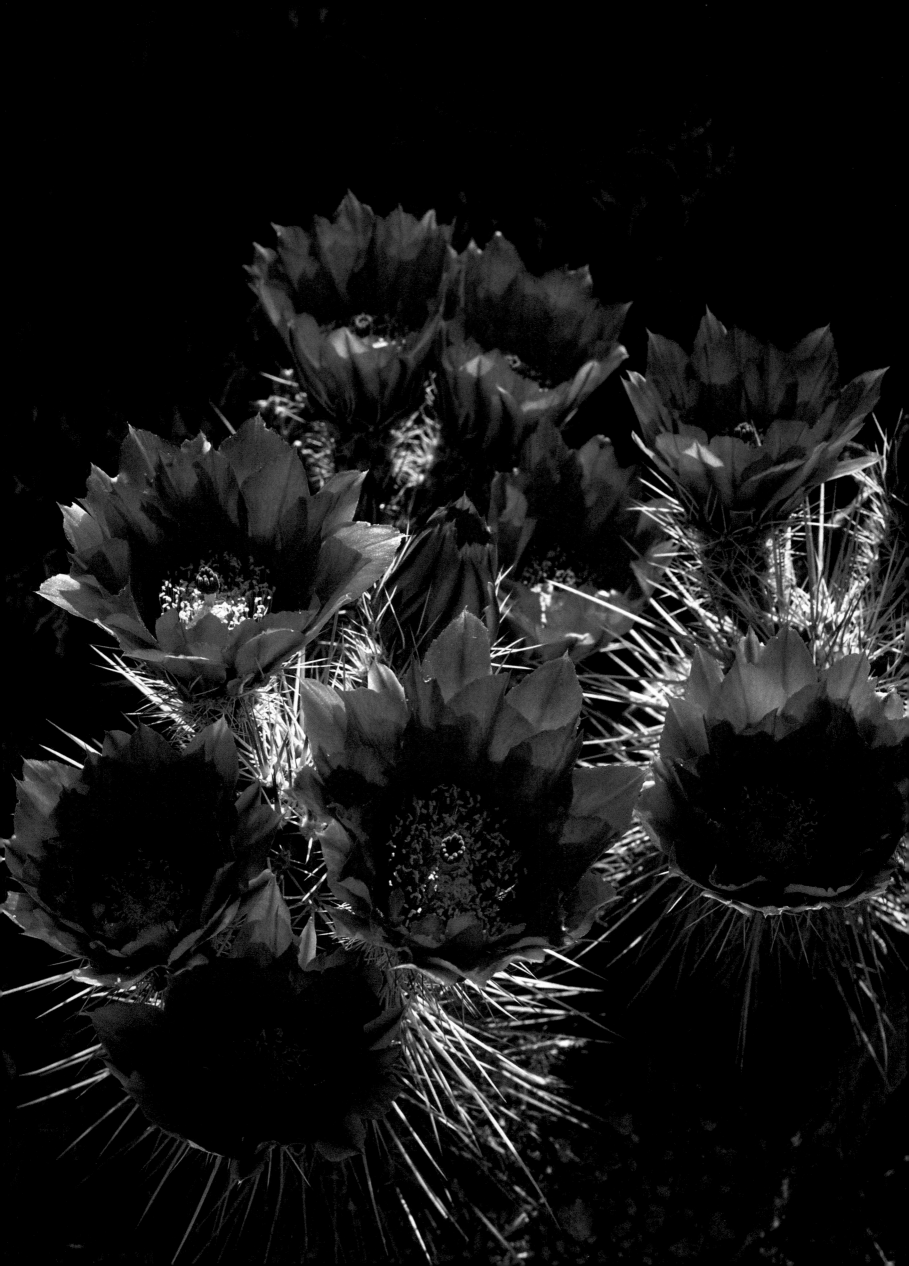

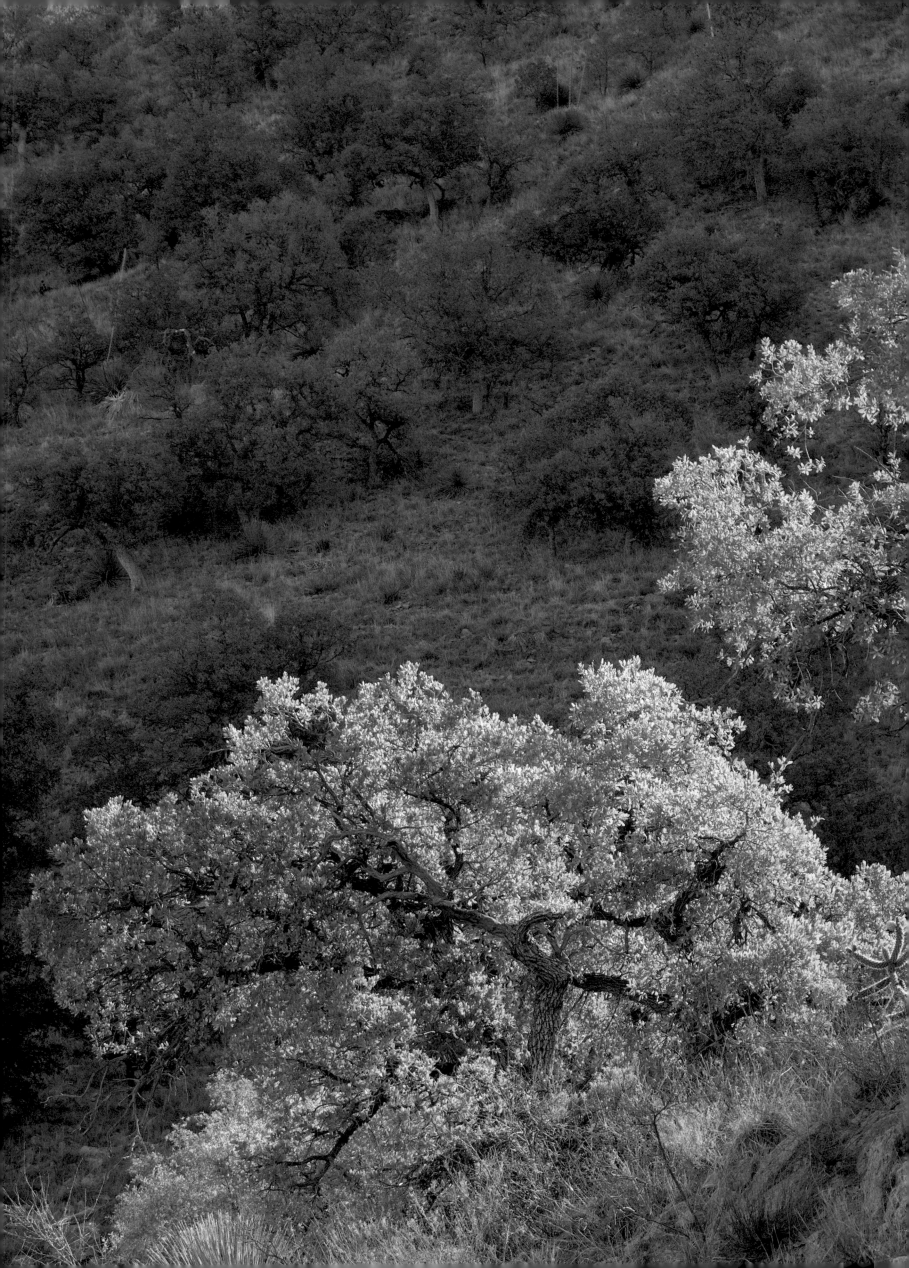

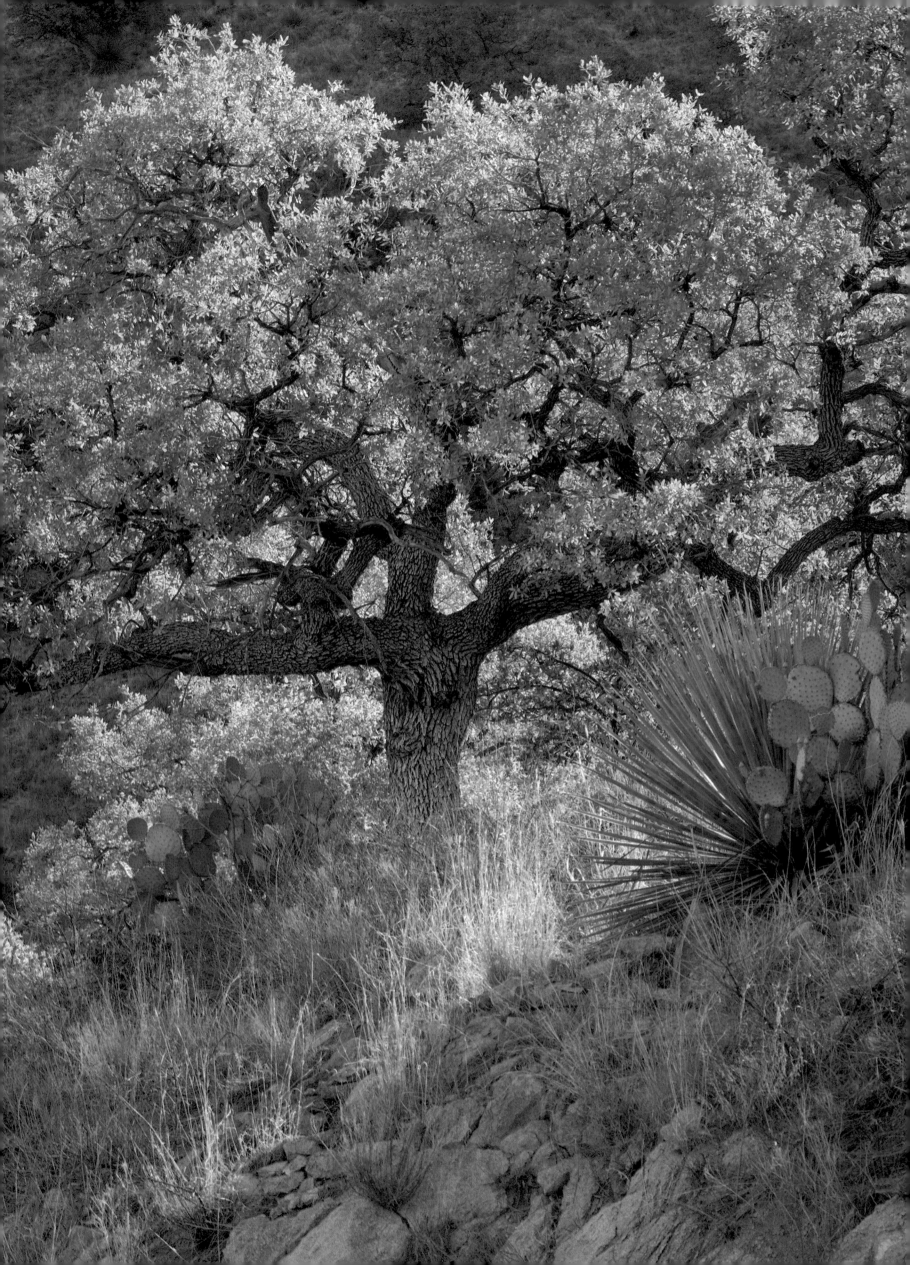

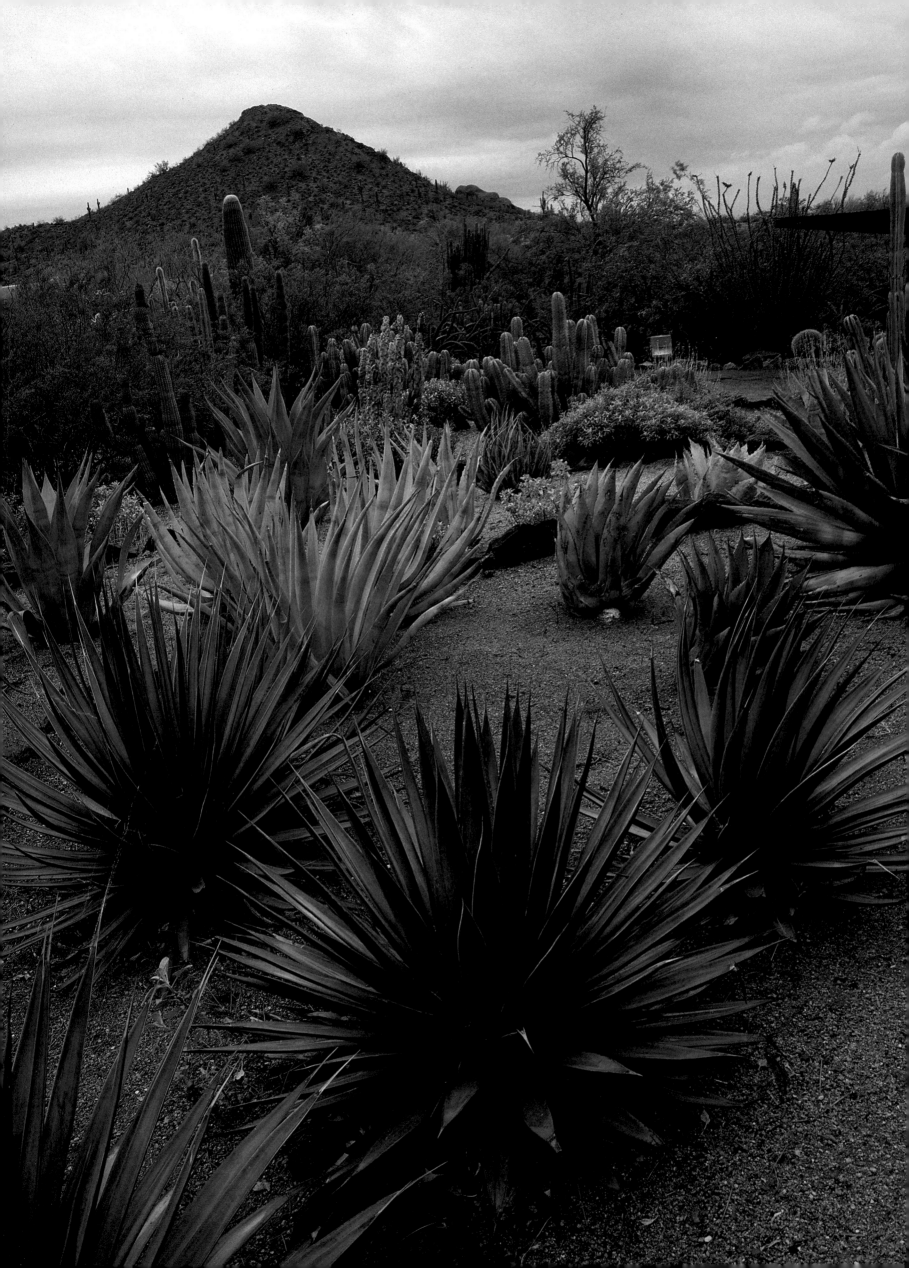

◄ Numerous species of agaves from Arizona and Mexico thrive at the Desert Botanical Garden in Phoenix. ▲ Sand verbena blossoms decorate Redfield Canyon in the Galiuro Mountains. Protection of riparian habitat in the Galiuro Mountains has become a prime concern of the Nature Conservancy of Arizona.

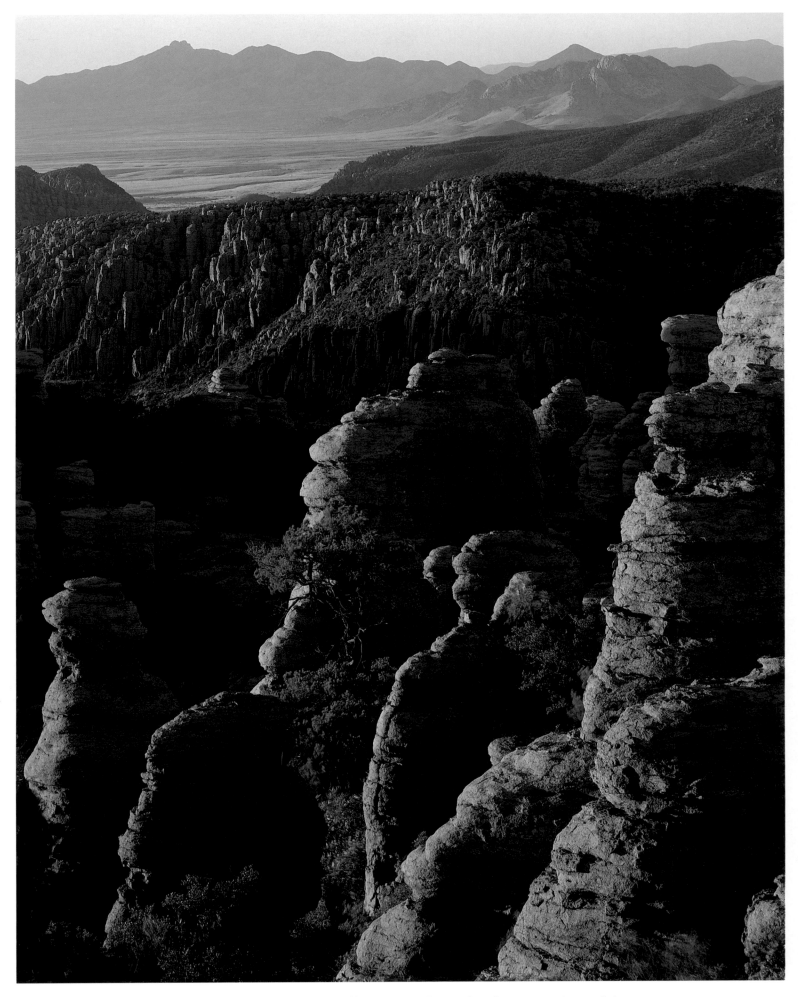

▲ The warm light of sunset illuminates volcanic hoodoos near Heart of the Rocks in Chiricahua National Monument. Geologists believe that about twenty-five million years ago violent eruptions from the nearby Turkey Creek Caldera spewed incandescent volcanic ash. This fused into a nearly two thousand-foot-thick layer of rhyolite from which the Chiricahua Mountains have eroded.

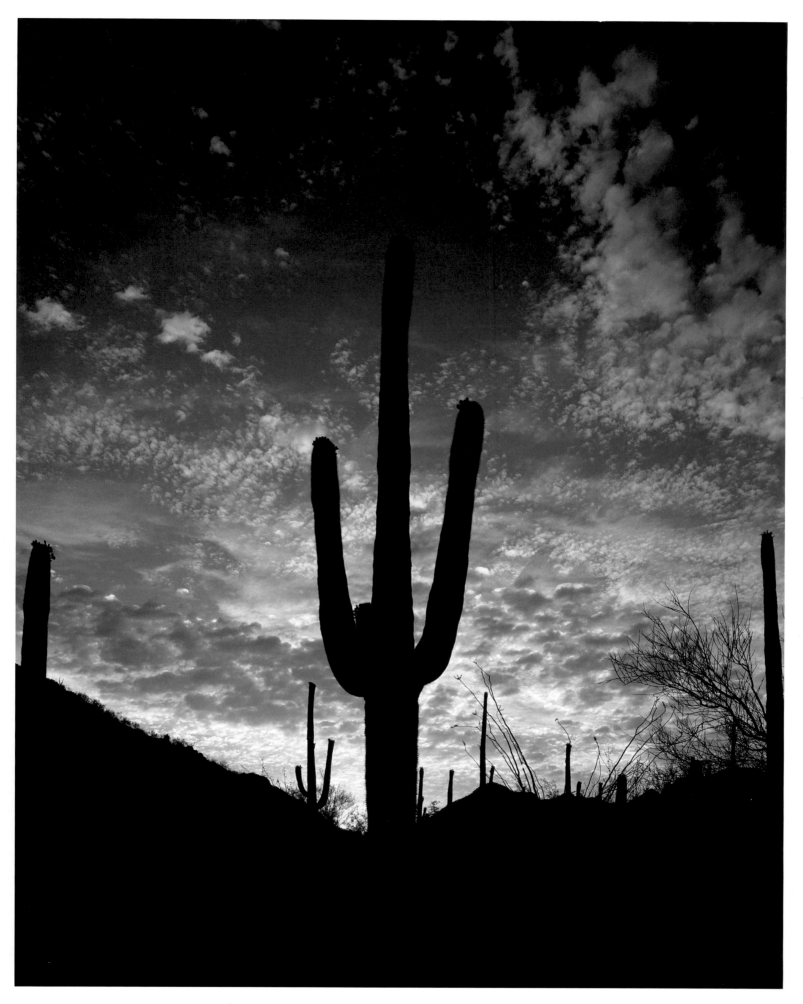

▲ A stately saguaro greets the morning sky in Saguaro National Park. This species of giant cacti is capable of reaching heights of up to fifty feet and may weigh more than nine tons. The saguaro's range stretches across southern Arizona, Sonora, and the extreme southwestern region of California. Its fleshy red fruits are relished by both birds and mammals — including humans.

▲ A shattered boulder of obsidian breccia rests on the floor of Aravaipa Canyon. Obsidian, or volcanic glass, forms when red-hot lava encounters cold water and then rapidly solidifies. This boulder, which crashed down from the steep slopes above, silently tells a partial story of the Galiuro Mountains' fiery volcanic past.

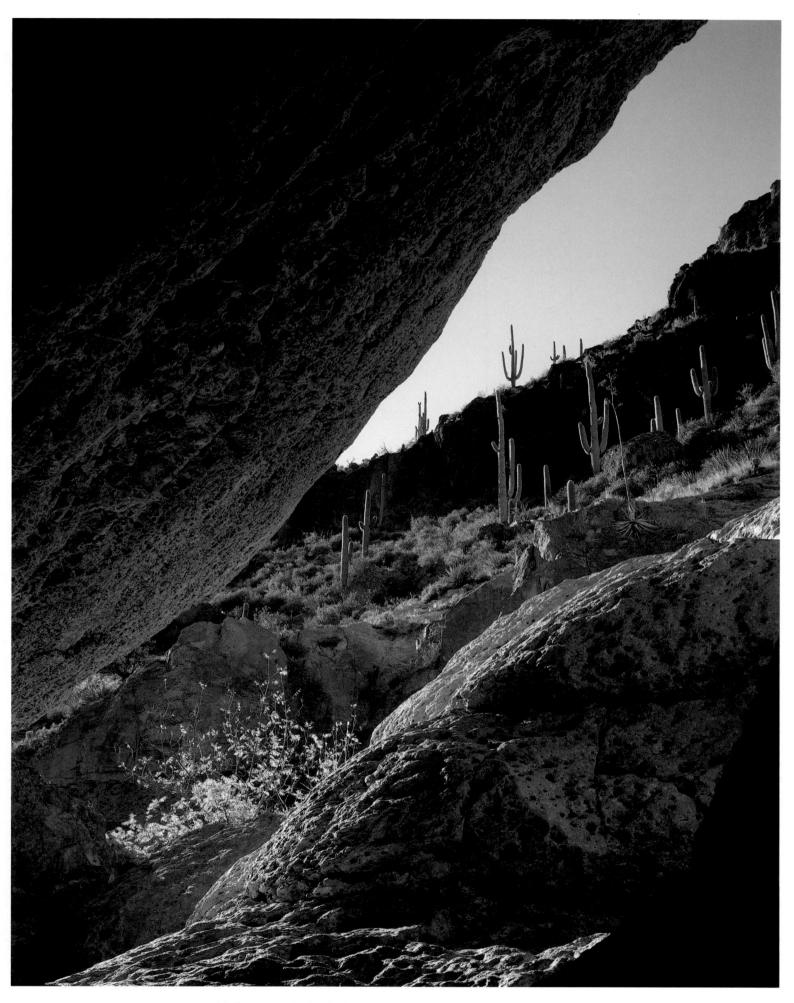

▲ A rockfall cave in the bed of Booger Creek frames saguaros in the Aravaipa Canyon Wilderness. ► ► A blazing sunset silhouettes saguaros in the Tucson Mountain Unit of Saguaro National Park. East and west of Tucson, the two units of the Saguaro National Park provide refuge from the bustling city.

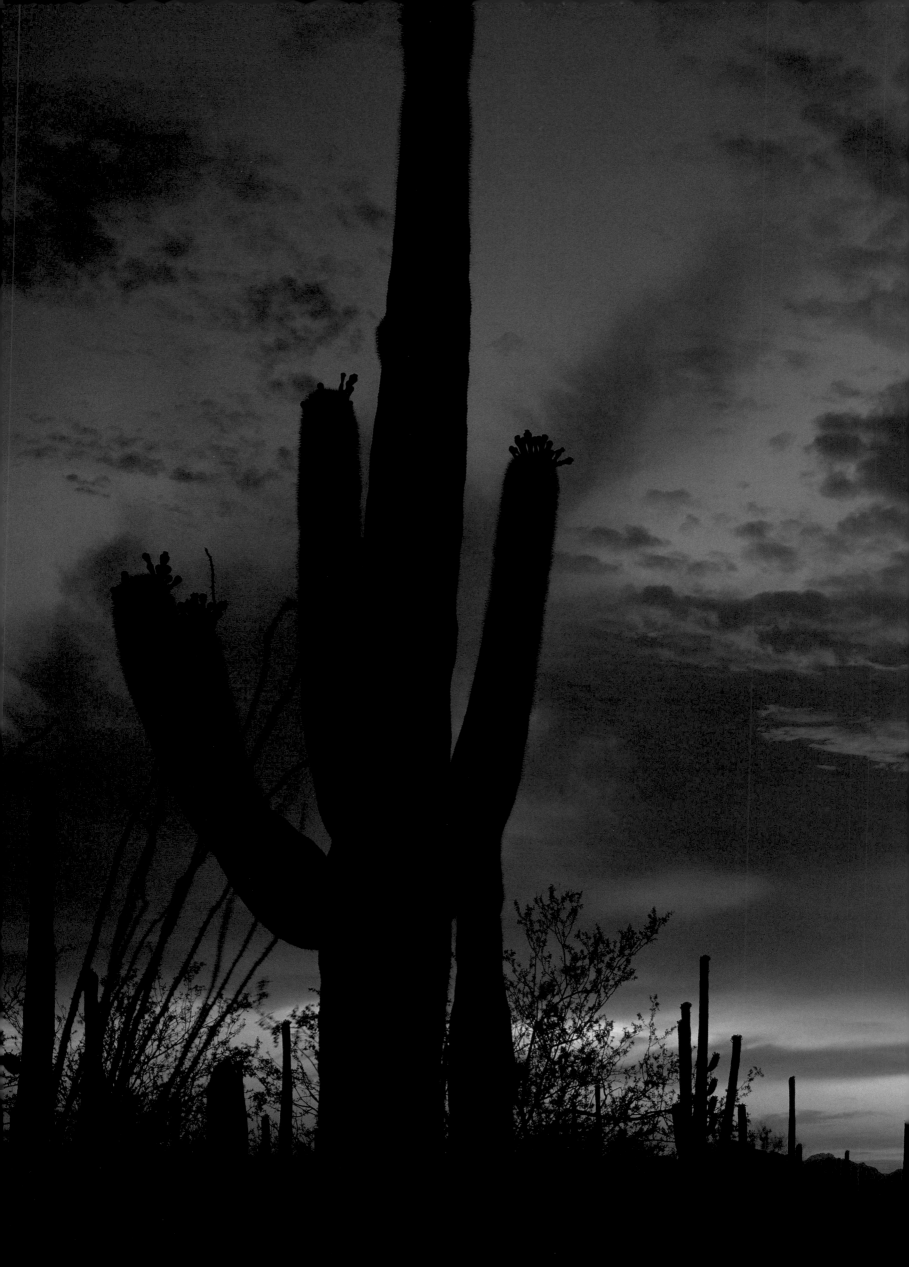

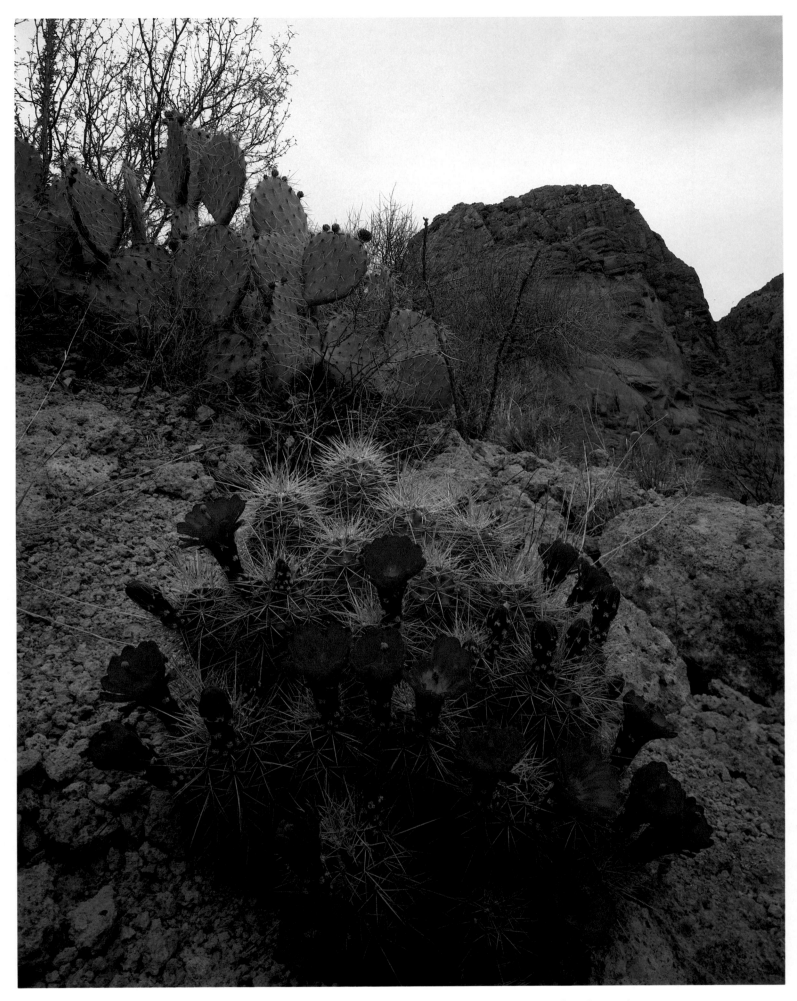

▲ A claretcup hedgehog cactus comes into full bloom on a rocky slope of Redfield Canyon. Hedgehogs are the earliest blooming cacti in Arizona, reaching the peak of their flowering season in April. ▶ Saguaros on the Tohono O'odham Reservation, may begin to bloom in April but they reach their peak in May.

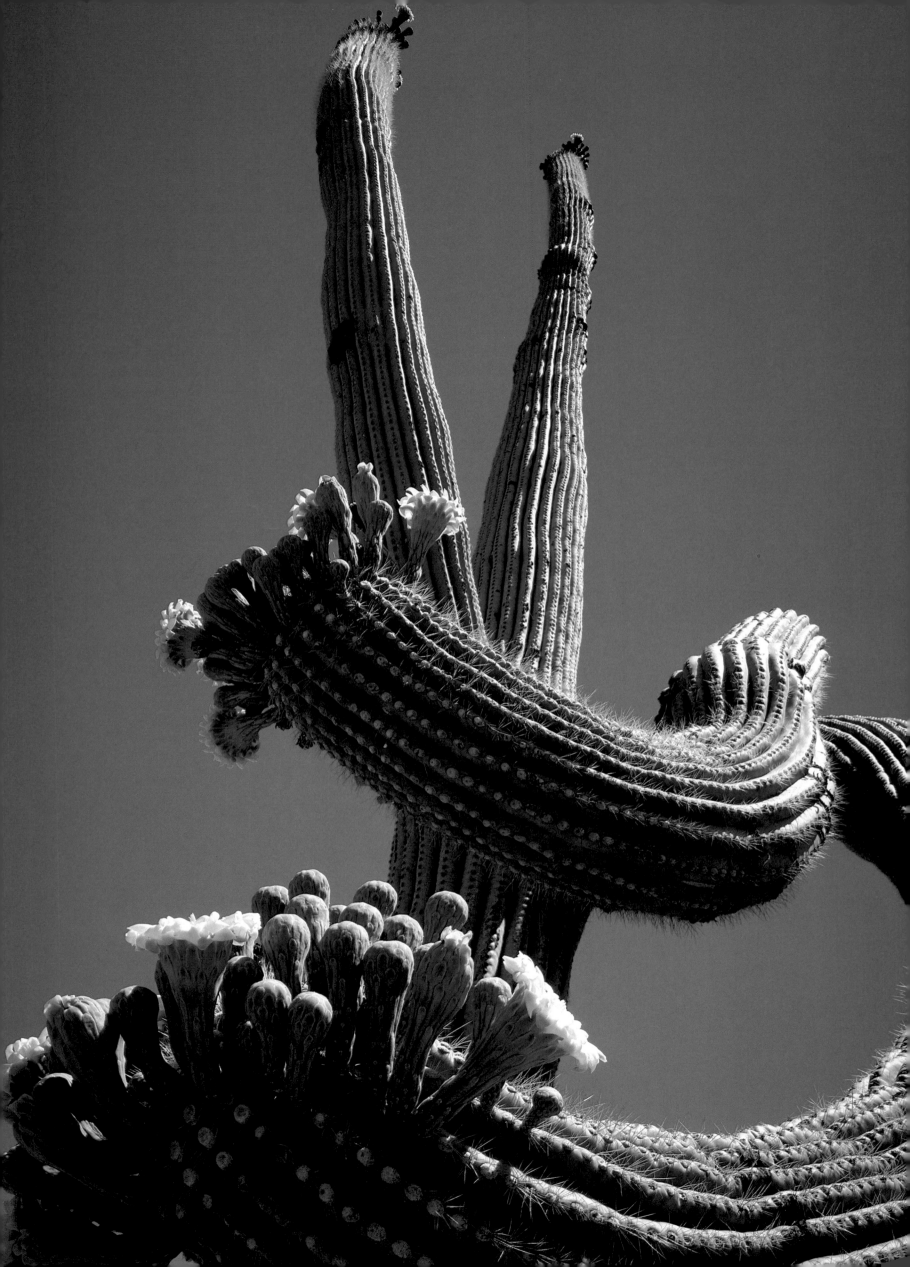

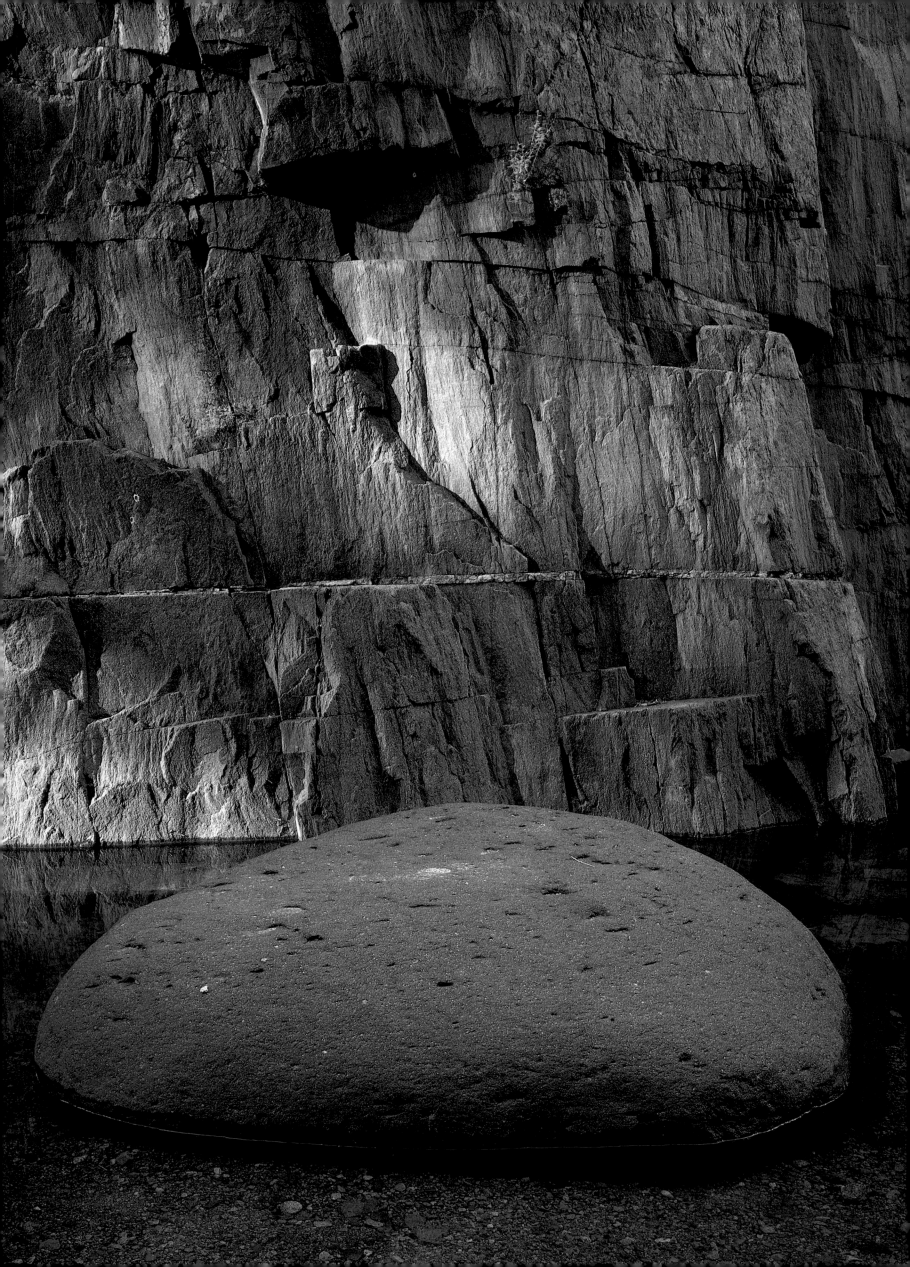

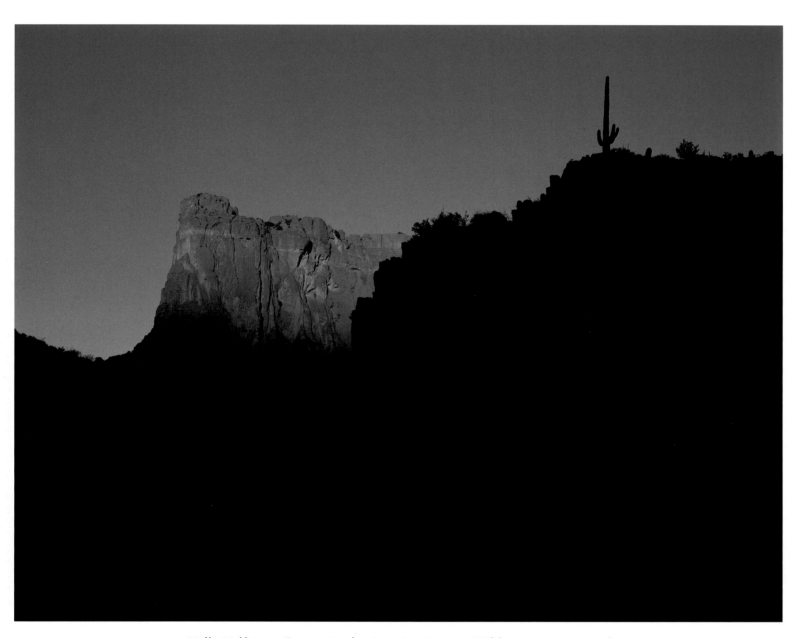

◄ Hells Half Acre Canyon in the Aravaipa Canyon Wilderness appears to be more peaceful than its name implies. Arizona ranchers, when a canyon was found to be impassable, often used "colorful" language to describe the place. ▲ Last light of sunset catches a wall of Aravaipa Canyon. The Bureau of Land Management limits the number of people visiting Aravaipa Canyon Wilderness.

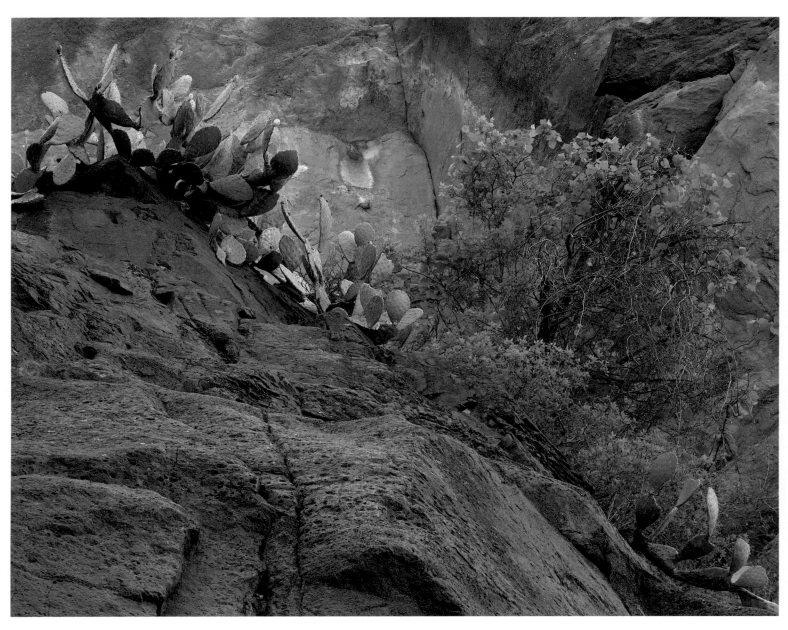

▲ Prickly pear and redbud cling to Rock Canyon's walls on the White Mountain Apache Reservation. ▶ Sabino Creek tumbles through gneiss at Anderson's Dam in Coronado National Forest's Santa Catalina Mountains. ▶ ▶ Morning light catches an organ pipe blossom at Organ Pipe Cactus National Monument.

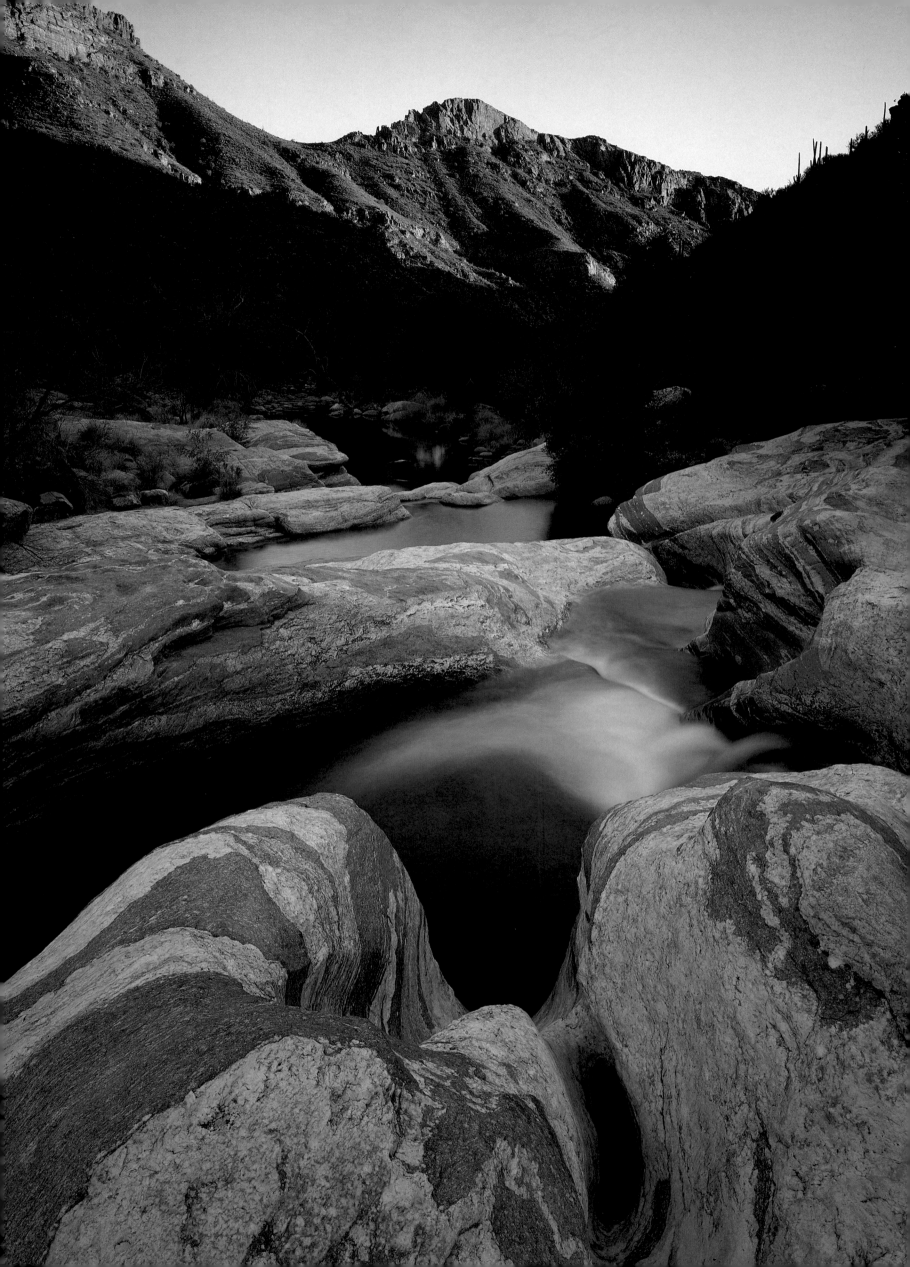

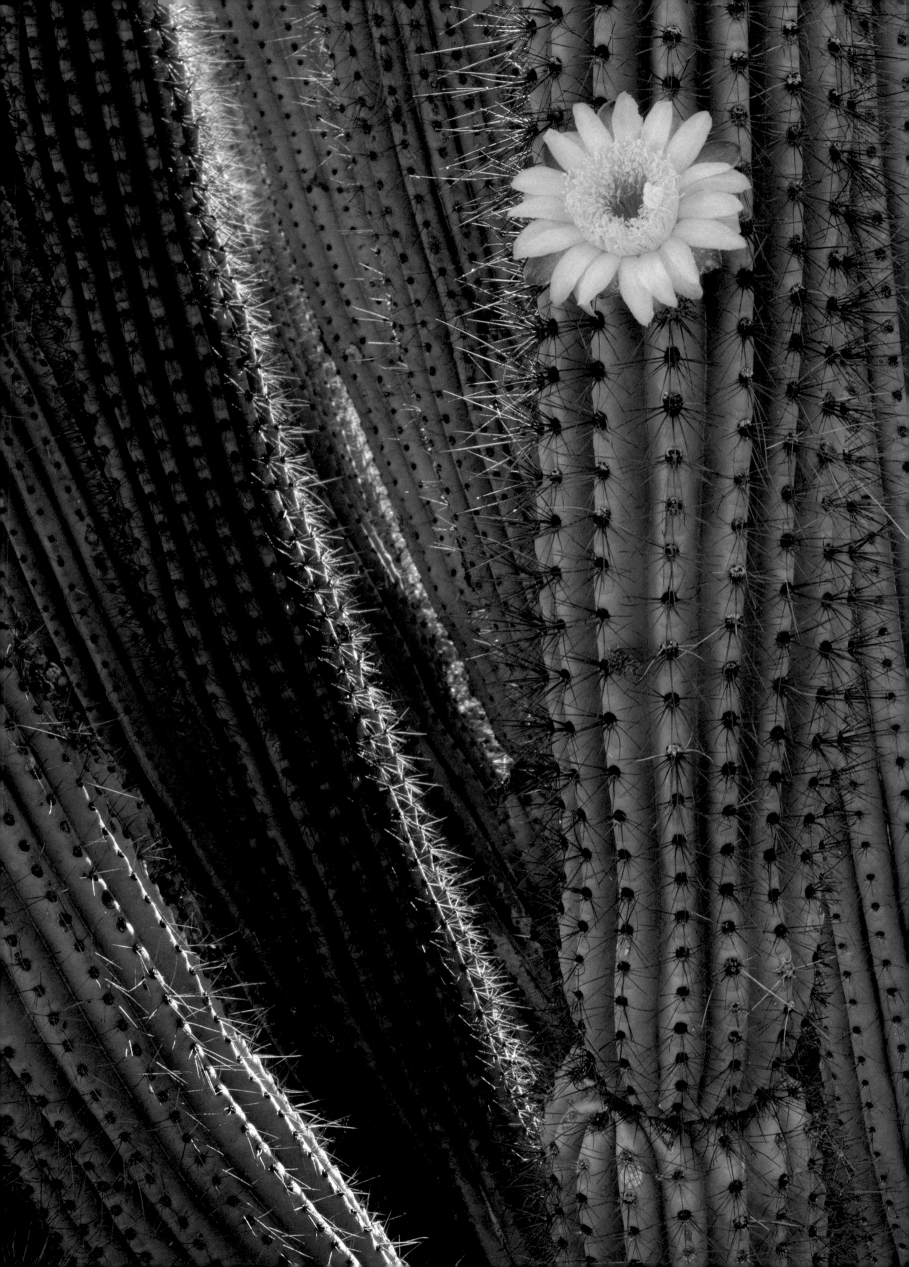

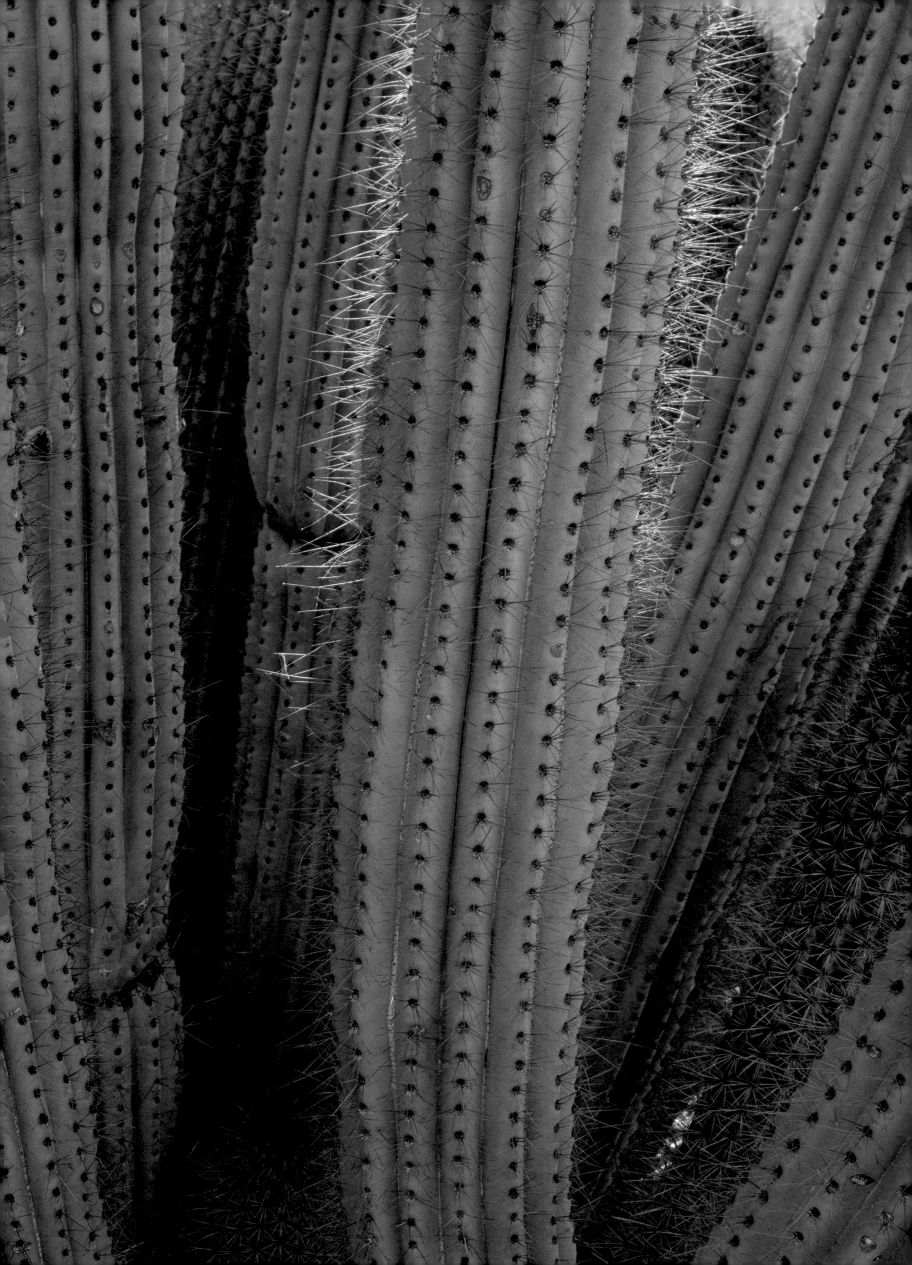

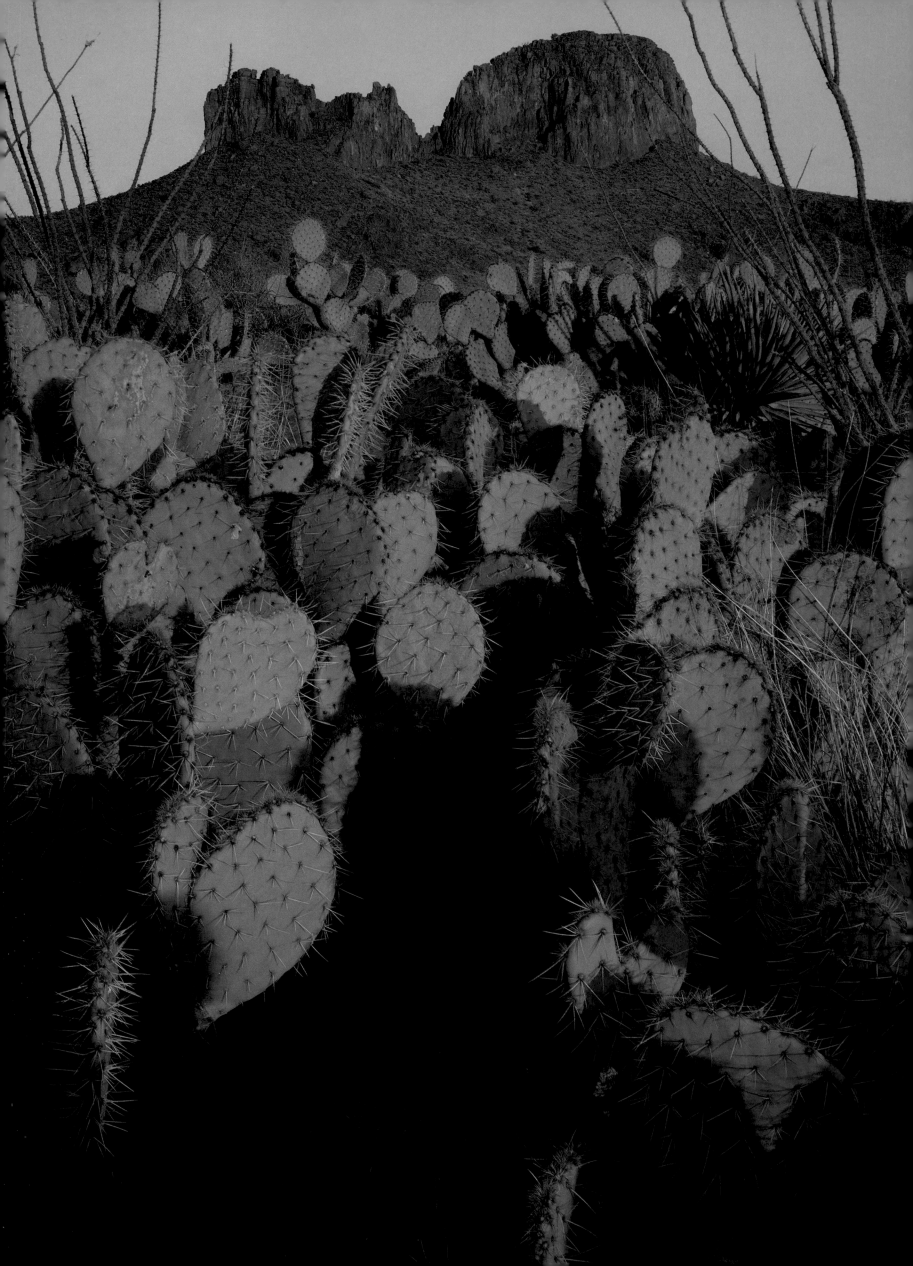

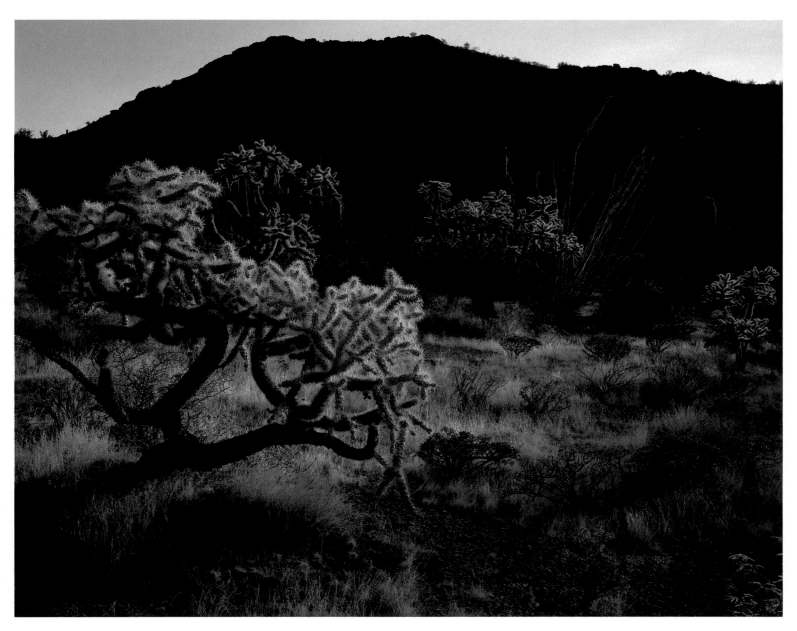

◄ In the Black Hills of southeastern Arizona, the fiery light of sunset illuminates prickly pears and ocotillos growing on rocky land renowned for deposits of fire agate. ▲ Chain-fruit cholla and ocotillo grow on the *bajadas,* or low-lying gravel slopes of the Ajo Range in Organ Pipe Cactus National Monument.

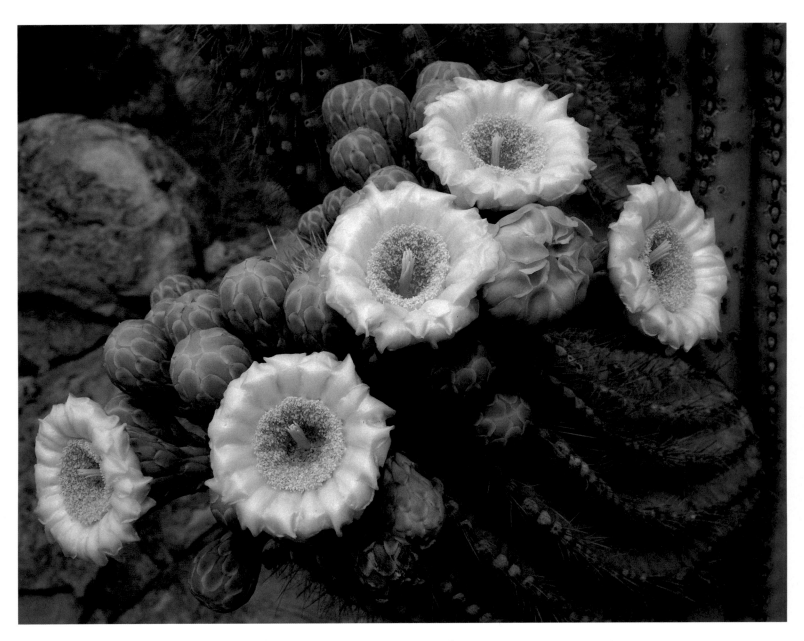

▲ Numerous blossoms grace a giant saguaro in the Dripping Springs Mountains. The state flower of Arizona, the saguaro blossom opens at night for pollination by nectar-feeding bats and remains open through midday when bees and white-winged doves visit. ▶ The cool water of Seven Falls rewards hikers exploring Bear Canyon in the Pusch Ridge Wilderness of the Santa Catalina Mountains.

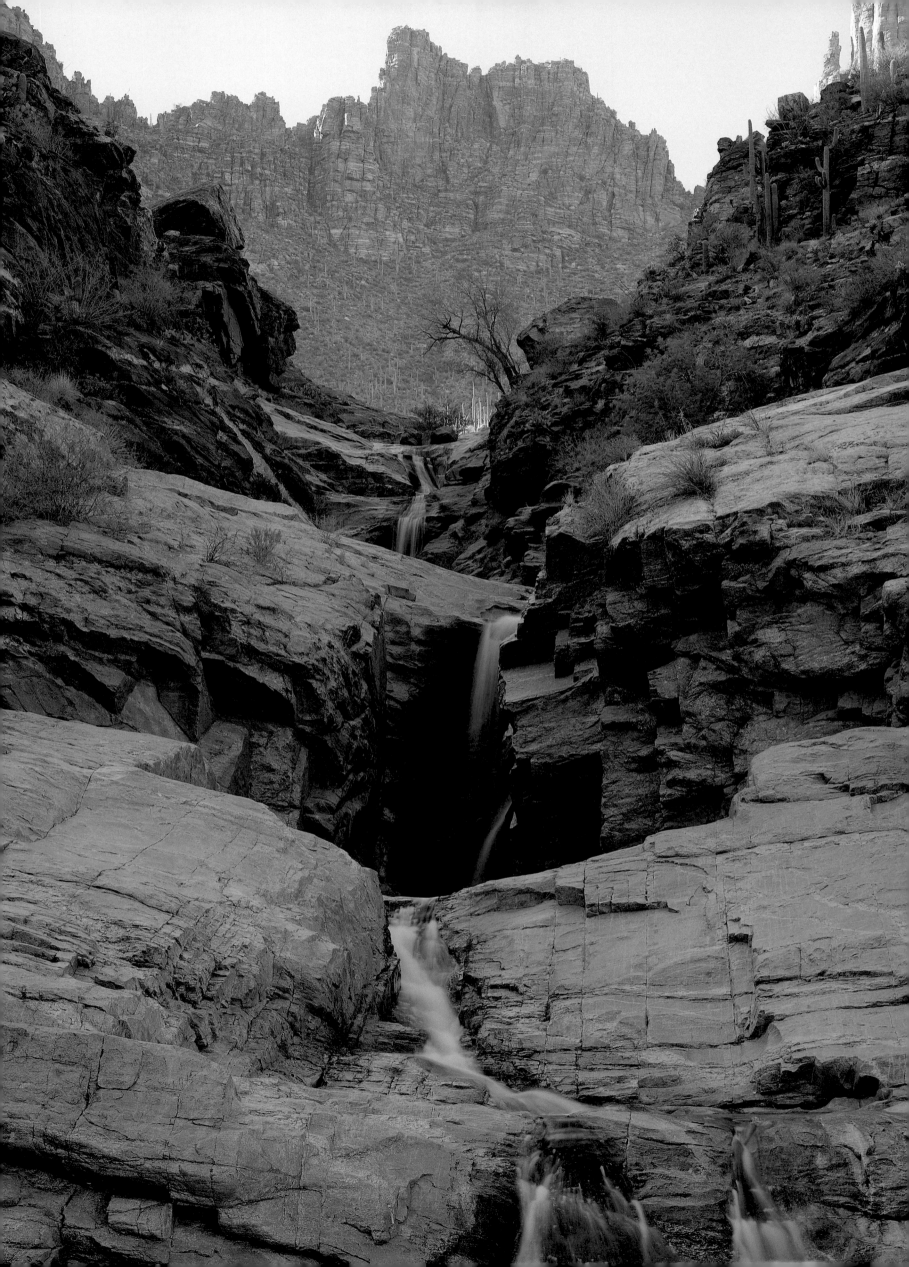

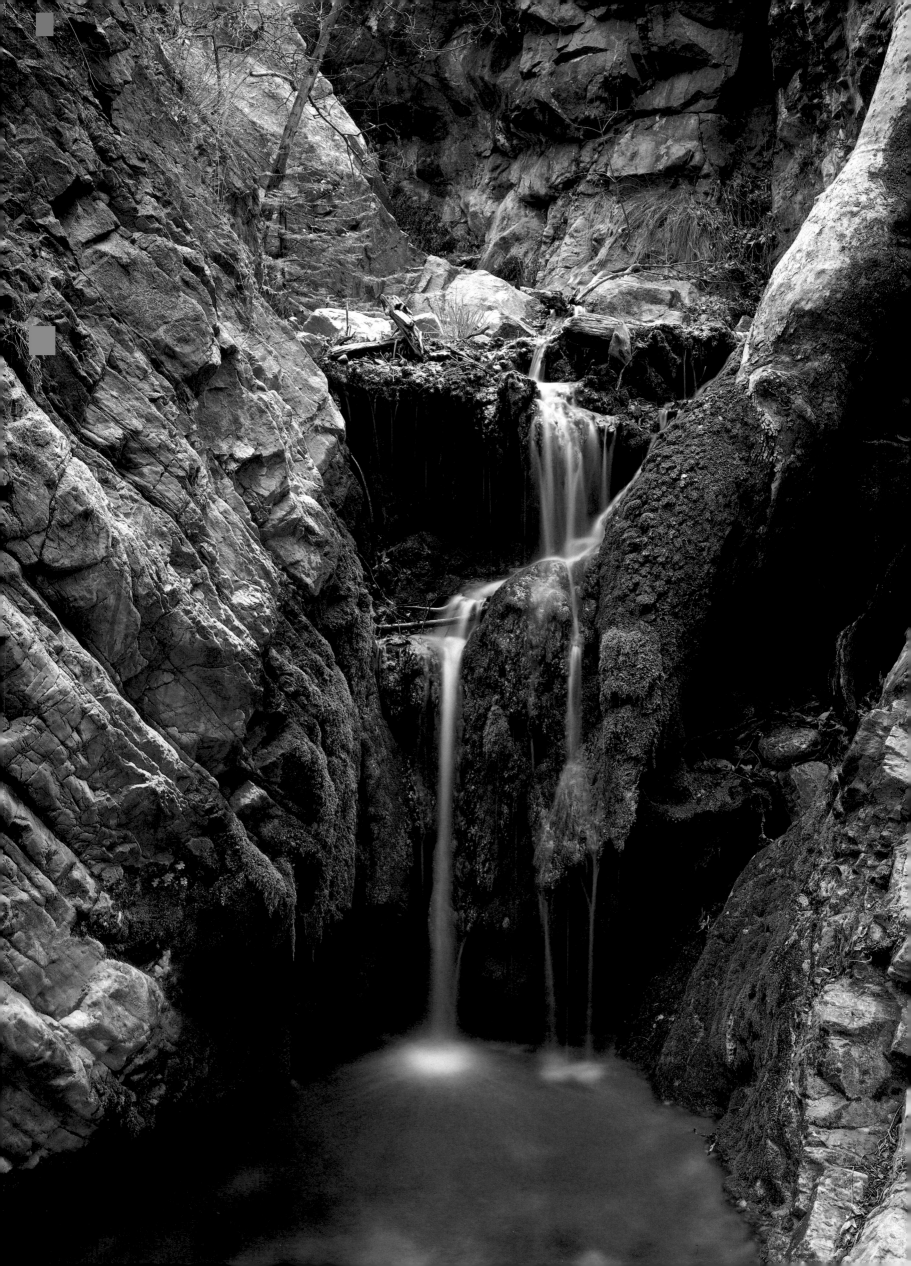

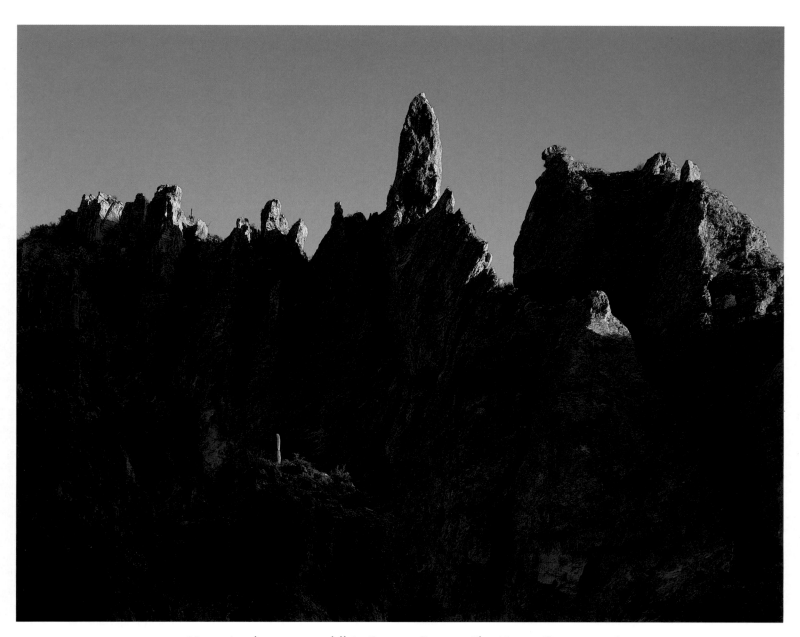

◄ Vegetation hugs a waterfall in Ramsey Canyon. The Nature Conservancy's Ramsey Canyon Preserve and Coronado National Forest's Miller Wilderness protect much of this fragile riparian stream that spills from the Huachuca Mountains. ▲ A knife ridge of the Galiuro Mountains rises above the rugged and remote Redfield Canyon, part of the Nature Conservancy's Muleshoe Ranch.

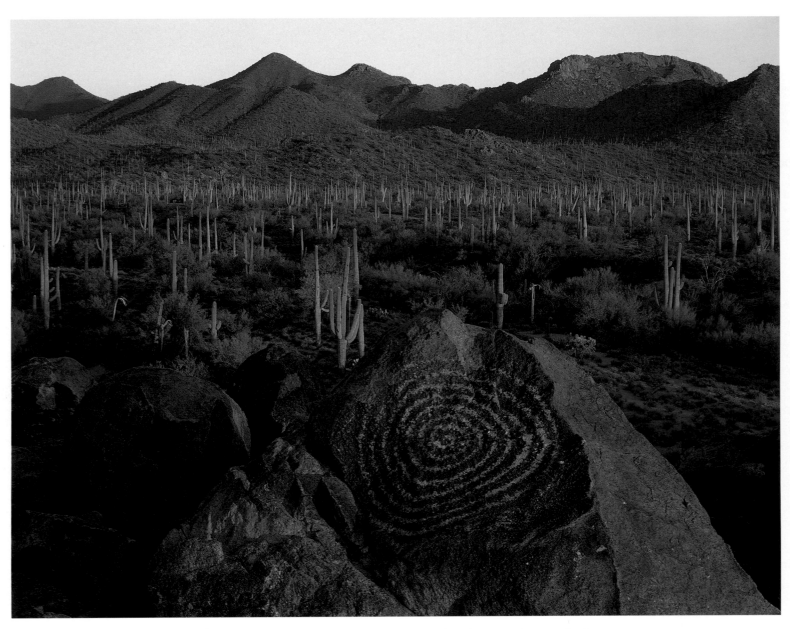

▲ At the crest of Signal Hill in Saguaro National Park, a spiral petroglyph has witnessed thousands of sunsets over the surrounding acres of cactus and paloverde. ▶ Near the Superstition Mountains, sunrise strikes the rim of Fish Creek Canyon near its confluence with the Salt River on a stormy morning.

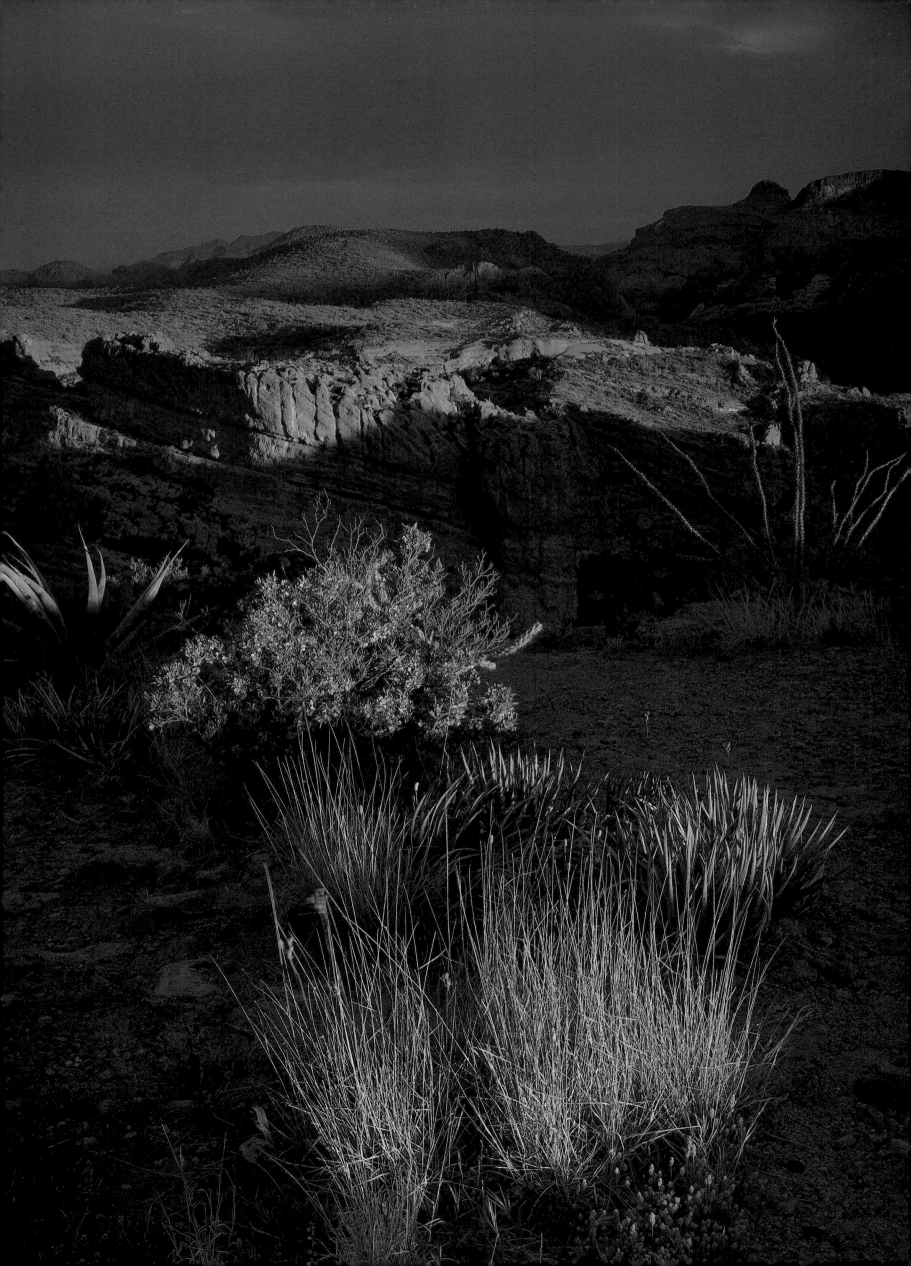

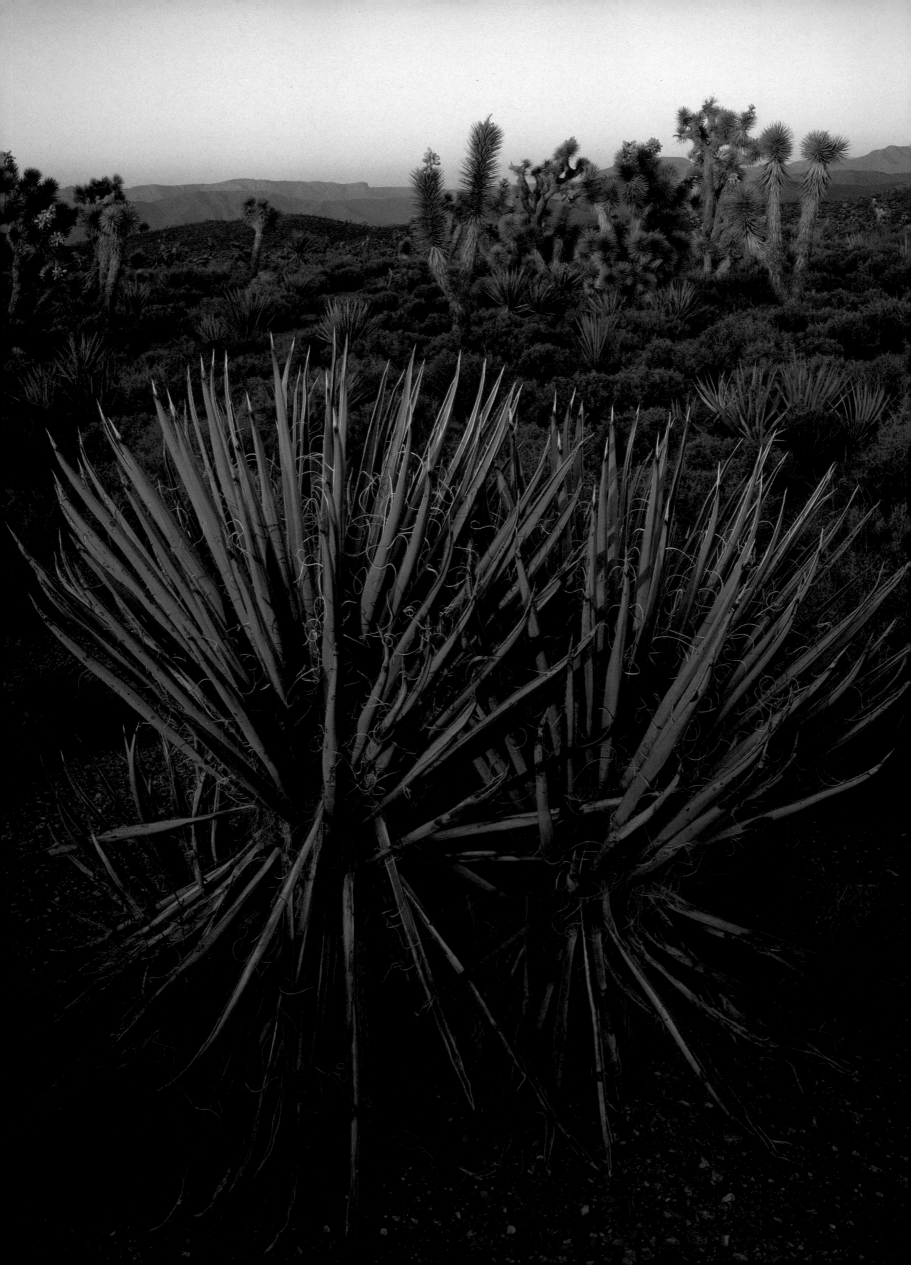

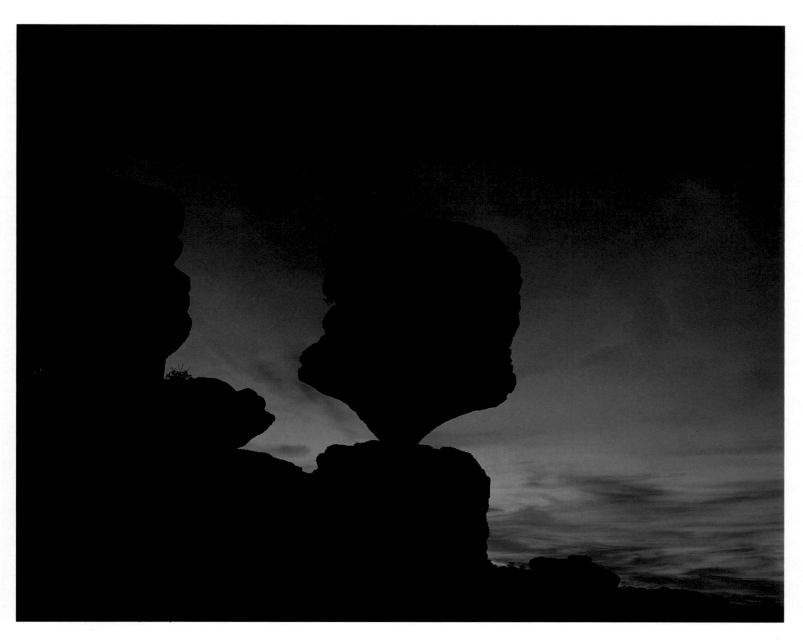

◄ Mojave yuccas and Joshua trees cover the White Hills south of Lake Mead.
▲ Sunset silhouettes Big Balanced Rock in Chiricahua National Monument.
► ► A cholla skeleton stands in Cabeza Prieta National Wildlife Refuge. Annual rainfall of three to nine inches supports over 275 plant species on the refuge.

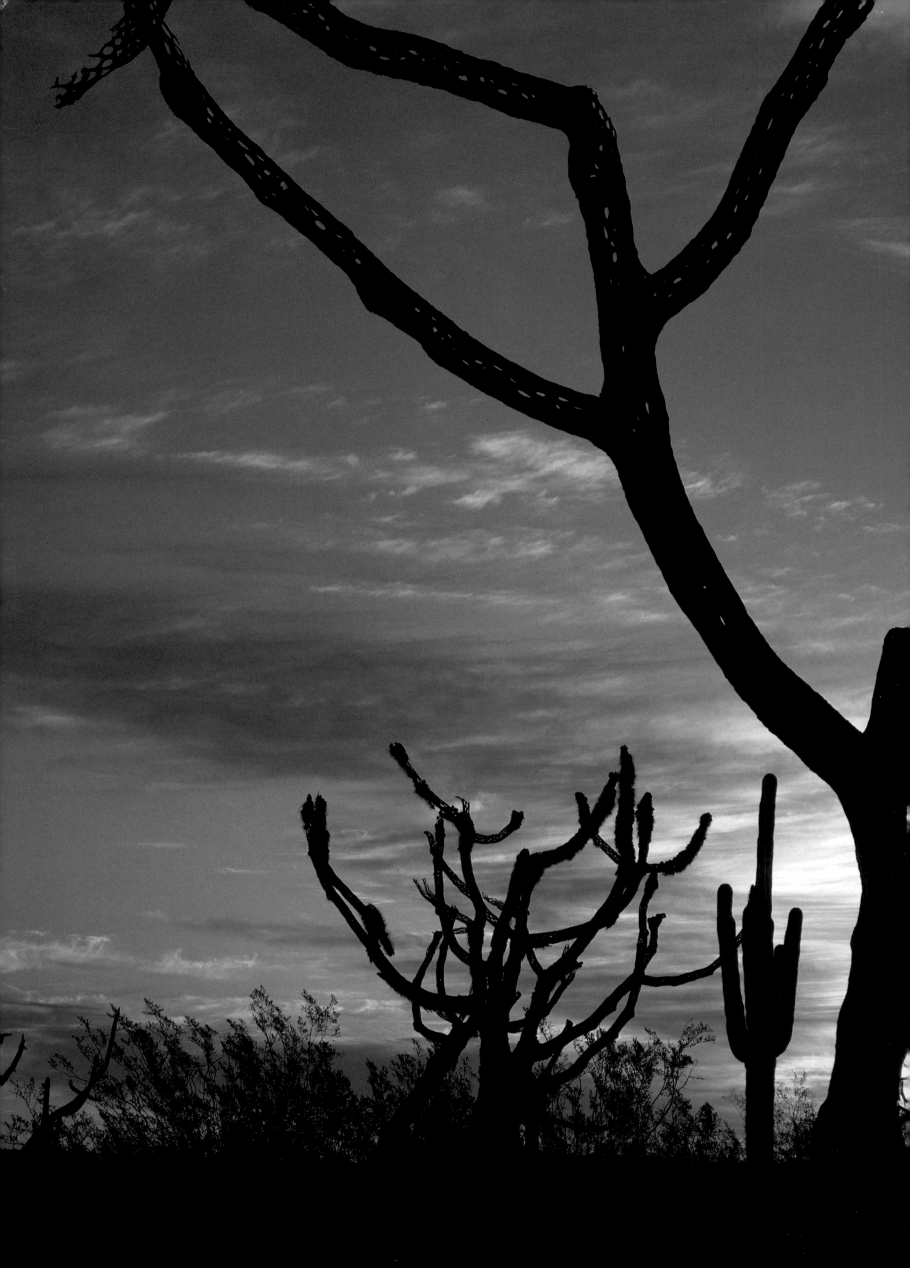

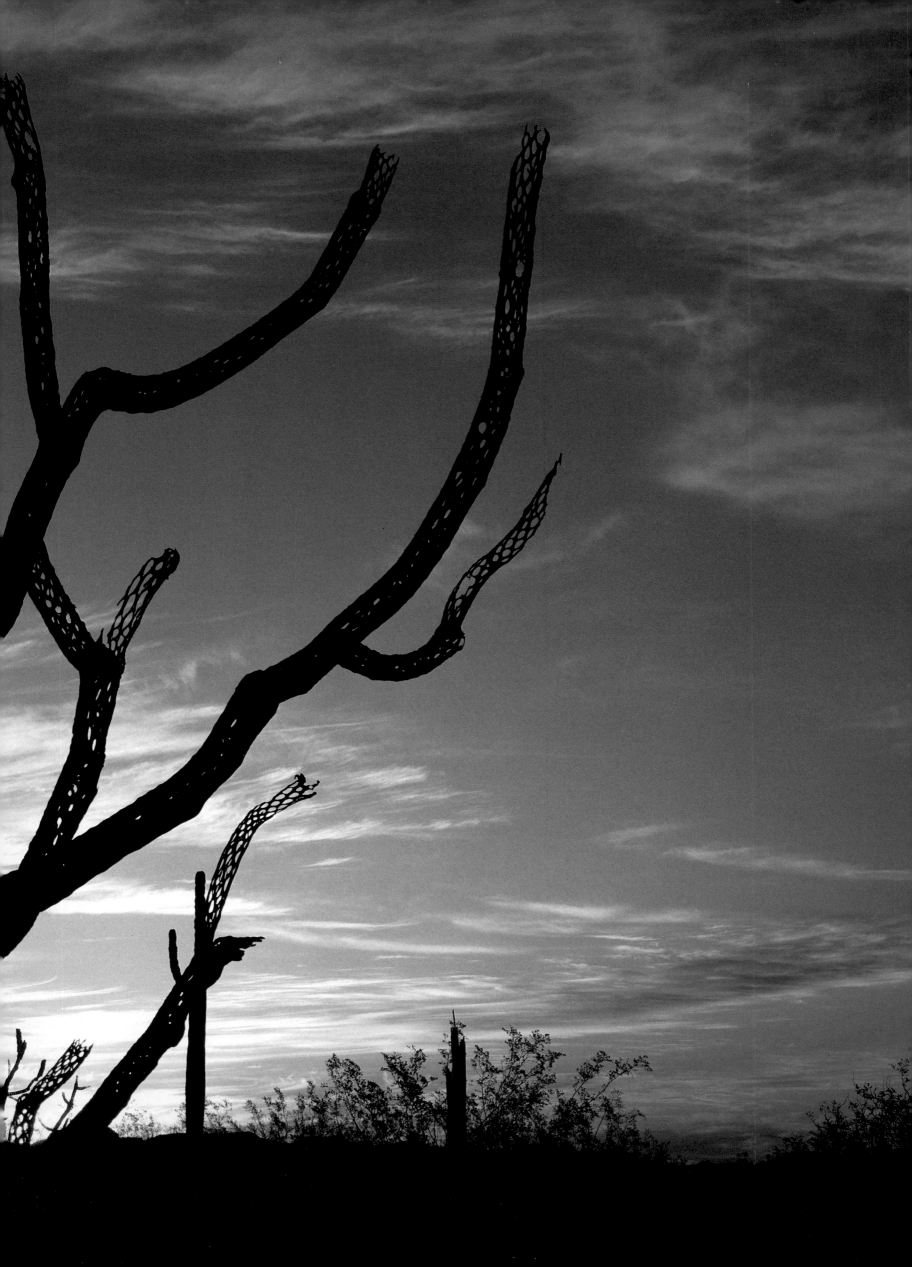

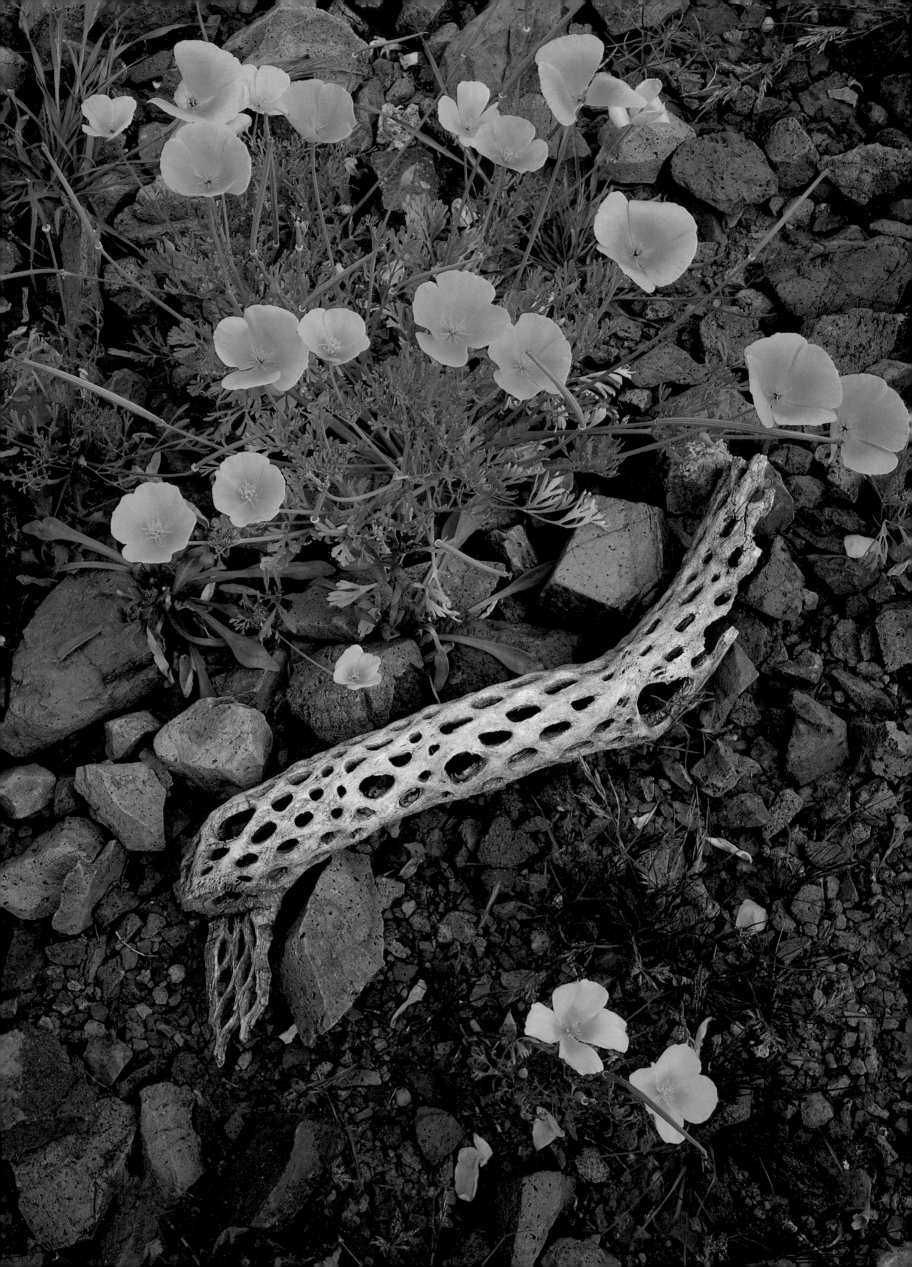

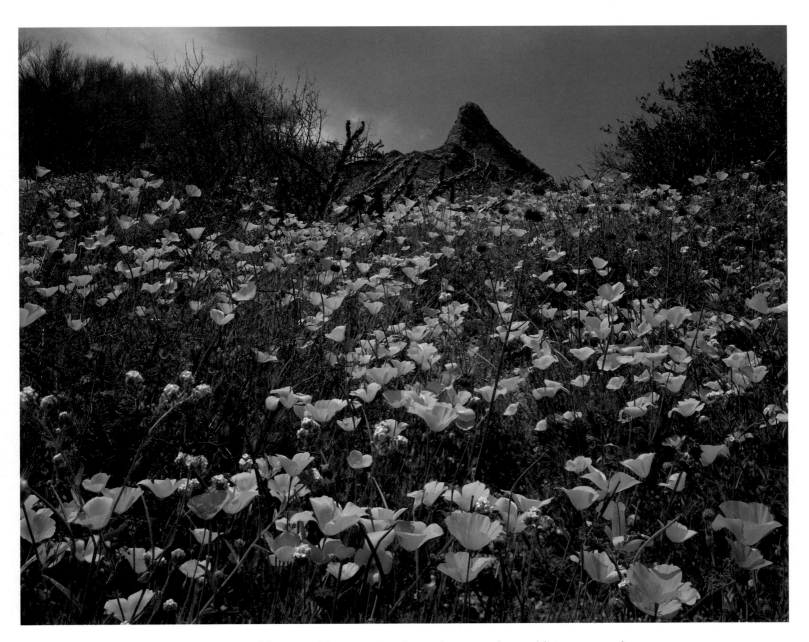

◄ Mexican goldpoppies bloom at Picacho Peak State Park. In addition to superb poppy shows, Picacho Peak is also known for a Civil War battle of April 15, 1862. ▲ Below Bronco Butte on Tonto National Forest, Mexican goldpoppies cover a hillside. Fall and winter rains trigger spectacular spring poppy shows.

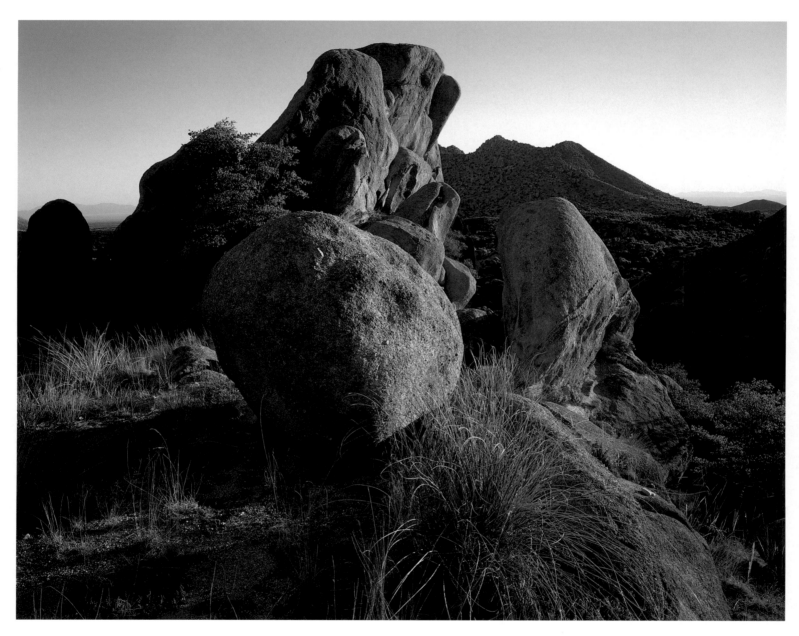

▲ Texas Canyon in the Little Dragoon Mountains has myriad granite boulders and tors. When granite erodes, it may exfoliate gently curved flakes of rock, sculpting fanciful shapes. ▶ Virgus Creek tumbles through a chasm of pitted volcanic rock. Sparkling streams course through many canyons in the Galiuro Mountains.

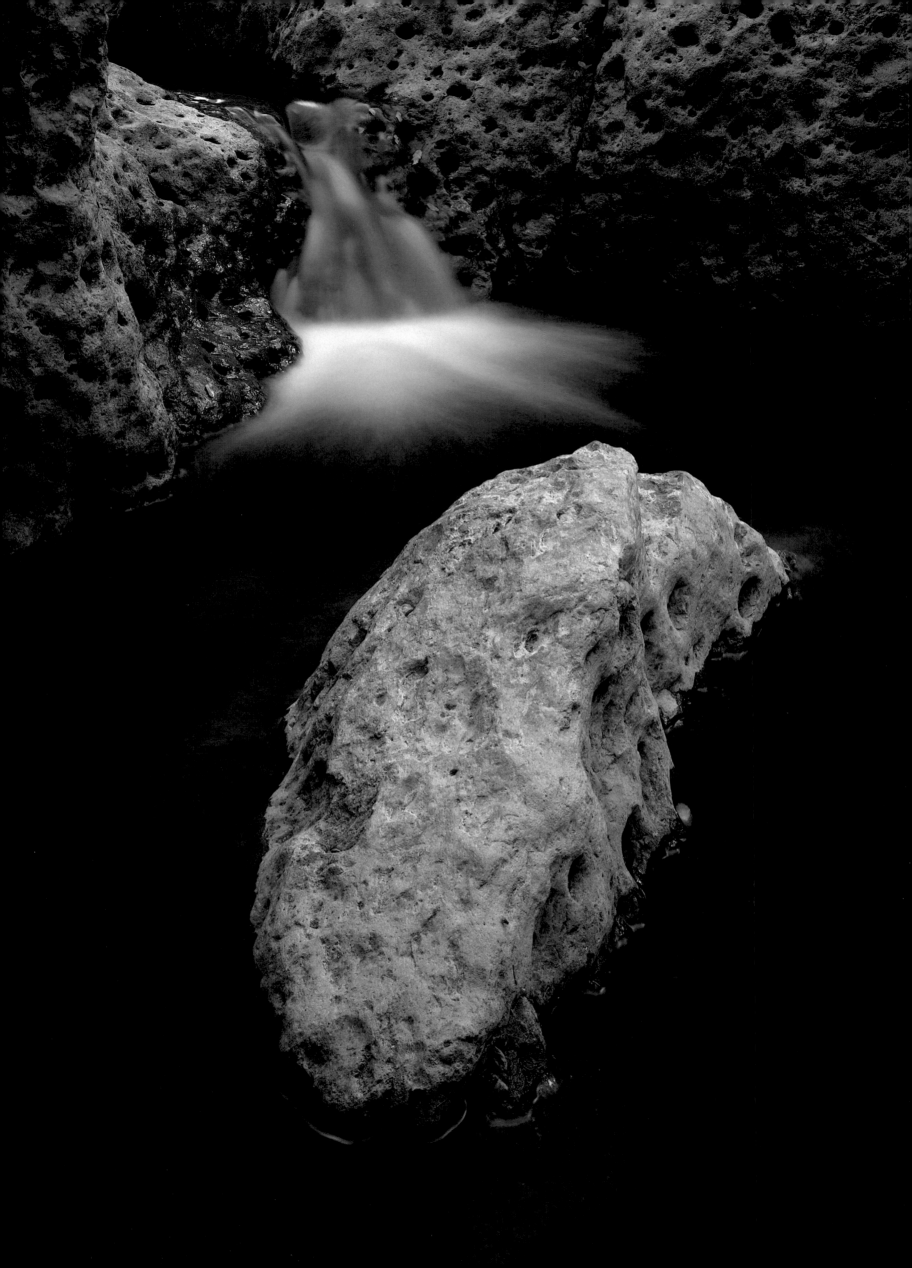

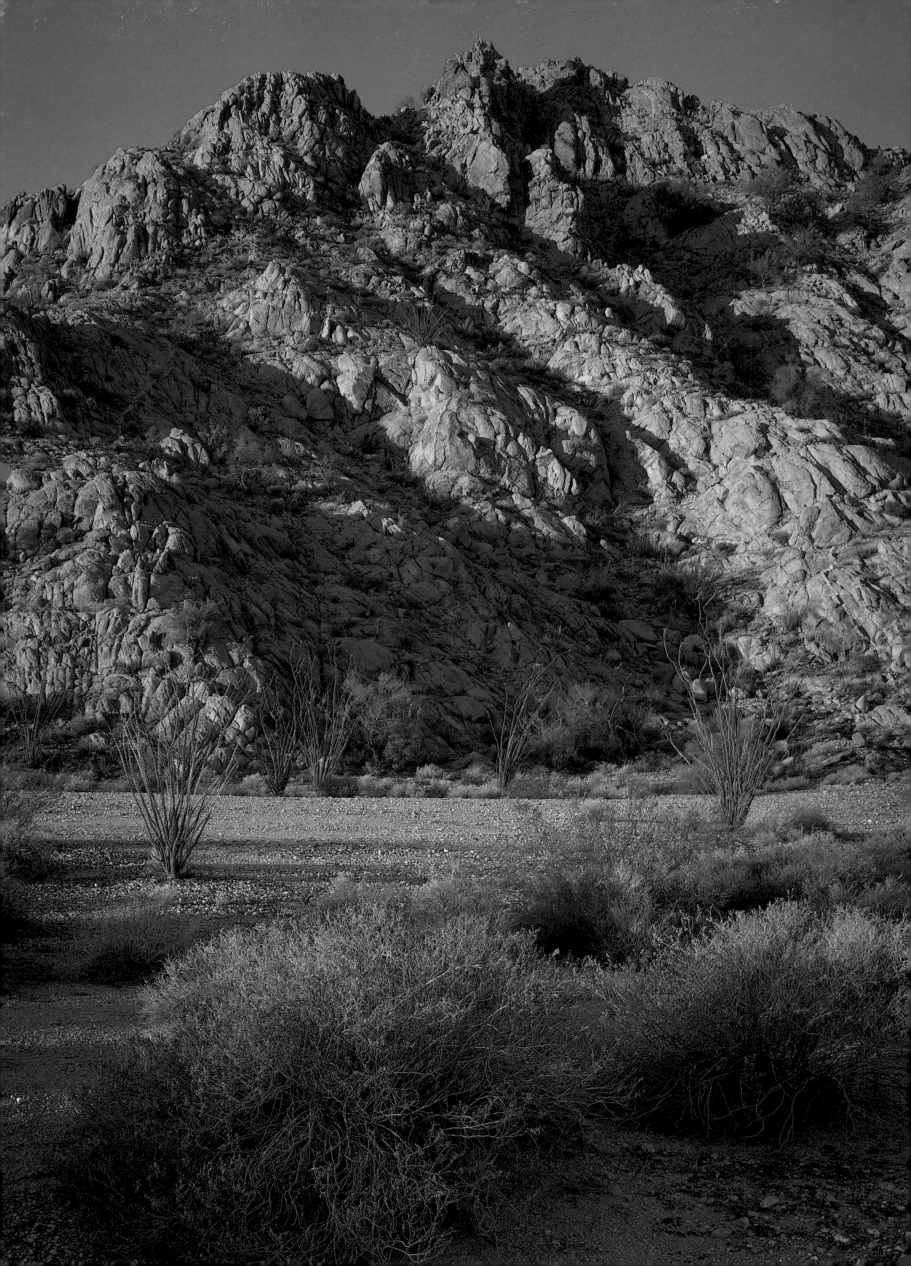

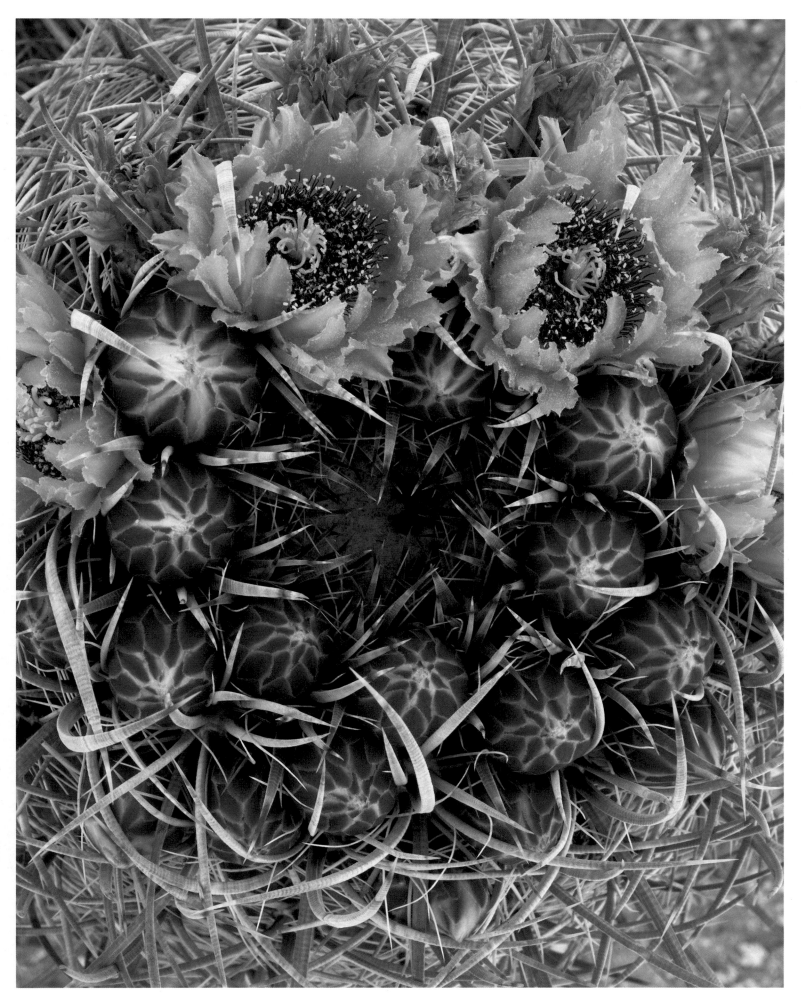

◄ Morning illuminates the Cabeza Prieta Mountains in Cabeza Prieta National Wildlife Refuge. With permits from the Fish and Wildlife Service, visitors may drive high-clearance vehicles over the historic *Camino del Diablo* or "Devil's Highway." ▲ Barrel cactus blossoms erupt in the Cabeza Prieta Mountains.